Inner Monologue in Acting

Inner Monologue in Acting

Rob Roznowski

INNER MONOLOGUE IN ACTING

First published in 2013 by
PALGRAVE MACMILLAN®
in the United States—a division of St. Martin's Press LLC,
175 Fifth Avenue, New York, NY 10010.

Where this book is distributed in the UK, Europe and the rest of the world,
this is by Palgrave Macmillan, a division of Macmillan Publishers Limited,
registered in England, company number 785998, of Houndmills,
Basingstoke, Hampshire RG21 6XS.

Palgrave Macmillan is the global academic imprint of the above companies
and has companies and representatives throughout the world.

Palgrave® and Macmillan® are registered trademarks in the United States,
the United Kingdom, Europe and other countries.

ISBN: 978–1–137–35427–3 (hc)
ISBN: 978–1–137–35428–0 (pbk)

Library of Congress Cataloging-in-Publication Data is available from the
Library of Congress.

A catalogue record of the book is available from the British Library.

Design by Newgen Knowledge Works (P) Ltd., Chennai, India.

First edition: September 2013

For Sadie and Chip Carter

Contents

List of Exercises ix

Acknowledgments xi

Introduction 1

1 Acting 5

2 Inner Monologue (IM) in Basic Psychology 9

 Mikayla, Actor 19

3 IM Everyday 21

4 IM in Acting 27

 Carolyn, Actor 37

5 IM as Enemy 39

6 IM versus Subtext 47

 Jacqueline, Actor 53

7 IM in Transitions 55

8 IM Alone Onstage 61

 Kirill, Actor 67

9 IM in Objective/Tactic/Obstacle 69

 Stephanie, Actor 79

10 IM Out of Your Head 81

11 IM in Script Scoring 93

 Zev, Actor 111

12 IM in Drama 115

13 IM in Film 121

14 IM in Classical Theatre 127

 Sarah, Actor 135

15 IM in Musical Theatre 137

16 IM in Comedy 147

 Andrew, Actor 155

17 IM in Style 157

 Rachel, Actor 169

18 IM in Auditions 171

19 IM in Other Psychological Theories 179

20 IM in Other Performance Forms 191

 Ian, Actor 201

Conclusion 205

Works Referenced 209

IM Testimonial Contributors 213

Index 215

Exercises

Bench Exercise #1	12
List Exercise	13
Bench Exercise #2	14
I Want Exercise	15
Bench Exercise #3	16
Dream and IM Journal Exercise	22
Free Association Exercise	22
Priorities Exercise	23
Out Loud Exercise	23
Projecting Exercise	24
Choices Exercise	30
Note Exercise	33
Inner Dialogue Exercise	33
In and Out Exercise #1	34
Percentage Exercise	41
Cast Your IM Exercise	44
Simple Script Exercise	49
Handbag Exercise	50
Subtext Exercise	51
Transition Exercise	59
Blocking Exercise	62
Alone Onstage Exercise	63
Props Exercise	65
Objective Exercise	70
Tactic Exercise	72
Expectation Exercise	73
Obstacles Exercise	75
Wins/Losses Exercise	76
Debate Exercise	82
Physical Exercise	83
Focus on the Other Exercise	85
Single Word Exercise	86

Image Exercise	86
Music Exercise	87
Audience Exercise	88
One Actor / Many Choices Exercise	91
In and Out Exercise #2	108
Narration Exercise	118
Listening Exercise	123
Confessional Exercise	126
Apostrophe/Soliloquy/Aside Exercise	131
Recording Exercise	138
Solo Exercise	140
Ensemble Exercise	143
Dance Exercise	144
Audience Laughter Exercise	150
Personal Clown Exercise	151
Complications Exercise	152
Double Take Exercise	153
Are We Compatible? Exercise	158
Mentalization Exercise	184
IPC Exercise #1	185
IPC Exercise #2	186
Core Conflict Exercise	187

Acknowledgments

Dr. Chris Hopwood for his inspirational and supportive guidance throughout the writing process.

Barry Delaney, Kirk Domer, Lisa Herbold, and Edward O'Ryan for reading early drafts.

Colleagues Mark Colson, Dan Smith, and Ann Folino White for their assistance.

Carolyne Rex for early editing and style decisions. Morgan Messing and Ian Page for their undergraduate assistance.

Graduate students Carolyn Conover, Sarah Goeke, Andrew Head, Kirill Sheynerman, Zev Steinberg, and Jacqueline Wheeler for their suggestions, contributions, and willingness to try the exercises and experiment with my ideas.

Special thanks to Carolyn Conover for her writing of the Ism Style section and her assistance in editing in the final stages. She was invaluable!

To my friends for helping me connect to others for chapter 20, especially Robbie Young, Alessandro Ferdico, Pauline Frommer, and Matt Zink.

And mostly to students past and present for helping me define and refine my approach to inner monologue in acting.

Introduction

The following passage was written by an undergraduate student who returned to college later in his life after having had success as a professional actor:

Nic, Actor: "I never really had trouble being cast in shows. I'd show up to auditions at school or local theaters, I'd make some bold choices, and more often than not, I'd walk away with a role. But during the rehearsal process, I felt I could only go so far without getting blocked. This was especially true of dramatic and emotional moments: directors became frustrated with me and my inability to go beyond what I showed them on the first day.

Perhaps that is just the type of actor I am, I thought. I'm a sprinter, not a long distance runner. I start off strong and then begin to flag once the real process begins. Maybe I'm just an improv actor. I wasn't happy about it, but I did my best to try and make it work.

It got to the point where the first thought I had was, 'Fooled 'em again!' every time I was cast. I no longer thought I deserved parts but had somehow bamboozled the directors into thinking I had talent; now that I'm cast, they're stuck with me. Maybe they could get something out of me, but I had no idea how to get it out of myself. This is no way for an actor to feel about his own work.

In college, the old tricks didn't work as well. I got parts, but because the focus was more on student growth than just putting on a crowd-pleasing production, all of my cracks started to show. I'm awkward with physicality, I can't take myself seriously, and I can't make myself feel powerful emotions. I was doing my best to learn all I could, but these issues were still the core of my problem.

Then, during an acting class in my junior year, we were doing a scene from *Waiting for Lefty* by Clifford Odets. All my [previous] acting issues still applied, so I was still not fully committing to the character. I was stopped mid-scene and was presented with this question: 'What is your character thinking?'

I froze. What was my character thinking? It's right there on the page; I'm saying it. Sometimes I mean the opposite of what I say, but that's just reading between the lines. I had a vague idea about his wants and goals, but I had no idea what he was thinking. I never thought about it. This is when I realized I had been acting throughout my entire career with no inner monologue.

I could fake it very well, but I was nothing more than a talented mimic of human behavior. I knew what people did when they felt emotions, I made dynamic-looking choices, and I was able to replicate good acting on stage, but I was never feeling a thing. My thought process while acting, the only inner monologue I really had at this point, sounded a bit like this: 'Alright, now walk in and close the door quietly. That'll look good. Now, approach her and touch her hair; I've seen couples do that. Now if I punch the wall when I yell, that will really impress the audience.' All of it was purely technical. They may have been correct choices, but they were coming from the wrong direction.

This was the root of all of my issues. Of course I can't do dramatic work well: the stronger an emotion is, the harder it is to fake. No wonder I can't take myself seriously: all I'm doing in my head is looking at myself and judging the best way to make the audience react. My physicality is awkward because all I'm thinking about is how I look doing these motions, with no thought to what's driving them.

Once I began to sit down and do the intricate work of inner monologue, my acting improved drastically. I was focused on my partner more than myself, and strings of thought connected one line to the next and drove my actions. The majority of my self-awareness slipped away; there was simply no room for it. I began to feel what my character felt, and this drove me to make bigger, better choices than I ever had before.

The work of inner monologue is absolutely essential for anyone who wants his or her acting to transcend mere human mimicry. It is more important than the words in the script; it is the lens through which those lines are interpreted and projected. It is the heart of your character and it is ultimately what makes a portrayal of a part unique to you as an actor."

Throughout this book, I will share reactions from students past and present regarding the use of inner monologue in their work. Some may have just completed an intensive section of an acting course devoted to inner monologue and are responding immediately, while others may have gone on to professional careers and are commenting on their use of inner monologue since their immersion in the concept years earlier. In any case, they were asked to share their personal

reaction to inner monologue work including their successes, frustrations, and how they personally adapt the concept for their process. My goal as author is to give you the information and exercises surrounding a method for acting that works for me and for many others. My hope is that you will read the book with an open mind and perhaps adapt anything that may resonate with you regarding inner monologue to create a personal version in your way of working on stage or screen.

I

Acting

May We Agree?

May we agree that good acting contains vulnerability, honesty, raw-
ness, flexibility, compassion, responsiveness, and boldness? If you
don't believe acting is any of these things, then read no further and
explore other methodologies. Any teacher or book is merely a guide
that allows you to find your personal way of accessing the truth. Truth
in acting holds varying definitions so you must find your best entrance
into creating honesty onstage. For some, it is inner monologue.

This is not a new pathway or even a novel concept. Inner monologue
holds a brief mention in most acting texts. What I expand upon in this
book is the importance of having thoughtful, conceptual, and vulner-
able actors who live on stage or screen with depth, complexity, and
obstacles. All of this is achieved or enhanced by inner monologue.

I yearn for a fleet of actors who understands and appreciates the
basic elements of human psychology. Who embrace the idea that
we are never inert. Who are constantly in motion, in critical need
and in recognition of motivation. In order to best represent our full
human selves onstage, we must tap into the source of a basic element
that drives us and our most intimate and honest expression—inner
monologue.

May We Accept?

May we accept that inner monologue is that constant stream of pure
thought that drives our conscious, subconscious, and unconscious
lives? Inner monologue is the voice within our heads that commands,
prods, guides, inhibits, consoles, and never rests. Inner monologue is

our best friend and our worst enemy, our moral compass and our ethical barometer. Even our dreams paint portraits related to our inner monologue. If this intrigues you, read on.

How can we harness what is true? The ugly? The vulnerable? The reality that is within each of us? How can we best represent honesty? The answer to me and to countless others is inner monologue.

I wish to share what has worked for me as actor, director, and educator and what has given pause and depth to actors in productions and students in classes. I in no way suggest that this is the ultimate answer to acting. I do, however, avow that this overlooked approach is a new way of enhancing the tried (and in some cases tired) methodologies of acting.

What is it that makes an actor special? Analytical skills? Sense of humor? Ethics? Honesty? Knowledge? Point of view? All are true. Any of these can be enhanced by a closer attention to the detail within inner monologue.

Do not get me wrong; I believe that a character wants something (an objective or goal) and a character has ways to get there (a tactic or action) and there are things that prevent her/him from achieving this (obstacles or blocks). The connective tissue for each of these concepts is inner monologue.

I do not suggest discarding the established methods that have been the hallmarks of my acting, directing, and teaching. These are the basics of the traditional Western method. I do suggest the addition of a new way of approaching performance, direction, or coaching to assist an actor in finding new levels in her or his work. Inner monologue is offered as an augmentation, a supplement to an actor's standard approach.

I wish (as I hope you do) for a better world of honest, reactive, and vulnerable actors. Inner monologue can assist with getting us there.

May We Align?

May we align our purposes? Whether you are reading this book as actor, director, or educator, the end result is the same—honest acting. The goal is similar, but the rationale may be different.

My goal as actor is to never settle for the same old choices, but rather have a variety of options ready to go at the audition or in the rehearsal room. In order to initially get the job or be hired again by the same producers, I aim to create a reputation for unfettered imagination combined with technique that allows great work.

My goal as director is to make an actor in a production seem to truly inhabit the world we (playwright, designer, and all collaborators) have created. That means creating a shared version of style, environment, stakes, and logic through deeper interaction with the cast. I aim to create a unified production that answers the needs of the script.

My goal as educator is to expand actors' current choices by developing their standard analysis. I must push an actor to test his or her boundaries, explore new strategies, and try various options. I aim to create a class where students can invent many justified versions of the same scene in order to fully connect with their partner.

For actors, my aim is to give you the tools for deep and complicated work that allows you to create communion with your partner and the text.

For directors, my aim is to ensure you have seamless transitions and honest moments of clarity and depth onstage.

For educators, my aim is to offer you options that test your students to always remain alive onstage and prove that they have done their homework.

No matter the reasoning for reading thus far, you must understand that this book and its musings and exercises have three very different audiences in mind. My hope is that you will explore it from these various vantage points and appreciate its main emphasis: the creation of honest and thoughtful acting.

2

Inner Monologue (IM) in Basic Psychology

Certainly any book on Inner Monologue (IM) must answer the most basic psychological question: where does IM come from? Dr. Christopher Hopwood from Michigan State University's Department of Psychology states:

> I guess the short answer to your question is that, as far as I know, there are no well-accepted theories about where inner monologue comes from. We certainly have theories, just not unanimity. For instance, whereas social and clinical psychologists might tend to emphasize the role of motivation (but disagree about how conscious the motivation likely is), cognitive psychologists would likely focus on memory and information processing.

Inner monologue; interior monologue; conscience; good angel vs. bad angel; voices in your head; stream of consciousness, free association, underthoughts; a conversation with oneself; subvocalization; cognitive linguistics; language of thought; libido: no matter what the theoretical or colloquial label, the result is the same—a constant, nearly uninterrupted flow of thoughts that occur in every person's mind. For actors, the trick is understanding, harnessing, and adapting their personal inner thoughts in order to create the IM for the character they portray. For the director, learning to speak this most intimate interior language with the actors paves the way for more depth in discussing performance and a compelling connection to the cast. For educators, the goal is to assist a student in understanding the nuances of the individual personal IM and character IM.

In the basest of psychological terms, IM can be traced to the fundamental subconscious of any person. This subconscious metaphorical pinball game of contemplation whizzes from thought to thought, based on stimuli and free association. With IM, one thought leads effortlessly (or some might say, with great effort) to the next. The basic transaction of thought occurs spontaneously and sometimes defies words. Your IM can be comprised of ironic musical phrases, images of past lovers, or the recalled smell of a favorite ingredient.

Examine a few common tasks:

Reading a message from an old friend sparks various actions—this unexpected pleasure may take you to the memory of the last time you were together. To play your shared favorite song. To look at a picture from years ago. To remind you to write to another acquaintance. To find the link of the video you wanted to share with him. To check your sent messages to see whether you were the last to correspond. And there the original message awaits; unreturned.

Shopping online—you start searching your favorite site for the shoes you must have. You see a sale at a different site and click on it. That reminds you to check the movie listings. A banner ad catches your attention so you click and follow that like Alice down the rabbit hole.

Looking up news on your computer—reading a story may trigger you to click a new tab that catches your attention. Once in this new window, you may be distracted by an unrelated headline in the lower portion of your computer screen. This story makes you seek further information and definitions that could go on endlessly if time allowed and curiosity was unabated.

Your brain allows a series of "unexplainable" clicks that are ultimately unrelated to the original task. Your browser history may actually give you tangible proof of how your inner thoughts ricochet tangentially. You perform these tasks in outward silence while your loud IM drives you to other necessary or seemingly unrelated zones.

While these thoughts offer circumstantial proof of how your IM works, let your mind wander next time you take a shower. This private time is exactly that. In the spirit of full disclosure, here is part of my recent IM when showering: *I have to call her about the audition for that boy…was she mad? Seems—get that quote. Email—unfair. Shock absorbers. Laundry. Sigh. Warm. Too warm. Oh, damn, I forgot. You're late!* While not compelling playwriting, it makes sense to me (the main character). It offers a glimpse into the fractured way in which my mind connects the incongruent thoughts that infect my

brain for a second before floating away to be replaced by new ones. Free association. Sigmund Freud used the concept of free association in his work. In basic terms, a patient was asked to allow his mind to wander and verbalize her/his inner thoughts. (Author's note: for future reference I will use the terms "her" or "his" interchangeably.) Rather than an analyst's interruption or advice, the patient would be able to recognize and solve her problems through uncensored and free-flowing thought. The concept of free association is the use of IM as the most intimate way of understanding what drives any person. One of the earliest forms of psychoanalysis used the concept of IM as the gateway to the true core of any person. Free association and IM may be thought of as synonymous.

Using the most basic of psychological terms, you can break down the possible traces of IM using Freud's id, ego, and superego. This widely accepted (and widely derided) theory can certainly offer a springboard for the various functions and uses of IM in acting. I understand there are many psychological theories related to IM, but I shall use Freud's theories in their simplest forms in order to narrow our focus. My hope is not to educate you as actor in Freudian (or any other) theory, but rather to connect and expand your understanding of how your personal IM works and how you can use it to become a better actor. A great acting book that explores psychology from various points of view is *Tools and Techniques for Character Interpretation: A Handbook of Psychology for Actors, Writers, and Directors* by Robert Blumenfeld.

Id

In fundamental terms, the id connects you to your most basic needs. It wants you to feel pleasure at all times with no consideration of the consequences. A newborn is pure id—crying, sleeping, eating, or relieving himself whenever he feels the inclination. This idea of the id is closely related to IM and is your most personal relationship. IM is where you get to "say" whatever you wish. You "talk" to yourself about your basic needs. Your IM is constantly reminding you of how hungry you are, how attractive that person is or how boring this book is.

Your relationship with your id and IM is one of complete and utter trust. You subvocalize your most selfish and heinous thoughts there. The id is a large portion of your IM because it is hidden. It is private. It is basic. It is unconscious and uncensored thought.

Bench Exercise #1

Sit in a public area (a mall, a library, a bus stop) and simply focus on your basic needs—hunger, sleep, or sex. Let the stimuli of the trafficked area allow your IM to float from need to need.

What would make you happy? Would that food truck's offerings sate your hunger? Would that music lull you to sleep? Would that person be amazing in bed?

Try to focus your IM on simple and basic principles of pleasure. If your IM starts to judge or censor yourself for such "base" thoughts, simply disregard and try to focus only on the task at hand—satisfying yourself through IM. You may note that your selfishness and your libido take control and navigate your IM through this exercise. That is fine. Our next concept offers a more balanced approach. (Author's note: Some exercises are meant to be performed alone as actor, while others are written for educators or directors. Feel free to adapt based on your needs.)

As we go through our Freudian exploration let us use Tennessee Williams's *A Streetcar Named Desire* lead character, Blanche DuBois (a character devoted to her IM), as a theatrical example. Blanche's action in the opening scene of the play shows IM in its id form. Following her harrowing journey, Blanche surveys the cramped quarters of her sister Stella's apartment, wipes her perspiration, and most importantly, gulps down some liquor. The motive for each of these moments onstage is driven by the id part of the IM—she wants to stop the oppressive heat, dull the pain, and sleep.

As actor, how can you constantly keep Blanche's IM alive? It can be exhausting to create the inner life of this character. When portraying Blanche, you must constantly silence her blaring id needs in order to remain in this new household. Her past id actions have brought her to Stella's apartment where she is unwanted, so she must control them.

As director, how can you help your actor to understand the needs of the character through IM? You must assist your actor in exploring all areas of IM by offering variations of possibilities that the actor may not think of. Simply stop the rehearsal and ask an actor: "What is your character thinking?" It will begin a bond and contract between actor and director to share in the exploration of a character's deepest thoughts.

As educator, how can you endow your actors with the freedom to explore the many possible carnal needs of Blanche? You must assist your actors in exploring every conceivable id-based need in class that is a possible motivation for Blanche, using probing questions that cut to the heart of the character's thought process.

In choices onstage, the IM at times must spring from this selfish part of the character. Too often actors avoid the id IM because they believe it will make their character unattractive or unlikable. But are those moments not the most revelatory? When a character displays id-like behavior, you can recognize yourself in his base and primal motivations. This sort of IM work by an actor is to be encouraged. It offers complications and obstacles.

Ego

Once you have successfully navigated the part of your IM that connects to your basic needs, you can begin to explore what Freud calls the ego. The ego understands the basic needs of the id but adds a dose of reality to the situation. While the id explores pleasure, the ego understands that others may be involved with your basic need to satisfy your sole desires. The ego is organized and logical. So, at times, is your IM.

Your ego forces you to think about how your base id desires would realistically play out. While your id wants to eat the food in front of you, your ego balances the reality of the situation—you will gain unwanted weight. Your id shouts at the person who cut you off in traffic, but your ego tells you to calm down. Your ego acts as the reason between your id and the superego (to be explored next).

The ego is realistic balance and organization. When you actually verbalize your inner thoughts, how often are they related to organization? Quite often your IM is spoken aloud when list-making. You may mutter alone in your car, "Remember to buy eggs." IM as shopping list. As you continue to read this book, explore the moments when you actually verbalize what you are thinking. You may be surprised by its ego-base.

List Exercise

Without distraction, make a list of what you need to do in the next few days. This list will be created without the aid of pen, paper, or computer. Try to create a chronological and detailed catalogue of your actions—where you will need to go, how to fulfill your disparate chores and activities in the most expeditious and efficient manner. "If I go to the grocery store I should pick up the dog food at the pet store nearby before filling the car up with gas." "I can't call her because there is a time difference and she works late that night." "I want to take a nap, but I won't have time to complete the reading, and I have to do laundry."

You may recognize the ways in which your IM can categorize and prioritize quickly. You may also begin to realize that IM does not necessarily think in fully-formed thoughts. Before one though finished another replaces it.

Bench Exercise #2

In the same area where you performed the first bench exercise, allow yourself to explore your id thoughts again—the libidinous and selfish. While you do so, avoid the censorship of the act and rather think about the cumulative effect. Consider "if…then" statements: If you did _____, then that would _____.

"If I go up to her, then I would have to make awkward conversation." "If I ate that person's food, then they would be angry." "If I went to sleep right here, then I would cause a scene."

The thoughts are not about the moral ("Taking someone's food is wrong") but rather about the rational. In this exercise you must explore the realistic effect of your actions.

Blanche DuBois, in a later scene from *A Streetcar Named Desire*, has been upstairs at the neighbor's home all night after running from the apartment where she saw her sister Stella in a domestic dispute. One imagines Blanche has been stewing (alone with her ego) for many hours until she can finally make her way back to the apartment. Blanche has concocted a plan, through her ego-based thinking, to set up a shop for her and Stella. While the plan is flawed, her fragile logic is a perfect example of a character's ego at work. She has organized a plan as best she can.

An actor must make his behavior onstage logical. Logic is purely related to the ego. In most cases, you understand your actions have consequences, and therefore, you, as an actor, must fulfill those expectations in order to enhance the experience for the audience.

It is imperative for a director to manage an audience's understanding of a character's motivation. How often do you watch a show and think about a directorial choice: "That doesn't make sense. That character would never do that"? The IM and the ego must correspond through direction.

As educator, you may focus students by offering ego-based coaching. Organize your thoughts rationally before responding to a scene. Offer notes that suggest various consequences within the global context of the play. They may be rational notes that comment on where the scene falls within the dramatic structure of the play or

organizational notes that logically inform the actor that if this decision is at this moment in the script, it impacts the rest of the play.

Superego

Once you have become the master of rational ego thought, you must explore the final major component of both Freud and IM for actors—the superego. The superego is the element that affects IM through morality and acceptable behavior. It forces you to think about how your actions will be perceived. Too often the actor's personal IM usurps the character's IM with the actor's personal superego worrying about what the audience thinks about him.

Your superego is that voice inside your head that is closely related to your upbringing. It is that part of your IM that tells you not to do something because "it is wrong." The idea of a "voice" inside your head rather than your personal inner thoughts is what defines the superego. Your id may want to eat another person's food. Your ego will tell you that will cause a series of problematic interactions. Your superego will tell you that stealing is bad and one should not do it. Your superego is your moral compass.

I Want Exercise

This exercise is designed to allow you to explore the differences between Freud's three delineations of thought. Open a magazine, flip through channels, or surf the web. Allow your thoughts to be dictated by the stimuli presented to you. Stop on whatever captures your imagination—the image, sound, or feeling that most intrigues you. Then explore your thoughts. Most likely your reason for stopping is based on your id. You are attracted (in various ways) to the image. Once you have landed on the image, your thoughts may be reflected in the ego, which tells you that this image is possibly unattainable. The final wave of thoughts may contain superego, where you feel guilty for having stopped on this particular image because it is unacceptable.

"That actor is so hot" is the voice of the id.

"He is a movie star and you don't even know him" comes from the ego.

"Plus, you're married" reminds the superego.

While the exercise is not designed to create a psychological expert, it may offer a glimpse into the place from which your synapses fire. Understanding their birthplace may allow you to lessen their mystery

and therefore their power so you may transform your personal IM to that of the character.

Bench Exercise #3

At this point you understand the id and ego thought process; now you must add the superego. In the same area where you performed the first bench exercise, sit and explore similar locations and stimuli to guide your IM. Allow your thoughts to flow openly and unfettered by any guidelines. While you do this exercise, ride the various external or internal cues that force your IM to new areas.

I love that car. She is so mean to her child. I have to get my clothes out of the dryer. I hate guys who dress like that.

After extended surfing through your IM, try to remember your various thoughts and separate those thoughts into their Freudian categories. Decide what was id-, ego-, or superego-based behavior. At times the categories may blur, but more often than not, you should, in a very basic way, be able to categorize from where your IM emanates.

Blanche DuBois is most connected to her superego whenever her actions are being scrutinized. Her superego behavior reveals itself when she wipes the glass from which she gulps her id-based liquor. Blanche understands that her sister will realize that she has been drinking so she must destroy the evidence. In that moment, her fear of being caught showcases superego behavior. She understands that her basic id needs (which she cannot control and which are thus her downfall) must be hidden.

As actor, superego-based IM allows your character to reveal her warped morality. Even in Blanche's distress, she has the wherewithal to avoid discovery of her id-based behavior.

As director you may work with an actor to agree upon the emotional state of any character through checking in on the superego thought process. When does Blanche abandon this sort of thinking? That could be a great conversation between actor and director.

As educator, asking probing questions from assorted perspectives can allow the actor to understand that Blanche can be played in various ways. "In the first scene, when explaining about leaving her job as teacher, do you believe Blanche lies or is telling her version of the truth?" Then ask the actor to play the scene in both ways to understand how choices affect a scene.

In the same opening scene about her expulsion from Laurel, Blanche's explanation to Stella is a study of balancing the id, ego, and

superego. She must avoid revealing her past id-based behavior while pretending to be more aligned with her moral superego side. All the while, Blanche is balancing the truth (id) and fantasy (superego) to ensure the story makes ego-based sense. The genius of Williams is his reversal of our "normal" understanding of psychology related to acceptable behavior. We shall explore more of Blanche's IM later in the book.

As actor, knowing the influences that connect the various elements of Blanche's IM will allow the thought process between the spoken lines to be clear and consistent and allow you to effortlessly traverse the many seemingly bizarre transitions of the character.

As director, pointing out the various moments in the script where Blanche jumps topics can create a discussion about her IM. By creating internal logic together as actor and director, the two of you may discover a Blanche whose seeming inconsistencies become consistent.

As educator, helping an actor define the source of a line within their character's thought process allows for deeper discussion of motivation.

While we have explored that actors must make selfish choices to fully reveal a character, actors must also advocate for a character's behavior. Thus the character must have a sense of morality that is personal to the character. So, while you may play a sadistic killer in a role, you must explore how the IM of this amoral (as defined by societal strictures) character allows him to function in everyday life. How can the superego of this character still remain a part of the IM?

Your thoughts can also be defined as conscious or unconscious. While your IM may be id-, ego-, or superego-based, you have little or no control over how the thought process comes to you. Your thoughts are merely souvenirs of an intersection of obvious stimuli and unimaginable responses. So too must you as actor, director, and educator examine what is obvious to the character (conscious) and of what the character is unaware (unconscious). Only then can you begin to fully inhabit the character.

Unconscious or conscious? Each refinement of the IM draws us further and further into the debate of the IM's origin. Not wanting to claim "truth," I have included a later chapter that explores several interesting psychological theories that can assist the actor and affect the IM. I have delayed this chapter, as the actor/director/educator must first become comfortable with the concept before abstracting.

Mikayla, Actor

"Inner monologue: it is a river of thoughts, emotion, and complexity of a character that simmers under the surface of dialogue and outward appearance. Sitting in a darkened movie theatre with the face of an actor glorified on the silver screen, their eyes heightened and vastly displayed during a close up, the audience can easily tell if an actor's eyes are 'dead.' Whether or not they know what to title this approach to acting, its absence is irrefutable. When an actor is actively engaged with inner monologue on camera it's almost tangible; the subtext seems to leap straight from their eyes. With the live nature of theatre, inner monologue can guide the energy in the space, pulling the audience along with each transition of the text, if properly mapped out.

My first true reliance on inner monologue was during a scene study class where I was coached to approach the scene entirely with inner monologue versus my usual blend of methods. My initial frustrations with the approach came from my own rigidity at what I felt the monologue had to entail. Words; constant and complete sentences. The approach seemed exhausting and overwhelming. Not from the sense that I wasn't willing to write it out, but from the perspective of memorizing pages of my preordained inner monologue along with the complex text, and delivering them both all while trying to stay fully present in the moment. I found myself entirely in my own head and unconnected with my scene partners or the ever-changing energy of each live performance.

Throwing away that rigidity and giving the monologue over to the infinite nature of the human brain made the tool accessible for me. The realization that the brain does not function in one way or deal solely with words opens the inner monologue to a fabulously complex compilation of images, colors, external stimuli, memories, faces, emotions, paradoxes, formulas, smells, quotes, historical facts, music, morals, conscience, reactions, and every now and then, maybe even

a full sentence. The freedom to draw on so many different platforms lays down the most solid foundation for an inner monologue and more closely mirrors that of real life.

In my own journey with inner monologue, I am still pushing myself to refine and chart out the most active thought process that coincides with the text while simultaneously giving my inner monologue the flexibly to react in the moment. Like dialogue itself, the transitions of thought need to be right. If that means dwelling on a particular thought longer than usual or quickly transitioning, it can't be forced. The most important thing is to stay active and engaged in the present moment. At the end of the day, it is a tool to bring the text to life no matter the medium. When properly employed, it can broadcast the psyche of a character loud and clear and that endgame alone makes this approach a vital tool for actors to have in their arsenal of study."

3

IM Everyday

For most of us, life is spent trying to silence our IM. Clearly in our alone time, most of us would rather distract than remain "lost in thought." We watch television, listen to music, surf the web, read, or game in order to avoid the various solo conversations awaiting us in silence. The final moment when we power down the distractions, extinguish the light, or close the book is one of inescapable connection with our IM.

The moment between lights-out and actual sleep is fraught with IM. For some, that interval is filled with list-making of commitments for the next day; for others, it is a replay of the past day's events; and for many, it is a roller coaster ride from image to image. That interval between the end of outside distraction and the release of IM to slumber can sometimes be interminable—sleep aids and counting sheep are testaments to that.

It is within this timeframe that you may most closely connect with your personal method of IMing. Here you may most purely see how your IM operates. Each evening when the lights go off, take note of how your IM prevents the sweet release of sleep.

You could say that your IM does not ever rest but actually affects and shapes your dreams as you sleep. In analyzing your dreams, you see your IM at work in your ever-shifting thought patterns. The unconscious dream state may further reveal clues to your IM.

Waking up you are immediately reintroduced to your IM. *What time is it? Is that really an alarm? Today I have to read that article before I leave. What was that dream last night?* And so the day begins...

Dream and IM Journal Exercise

Expanding upon the standard concept of a dream journal, next to your bed keep a journal in which to write your final thoughts of the night, your ideas when waking up intermittently throughout the night or your thoughts when you first awake. Write down the details of the dream you can remember and try to make connections to your most recent IM. This journal may reveal the intricate workings and the various permutations of your personal process of IMing. If you find that your writing cannot keep up with your mind, try an audio journal. Remember you rarely think in full thoughts, so your journal should reflect that.

In order to be a flexible actor, you must be cognizant of the wide-ranging thoughts you experience every day. Is it not true that you examine every hazard, reward, or moment from various points of view? The items on a menu? Oncoming traffic? Each first meeting? All iterations are fraught with a sub- or unconscious speech that melds you with your inner voice. If you take the psychological definitions of IM as truth, then you must explore how you personally experience IM in your real (non-scripted) life.

To best understand IM, you must explore your personal manner of thinking. Do you think in elongated phrases? Do you think in images? Do you sing each moment? Do you feel an onslaught of various emotions? No matter how you "talk" to yourself, you must admit you do IM.

Free Association Exercise

Shut your eyes. Shut out distractions. Avoid sensory interference. Just be. This is you at your core. This defines your interaction with your subconscious and your outward self. Spend as long as you can free-forming thoughts. Go from one image to the next. Ride the waves of past regret or future expectation. Just be.

Spend a full five minutes (set a timer if you must) just living with the idea of IMing. Expand the time incrementally whenever you next try this exercise for a deeper understanding of the process.

The discoveries contained in this exercise help define your personal IM. You should have clearer notions of just how your brain fires and how it goes awry. How one thought gives way to the next or how doggedly linear your thinking is. No matter how your personal IM works, you must be aware of your thought process so you

may enhance or transform your way of thinking to meld with any character you play.

The next time you are waiting in line, grocery shop without a list, or wait for a friend at a restaurant note how intimately acquainted you are with your IM. You judge, you joke, you plan, you make lists, you prioritize. Your IM offers you security when needed, boosts your self-esteem at low moments, and offers guidance in a crisis.

Priorities Exercise

Without the aid of anything other than your IM, make a list. Make a list of what you have to do the next day, the next week, or the next year in order to be happy. You use your IMing skills whenever you are making a list, reminding yourself of chores or following steps to complete a recipe. This very basic and practical connection to calming or organizing yourself makes for your easiest entrance to IM. Unlike the earlier ego-based list exercise, this list should include larger conceptual and emotional choices that incorporate dreams, goals, and benchmarks. "In order to find love I must…" "I have to read more books so that I can…," "To be truly happy I need to…"

As mentioned, list-making offers unique ways to explore your logical and rational thoughts (ego). Prioritizing and scheduling the correct amount of time devoted to a task is usually done internally. Your figurative errand list in your head uses the idea of time management and efficiency, but it also contains intimate knowledge of your insecurities, traumas, and desires. This exercise expands the scope of your heretofore practical or immediate IM.

At very certain times, your IM bubbles up and becomes audible. Sometimes when you are alone you will verbalize what you are thinking. Often it is only a half sentence. *I can't believe she…*, *I have to remember…*, *Where did I…*, but it happens more often than you usually remember. It also surfaces at moments of highest stress or ultimate sadness. A deep sigh is IM. Proof that the IM is simmering always just below the surface.

Out Loud Exercise

Allow yourself to do a free-form experiment similar to the "Free Association Exercise" but verbalize as much as possible your thoughts or images. Be sure to do this alone and with as little sensory distraction as possible. Be sure to avoid performing. Do not allow yourself to pretend to verbalize your thoughts. Force yourself to do it as

authentically as possible. You know what IM is; share it honestly. *Dinner at Harry's—bring wine—do I have time—Linda said to— Why do I always...* And so the IM is verbalized as best as possible to capture your tangential thinking.

Hearing yourself verbalize your IM is sometimes jarring. You may realize your verbal skills cannot keep up with the thoughts whizzing around your head. Usually you cut one sentence short to capture the new thought spurred by different contemplations. Speaking your IM also offers an odd disconnect from the private and interior life contained within your head and the traditional and verbal elements of dialogue. This exercise can often sound fake, hollow, or performed as you are speaking the usually unspoken.

You may realize that your IM cannot be summarized with only words. You have created your own shorthand language where you use abbreviations, sounds, and images that are knowable only to you and your own IM. This is something to be explored so that you may adapt your process as actor from scripted to lived.

Having a keen grasp on your personal IM allows you to become hyper-aware of the form. This awareness will serve you well when approaching the analysis of any character. "How does this character think?" is one question. But "How does he think differently than me?" is the larger question. The exploration of your IM process will reveal what needs to be restructured when exploring a character. If you find every character that you play has an IM that is as linear, joke-y, or expletive-laced as yours, you may realize that you have not adapted your IM to the playwright's intention.

Your IM is your friend who calms you down as you meet the in-laws, entertains you at the boring meeting or encourages you to talk to the handsome guy. Your IM is your authentic self.

Projecting Exercise

In a public area, concentrate on one person sitting by himself. Project your analysis skills onto this person. What is he thinking? What drives him? Is he happy? Allow yourself to think in first person as the person you are observing. An IM might go something like this:
I can't believe she stood me up again. I'll give her five minutes. No! Why should I? She might have been caught in traf—too bad. She could call. This is over. Is that her? Ugh. Do I need to get back to work? Well, now we only have like ten—what a waste of—but she said she loved—whatever. I'll never find the right person. Wait! There she is!

While this IM is very basic and a little obvious, it does allow you to start figuring out how another person's mind works. The idea of projection to discover another person's IM allows you a chance to expand your analysis skills as actor. It is something that can be done outside the walls of the classroom or between gigs. It allows you to realize the sparks that ignite and connect another person to their truest self. IMing for another is great preparatory work for any actor at any time.

Using this concept of thinking for another will allow the actor to understand the transitional process of thinking like the character, making the odd transition from "It's not me thinking, it's the character." It also allows you to loosen the control from your personal IM and insinuate yourself in the thought process of another. In high-pressure situations like performances or auditions, thinking like another mollifies fear and allows you put away your closest confidante (your personal IM) as you connect to the IM of your character.

As actor, knowing your personal IM allows you to enhance your choices.

As director, understanding the actor's personal process can sharpen your notes.

As educator, empathizing with your students' IM allows you to guide them to deeper work.

All of these preparatory exercises and examinations of personal IM lay the groundwork for the moment when "acting" begins. This odd moment that we have devoted our lives to when we pretend to be another. We make-believe we are not ourselves. Acting is not simply about wearing another person's clothes, it is about actually pretending to become a different person. And in our ultimate goal of fooling an audience that we are this new person, we try to be as realistic and honest in our lie as possible. In our goal to alter ourselves, we transform not only the externals (through makeup or altered physicality) but also the internals—the inner workings of the character. The way she thinks. And in this moment of ultimate make-believe, we must incorporate a major part of any human being—the thought process. The IM. We agree we all have it, so why wouldn't the characters we are portraying?

The actor must transition from her backstage reality to her new onstage life whenever she crosses the set's threshold or whenever a director yells "Action!" This moment of becoming another means stopping her personal IM and taking on the character's IM as much as possible. The moment when she acts. When she stops thinking as

herself and thinks as the character. The moment when the innermost thoughts are that of the character she is portraying and not her own. Just as the actor makes obvious adjustments externally through vocal and physical adjustments, so too must she make internal adjustments to act as another.

Full immersion is difficult. The actor is divided between two realities. In most situations, an actor must imagine he is part of the fictional world onstage while also having realistic recognition that he is pretending to be someone else as part of his job. Katherine Hitchcock and Brian Bates, in their essay "Actor and Mask as Metaphors for Psychological Experience," describe the concept of acting as a schizophrenic state. There is a sort of dual reality where the actor is living the role as well as having his own personal thoughts. When an actor is acting, there is a "possession" where he is playing another while remaining himself. The authors' use of the words "possession" (inhabiting a character) and "schizophrenia" seeks to understand the dual realities an actor faces when plying his trade. The rest of this book will explore the notion of duality in IM. There is the actor's personal IM which includes his everyday thoughts and then there is the character IM that are the thoughts of the character created by the actor based on anlaysis of the given circumstances in the script. Possession, schizophrenia, make-believe, pretend. All these point to the duality or falsity of the profession of acting. All also point to the inhabitation of another. In order to fully inhabit another, you must include the character's IM.

4

IM in Acting

What should actors be thinking when performing? This is a purely personal process and each actor is different, but by concentrating on IM, an actor will deepen her choices. Does an actor think in objectives: "I want to seduce her"? Or does an actor think in corrections: "I was told not to jut my head forward"? Or does an actor think in units: "This is the climax of the scene"? While there may be actors who may subscribe to only one of these ways of thought, all of these thoughts are IM.

More likely than not, an actor thinks about many things when performing. Whether personal or character-based, the connective tissue between the lines of the script is the IM. As actor, director, or educator, the goal is to refine the IM to active listening and the ability to respond with alacrity. This concept blends relaxation with the free flow of thoughts aimed at the character's needs and goals within his IM.

What follows is the beginning of a scene from a play I wrote, called *Happy Holy Days*. At a Fourth of July celebration, the two main characters meet for the first time. When reading the scene, look at Dale's dialogue closely.

[A park in the early evening. Pure Americana. Bunting and gazebos. There is a line of people waiting for a port-o-john. Dale runs in.]

Dale: Jesus.

[He stands in line uncomfortably. Sherrie runs in.]

Sherrie: Jesus.
Dale: That's what I said.
Sherrie: For real.

Dale: First, I can't believe I am going to use one of those port-o-johns and second I can't believe the line. There aren't that many people here.

Sherrie: You read my mind.

Dale: Well, I guess there are a lot of people who drank beer and ate fried food.

Sherrie: Ew. Makes me want to use it even less…Beer. [She laughs.] Fried food. And pickled food. Did you see that? Who eats anything pickled? What does that even mean?

[Dale laughs.]

Dale: Right. [Pause.] Guessing you aren't from here.

The scene continues as the two characters find themselves attracted to the other, but for this moment, let us explore Dale's IM in the beginning of the scene. At his entrance, it may be clear that Dale is thinking only about going to the bathroom. He has been at a celebration and had a few beers and now has a great need to relieve himself. His IM is in italics.

I gotta go. Shouldn't have had that last beer. Hope there isn't a line. How far away is this thing? [He sees the line.] *Jesus. Jesus.* (You will note that his IM and text are the same here. He actually speaks aloud his IM.) *God, how much longer am I gonna have to wait? Should I go in the bushes?*

You will note that my way of thinking corresponds to the joking manner in which Dale speaks. It makes sense that his brain works similarly. Upon Sherrie's entrance, his IM now includes her.

Oh great here comes another person. Ha, she said Jesus too. Damn I gotta go really bad now. Keep talking. Distract yourself. Look at this place. I am actually in line at a fair to use a port-a-john. Hey, she's laughing at my jokes. She is kinda cute. Probably crazy. Oh, she hates beer. Snob? Still cute though. No wedding ring. She's funny.

You can see that while Dale's dialogue continues benignly, his IM is intently concentrated on Sherrie as a possible date. He is testing her with jokes and observations to see how she reacts.

What's wrong with pickled food? I love pickled food. Awkward. This isn't going to work out. She's out of my league. She's not like the girls around here.

Dale's final line corresponds rather closely to his IM, although his judgment of her as an unsuitable mate is not included in the dialogue. Dale has been actively thinking throughout the scene, and the actor

portraying him should have similarly active thoughts that concentrate on the given circumstances and honest reactions to the actor portraying Sherrie.

This short example is just a long string of IM that an actor may employ throughout her work on stage or screen. It is mentally exhausting to stay devoted to the IM of her character, but as much as possible, she should try to align her thoughts to that of the character. When an actor's concentration flags or veers to personal IM rather than the characters', as it inevitably does, a performance can run into problems. More on that in the next chapter.

As mentioned, you rarely think in full sentences of IM in your personal lives and so too, it should be on stage or screen. In the above example, I have written in sentence form to understand the basic principles. Were an actor to fully think those thoughts, it would be the longest night of theatre ever. That is what rehearsals are for. An actor charts the thought process, perhaps in full sentences at first and then later reduces them to half-sentences, images, music, or other shorthand to recreate the internal language of the character.

Therefore Dale's IM can possibly be reduced to a version of the following:

Gotta go. Image of 6 bottles of beer. Wait! Jesus. Bushes? Another person. Ha. REALLY GOTTA GO! (Singing) 99 bottles of beer on the wall. NO! Smell of the port-o-john. She's laughing. Cute. Crazy. Image of last psycho girlfriend. Snob? Still cute though. No ring. Funny. Pickled? Awkward. No way. Hmmm.

By condensing the extended rehearsal IM, you more closely hew to the distracted and whizzing IM that is most like human behavior. The rehearsal process allows you to explore the characters' train of thought. Sometimes your initial idea of what the character is thinking may take you to a dead end that must then be reconfigured to get you logically and honestly to the next thought. The logic I mention here is the logic of the character and not your own. While I may think in a less joking manner than Dale, when playing him I have to use his way of thinking in order to get me to the last line of "You aren't from around here" and still keep the scene moving positively.

I am not expecting actors to become playwrights who speak and think in the exact manner of Tennessee Williams's florid dialogue, but thinking like the character requires an assimilation or representation of the style of the show. So, when I play Dale or Blanche, the

way in which I think is extremely different. The given circumstances and the environment of the play require it. Does this mean that when playing Shakespeare I think in iambic pentameter? Absolutely not, but I don't think in the contemporary expletive-laden way I would if performing a Mamet play. (More on classical IM later in this book.) Throughout rehearsals, actors become immersed in the style and language of the play. Therefore it becomes easier to think the type of thoughts that would realistically exist in this time period, climate, and environment. This is done through research and analysis.

From the moment of receiving the script, you start to make psychological choices that string together the "type" of person you are portraying. You may realize that the character is a selfish person or she is insecure. Those immediate diagnoses all inform how the IM for the character will be shaped. Each revelation of the character's biography or armchair psychological diagnosis you make when analyzing a script informs how the character thinks. You analyze when you read the script, so why not incorporate these revelations into the character's thought process when performing?

When introducing students to a scene for a scene study class, I like to do this exercise after they have read the play without knowing which character or what scene they will be working on. So while they have read the play, they have made little investment in analyzing a particular character. The exercise aims to assist the actors to better understand the character's thought process related to the playwright's original intention.

Choices Exercise

This is the first exercise to introduce logic and psychology that inform IM. When the partners are prepared to receive the information, have one actor A slowly read the first line of dialogue in an unemotional tone. The other actor B will offer three possible and plausible yet divergent responses to this line. Then B looks to the script for the actual scripted line. Person A may read the line from the script, "How are you doing?" Person B, based on his limited knowledge of the script and character, may say, "You know better than to ask me that," "As good as can be expected," or "None of your business." When B looks to the script and sees the line is actually "Fine," he begins to make assumptions about the character's way of thinking. It is at this point that B starts to understand the thought process of the character. The exercise continues as A remains focused on B and does not jump ahead to

look at the next line. B then says the actual line, "Fine." A then formulates three possible responses. This back and forth exchange with three possible answers continues for the whole scene. This process is quite lengthy, but by following the exercise, the actors have begun to make connections as to how their characters "think." Instructor and actor will begin to understand the thought process / IM of the character. By the end of this exercise, actors usually begin to offer only one response that is in complete agreement with the script. It is also a great way to force actors to examine the script without making choices before they are ready or have analyzed it fully. It is also the first step to transition from personal IM to character IM. By the end, the actor is keenly aware of how the character thinks.

Choices are what make each actor unique. While this book constantly espouses that you should try to think the character's thoughts, it must be understood that the character IM is still filtered through your unique take on the story. Character IM is always infused with you. Through all analysis, you should never lose your personality within the IM. Your angle on the world directs your IM in ways that are uniquely yours.

This is evident when scoring a script. When an actor breaks down or scores a script through analysis, he usually combines elements like objective, tactics, and obstacles, given circumstances and character background in conjunction with his own point of view. All of these combine into a final scored script. All of these decisions inform his time onstage. Using the scoring, the actor examines all his choices in hopes of inhabiting the role and may funnel all of this work through the IM. When onstage, one should not be thinking in third person thoughts like "He wants to convince her" or "He had a traumatic childhood," but rather first-person thoughts that incorporate all analysis. *I have to make her believe me!* or *I can't forget what happened when I was a child.* The IM allows all analysis to come together and work toward driving the scene forward. The IM connects all of the analysis to the actor.

Some could argue that the use of IM actually slows the scene and traps the actor in his head. If used incorrectly, the IM can become a device that reverberates thought and does not propel the action or affect the other. When used correctly it is liberating to the actor and adds higher stakes to nearly any scene. I will address the idea of head-centered versus un-head-centered acting later in the book, but for now, let us look at the idea of how analysis can be enhanced by IM.

Research and interpretation combine when the actor scores the script. In this process, the actor examines the given circumstances of the play and defines his idea of the character's motivation. Why am I (the character) doing this, saying this, reacting like this? An actor usually breaks the scene into units of thought or subject matter and then begins to assign actions or objectives to these sections. Here is where IM can assist. Motivation is IM.

The scoring is usually forgotten onstage as actors listen and respond in the scene. That is exactly what it is supposed to happen. The choices act as a springboard for heated human interaction. So while I may have written on my scored script "I want to seduce her," my partner's choices have prompted a whole new direction for the scene. Also, I may have made some initial scoring choices prior to rehearsal but then the director has a new interpretation. My scoring has served me well in preparation but not in practice. (Scoring examples are offered in a later chapter.)

Using the IM, the actor can remind herself of the given circumstances of the play, the tactics or ways to go about getting what she wants or the etiquette of the time in which she "lives." The IM is the conduit for the actor's score and should be nurtured rather than stifled. Let her imagination run wild.

If I am playing Krogstad in *A Doll's House* and I have to make my entrance at the top of act 3, where I will hopefully be reunited with my former love Mrs. Linde, my IM is overwhelming. My time in preparation for that entrance, reminding myself of the given circumstances, could be all-consuming IM. As I stand in the wings, I recall images from our last meeting over a decade ago, flashes of my unhappy marriage to my deceased wife, thoughts of self-hatred for the man I have become, questions of how she knows Torvald, reactions to the bitter freezing weather, feelings about the holiday decorations along the street, worries about how I have aged, obsessive musings concerning how can I get my job back, anger over the letter she sent me years go telling me she cannot be with me, hope that she can possibly love me despite the man I have become, and fears of entering their home again. All of these thoughts and more whirl around my brain as I enter the stage. Before I have even said a line, I have invested fully into the thought process of Krogstad when just a few minutes earlier offstage I was talking to my fellow cast members about the movie I saw the night before. It is a quick and thorough way to immerse myself in the analysis I have done.

Note Exercise

Ask the actor A to create the conflict, environment, characters, and situation. The only instructions for A are that their scene partner B (the person they are entering the environment to interact with) will be absent. They should enter the scene with a purpose (like "to propose to B," "to avenge wrongdoing," or "to convince B to quit his job"). The educator or director should leave a note from the absent B with dynamic content written on it like "I hate you," "I know what did," or "Goodbye forever." Observe A as she enters, discover the note, process the information, and deal with it until their exit. Try to figure out what A's IM was at each moment. Discuss the probable IM based on what you saw. What was A thinking? The audience may not agree about what they saw. This is fine. Disagreement will give you a myriad of topics to discuss related to IM.

Some actors may not understand the process of IM no matter how it is detailed in this book. It may make perfect sense to them, telling them to think like the character. But that is very different from actually doing it. And despite their wish to do so, they may be unable to fully replicate the transfer of thoughts from personal to character. It is not until they actually have the thought process modeled for them that they understand. This next exercise is an easy and effective way to introduce acting students to IM. It is almost always a successful way to merge theory and practice and has been used to outstanding effect.

Inner Dialogue Exercise

This exercise is very effective and educates the beginning actor on the commitment needed for immersion in the thought process of the character and inspires experienced actors to make compelling new choices. Have a separate set of actors (IM actors) assigned to each of the regular actors within the scene. Have them whisper the IMs in the ear of their respective regular actors performing the scene. The IM actors must quietly and continuously verbalize the IM of the character based on the text and the given circumstances. The actors within the regular scene must work with the new IMs and justify them in their choices. The regular actors may not censor or ignore the IM actors. The regular actors must let the IM actors whispering infect their work. This takes concentration on the part of both the regular actors and the whispering IM actors. Rather than shut the thoughts out, the regular actors must embrace them. This exercise is perfect for injecting new life into a

stale scene as students are introduced to new possibilities and choices. If two IMing actors proves too complicated, reduce it to only one IM actor for one run of the scene and then another for a second run.

A teacher may also address actor problems by instructing the whispering IM actors to concentrate their IM related to specific issues. So if the regular actor only makes meek choices, the IM actor would whisper inner thoughts of aggression and strength. The regular actor may not want to physically connect with a partner, the IM actor would whisper inner thoughts of intimacy and touching.

This exercise is the best and most accessible approach to IM. Actors usually end it describing how difficult yet exciting it was, and most important, understanding the commitment needed to think like the character would onstage. That is the ultimate goal of the exercise. It is up to them whether IM is something they will forever incorporate into their work.

Just as all approaches to acting don't resonate with certain factions, IM may not work for everyone. Each actor's entrance into acting is unique, and IM is simply one more element in the actor's arsenal. And even if the past exercise did not work for an actor, perhaps an upcoming exercise can be used in a small way to augment one's work. Reminding an actor how IM can deepen his work is sometimes necessary to offer them an option. They may have explored IM in rehearsal or ignored it completely in favor of choices that go from line to line. This next exercise allows you as director or educator to examine the thought process of the actors. It ensures that IM is active and fitting to the demands of the script.

In and Out Exercise #1

To ensure that actors are truly connected to their work, allow them to begin their scene as rehearsed. At various intervals ask them to stop. They should remain connected to each other and immediately launch into their IM—verbalizing it quickly. At a signal, they then resume their lines from the script. Repeat this process throughout the scene having actors switch between dialogue and IM. Students immediately are committed and concentrated. For actors, it establishes a tangible connection between text and IM. It forces them to stay alive. This kind of stop and go coaching reveals to the instructor the actor's level of understanding of the scene and the depth of choices made by the actors.

With this exercise, actors, directors, educators are all privy to the very private IM of the character. It is a unique situation where all may

examine the inner workings of the character to see if there might be a way to streamline the thought process or guide it in a more appropriate direction. So, if an actor playing Krogstad's IM reveals that he is concentrating more on the cold Norwegian winter than his reunion with Mrs. Linde, he can guide his thoughts to the real conflict of the scene.

Throughout the rehearsal or performance process, the actor has numerous chances to lock into the thought process of the character she is portraying. She should have ample opportunity that allows her to fully invest in the character's IM. Using the three exercises provided, she has explored IM from the first moments of text analysis, the modeling of IM from another student, and the ability to go between dialogue and IM. The goal of each exercise throughout has been to silence as much as possible the personal IM and transform it to the IM of the character.

You may say that your personal IM is actually your character's IM. You may believe you must use your personal life onstage throughout to spur you to deeper and more emotionally charged choices. So, while performing as Krogstad, you may flash to your personal ex-girlfriend to summon up the correct emotional state related to Mrs. Linde before the entrance described earlier. Again, the goal is to find whatever works best for you. So, if the given circumstances in the script do not resonate in your acting process, then certainly substitute personal experiences rather than character IM throughout this book.

The ability to lose yourself as much as possible within the character does not mean a total immersion into the belief that you are the killer created by the playwright or the alien written by the screenwriter. No, there is a safe and healthy distance between losing yourself inexorably and investing in healthy IM of the character. The IM is meant to assist you to invest in the situation; not hypnotize you into thinking that the costumes and scenery are real. In our profession of make-believe, you must invest in one other element of pretend—the IM. Actors who are unable to separate the real and the fantastical worlds they inhabit have already begun an unhealthy IM that chooses to ignore conventions like the script, costumes or director.

Immersing yourself in a role must be approached with careful calculation in conjunction with a thoughtful exit strategy. You must maintain a healthy disconnect between self and character, at all times recognizing the schizophrenic demands of the profession.

In some cases though, living inside the head of an emotionally draining character like Blanche requires a sensitivity to return to the

actor's real IM. The taxing work of investing in a character's thoughts for three hours as she descends into madness requires a skill and technique beyond the normal actor investment. It is suggested that these times require a sensitive reimmersion into reality-based IM. So while I bow at curtain call, I have already allowed myself to begin to let go of the character's thoughts. I take off my period-appropriate filmy costume and replace it with my street clothes. I wash off my smeared and powder-heavy makeup and look at myself in the mirror. And my personal IM takes over and I think about the unwanted laugh from the audience when I first mentioned Allan Grey—how do I fix that? I remember I have to tell the stage manager the radio's knob is coming unglued again. I think about how lucky I am to have a Stella to play opposite me, who fixed the zipper onstage when it got stuck. And so I have returned to my personal IM. My thoughts are my own again.

Carolyn, Actor

"As an actor, my connection with using inner monologue has been bittersweet. IM creates clear links between actor choices and text, and I've often attempted it to justify the choices that I've made when creating characters. It is also a helpful tool in connecting backstory and given circumstances to the immediate environment of the scene. It is exciting to listen to the spontaneous changes in my IM when I must react and adjust immediately to a new choice from my partner. All of these elements make IM a useful tool, and I have experienced, firsthand, the creative benefits of this tool... but not often. For the most part, my appreciation of IM is limited to a few, successful attempts. I find myself using IM more as a resource for character and script analysis than I do for in-the-moment, acting work. As a key element of my analytical process, IM is hugely beneficial and interesting to me; as an acting method, I've probably done it a disservice.

Many times in my acting classes, I've heard my colleagues (and myself) utter the phrase, 'I was stuck in my head' to describe our reasoning behind why a particular scene or moment was unsuccessful. It seems this tendency to be consumed with how the mind is controlling or influencing the scene might be exaggerated by the use of IM, rather than allowing the actor to respond and react in the moment and without hesitation. Personally, there is no mystery as to why I get stuck in my head. As student-actors, we are often asked to write out our character's IM, and every time I take on this exercise, I get the same results: a verbose, detailed, complicated, and unnecessarily lengthy diatribe. Rather than using brief, choppy, and seemingly disconnected outbursts of commentary and questions—which is how our own IM actually seems to function most of the time—I turn my thoughts into a long and unrealistically linear narrative. The sheer length and detail of my IM almost certainly trap me in my mind when I attempt to put it into action.

It is noteworthy to me that the most enjoyable and successful times I have used IM have come when the IM is shaped by outside sources. Exercises involving images, sounds, songs, and the whispering of others have all stimulated a more effective IM than anything that I have created for myself. When the IM is not solely my responsibility, I am able to reap the benefit of keeping it short and succinct, as spontaneous outbursts rather than stream of consciousness narrative. I find myself much more connected to these images and songs—whether they are chosen by me or not—and thus more connected to both my character and my scene partner. These exercises also make the influence of IM much more immediate as opposed to the plotted nature of writing it out for each scene.

This idea of being stuck in our heads uncovers another weakness in my use of IM, and that is the question of whose head I am actually stuck in—mine or my character's. Sometimes, when working on a scene, I find my mind is spilt in a kind of dual IM, and then the challenge becomes balancing the two or, what is better, ignoring one. Most of the time, when I find myself hampered by IM during a scene, it is not the character's but rather my own, commenting, judging, and criticizing my work, my choices, my ability, and my success. And it is unforgiving. I hear these thoughts pop into my mind, and I am immediately disconnected from whatever progress was being made in the scene. It feels impossible to establish any true connection with my scene partner and turns any sense of vulnerability into selfish personal introspection. In all fairness, this pattern in my work is not a criticism of IM as a device, but of my inability to separate one IM from the other, an ability which will hopefully be honed through time and training.

What is interesting to me is that, if I allowed my character's inner monologue to have the same impact on my acting as my personal IM does, my acting would probably be much more effective. My personal IM has a tendency to overpower my character's, as negative, judgmental thoughts trump the useful, connected ones. There is no denying that IM has a profound and immediate impact on my work as an actor, but when I give more authority to my own IM rather than focusing on the IM of my character, I negate the usefulness of this valuable acting tool."

IM as Enemy

Nearly all actors offer feedback following a presentation in class or a performance of their work similarly:
"I was in my head."
"I was watching myself."
"I was judging everything I did."
That is the old IM talking. The actor is unable to turn off her personal thought process in order to inhabit the thought process of the character. Do I imply that anyone is ever able to do so fully? No. IM can never be achieved consistently or for the entire project. Reality inevitably enters our imagined world. The director yells, "Cut." The actor exits the stage and is immersed in the backstage world. A student in the classroom coughs and the entire mirage is shattered.

Those moments of real communion where the actor is thinking the character's thoughts and is listening and responding in the moment are magical. When achieved, they are what all actors crave again and again. When the actor "loses" herself in the given circumstances and communicates honestly, pushing all of the unnecessary personal baggage from her head and allowing herself to think the thoughts of the character, all comes together in that rare and addictive moment. The moment when it all works.

In his 1964 work *Religions, Values, and Peak Experiences*, psychologist Abraham Maslow writes about those rare, nearly transcendent moments when everything synthesizes and harmonizes. Maslow called them "peak experiences." For the athlete it is when he is "in the zone," for a jazz musician it is when she gets "lost" in the music, and for actors it is when they are having a communion onstage. Such a communion is an intimate, nearly impossible to define phenomenology

where the actor is invested in communicating with the partner and all else seems to disappear. Gone are worries of blocking, notes from the last run, or even the audience watching the scene. There is only the connection to the other.

Such experiences are rare. And they are addictive. We usually try to recreate this "lightning in a bottle" moment by doing everything exactly as we did in the amazing run of the scene, but the magic is gone. A peak experience cannot be manipulated. It cannot be recreated. We can only keep ourselves open, invested, and awaiting the next peak experience.

Jon Carroll of the *San Francisco Chronicle* writes about acting and peak experiences in his article "Transformed by Art":

> Such moments are rare, but they're not impossible. Peak experiences happen. They happen unexpectedly and suddenly. An actor can do three dozen shows and then find a role and a cast and a situation that transcends the job. A playgoer can go to a hundred productions and laugh and cry at appropriate moments, nothing special, and then one evening hit a life-changing performance.
>
> It may be that the audience is unaware that the actor is having a peak experience. It may be that the actor is unaware that the audience is having a peak experience. The mechanics of transcendence are tricky. Is it a communicable disease? Anecdotal evidence is inconclusive, and tests for ineffability have not been invented.
>
> But it's as real as dirt. Transcendence is why artists keep doing what they do, despite low pay and bad working conditions. That's why audiences continue to plunk down money despite numerous disappointments.

The main obstacle to achieving this amazing communion on stage or screen is the actor's personal IM. Actors are unable to turn off their constant companion. They spend more time analyzing and watching their work rather than thinking like their character.

Your response as actor, director, or educator may be, "Are you asking these actors to be in their heads all of the time?" My response is, "Yes, in the correct way." To simply ignore the honest and relentless IM makes no sense. Embrace it. We ask actors to score their scripts with objectives and tactics, but we expect them not to think about those choices when acting. There is a paradox that implies we want actors to ignore their thought process and to act on impulse, all while making choices.

Embracing your IM can deepen your work.

Percentage Exercise

Have actors perform a scene. Then ask them to examine how much they were aware of the audience, how much were they "in their head" or how much they talked to themselves. Ask them to offer personal percentages. "I was committed to the scene (___ percent), I was watching myself (___ percent), and I was thinking the thoughts of my character (___ percent)." Directors and educators may use this idea of percentages as a consistent tool for notes or feedback. The goal is to reduce the amount of time spent devoted to personal IM and expand the time within the character's thoughts. It is nearly impossible to have that peak experience of 100 percent commitment in every performance, so thoughtful and guiding questions can lead an actor to a more honest examination of his work.

There are many ways an actor can sabotage a performance through an overly active personal IM. Actors have various hurdles in their IM based on their connections to their id, ego, and superego. Their vanity, libido, knowledge of the craft, self-esteem, commitment to the work, or a myriad of other issues place a hurdle between their personal thoughts and the committed IM of the character.

I have divided the possible IM hurdles that an actor faces. I bring these to your attention so that as actor you can recognize your own thought process, as director you can assist the actor in recognizing the impediments to getting the performance needed, or as educator you can empathize with your student and assist in silencing this saboteur. The actor in performance falls into the following categories:

The champion
The oblivious
The planner
The critic
The rehasher
The audience
The director
The victim

While there are many other permutations of the personal IM overtaking that of the character, these seem most prevalent.

The Champion "This is Going Great"

The champion refuses to let anything in the way of his performance—including the character. This id-based actor's IM continues throughout

the performance and does not allow anything other than the pleasure of being on display into the thought process. While the IM does not offer contemplation, it offers the thrill of exhibition. The response following includes: *I thought it went perfectly* or *I can't imagine anything better.* While the IM may be silenced as the critical voice, it also shallowly offers little chance for growth. While all must praise the work when it succeeds, little self-reflection actually occurs when self or others offer only compliments.

The Oblivious "How Did I Do?"

The oblivious lacks the introspection necessary for any good actor. Introspection is IM. The oblivious actor may have calmed her personal IM but lacks the commitment or energy requisite for inhabiting the character's IM. The response following includes: *I guess it was ok* or *You tell me how it went.* This actor needs to have both her personal and character IM ignited when acting. Only then can she transition to the character IM.

The Planner "Uh Oh That Part Is Coming up"

The planner does not allow the actor to give over to the thought process of the character because of the moments that are upcoming. He sabotages himself by expecting disaster. He believes that an upcoming moment will not land due to self-esteem issues. He expects that *I won't get that laugh* or *I can never get to the tears.* The actor will not allow the character's IM to be heard because of his own ego-based thinking that rationally (and sadly) destroys any hope of living in the moment.

The Critic "That Was Fake"

The critic listens to each line and watches every moment on stage or screen. She hates her voice; she despises her looks or thinks that each line that comes out of her mouth sounds hollow or false. The IM creates a running review of her work as it happens. Rather than expecting disaster, the critic reports on it, sometimes simultaneously. *Why did you say it like that?* or *Stop standing like that* are common

critiques of her work. While self-critique is an important tool for an actor after the presentation, it is disaster within.

The Rehasher "Why Isn't It Going as Well as Last Time?"

The rehasher spends his time on stage or screen trying to recapture an awesome moment that occurred in rehearsal or recreating the choices made at the audition. Rather than allowing for the communion in the moment, he spends his time trying to recreate spontaneity. As he performs, he bemoans his present situation and aches for past success with IM that includes *Where did that moment go?* or *Last time this was really funny.* While moments of the character's IM may be included in their process, historical repetitions infuse their work.

The Audience "They Aren't Laughing"

The audience devotes a great deal of IM when performing, listening to, or watching the real audience. Whether in class or performance, she is distracted by the audience rustling or the high-pitched laugh. The audience's lack of response seems an affront. Their laughter spurs her to new ideas. All the while, the character's IM has been displaced by what the actual audience is thinking. *They love this part* or *Is that my mother who just coughed?* are possible thoughts during performance. This pattern of thought hews quite closely to the superego that worries about what others will think.

The Director "This Is Not How We Rehearsed It"

The director is drawn out of the scene by practical and staging concerns like line memorization and blocking. The active IM is focused less on interpersonal interaction and more on what was decided in rehearsal. In his quest to perfect and fulfill past plans, he spends time admonishing himself or his partner for dropping a line or for not crossing far enough stage left. *She forgot to look at me there. I was supposed to counter her cross. What did we decide about this part?*

The character IM is replaced by a fear of line memorization and concentrated on stage pictures.

The Victim "I Can't Do It"

The victim lacks the conviction in her own work to subvert her personal IM. She has little confidence in the choices she makes and does not allow herself to dare. The victim ensures that work will not succeed by flooding her head with thoughts like *I could never understand this part* or *My partner is better than me.* The IM here is lacking in the character's thought because the actor believes she is not worthy to think them.

Cast Your IM Exercise

Following any performance, have students explore the archetypes identified previously and ask them to define which type of thought invaded their work. Examine the moments—how or why it occurred. Have them try to pinpoint what interrupted their desire to think the character's thoughts. Only through examining the cause can they hope to reduce those pesky and inevitable personal thoughts when performing.

You may have noticed in the previous exercise that your IM when onstage included thoughts like the critic. You reviewed your work throughout rather than concentrating your focus on your partner. Then in the next performance, work to release yourself from those thoughts and steer your thoughts back to the matter at hand—your character's IM. Do not chastise yourself for or get frustrated by this lapse of character IM—by doing so, you are only compounding the problem. Don't allow energy that could be focused toward character IM to be distracted by even more personal thoughts. Simply accept the gap and gracefully guide your thoughts back to the task at hand.

Every actor has various parts of the archetypes within performance. Various stimuli may make you turn into the champion or the rehasher, but it is up to you to examine the cause and try to eradicate those patterns in future work. Depending on the situation, your IM moves from type to type or even blends elements. For example, you may think like the director when you haven't rehearsed enough while also thinking like the victim because you know you succeed only when you have rehearsed sufficiently. Identifying the type of IM you use lessens its power and effect over your work and allows you to commit more fully to the character's thoughts.

So often actors say they were "in their head" following a performance. What does that mean? Misdirected IM. Training yourself to release yourself from these embedded and established ways of thinking requires much practice. But your IM is one acting tool that you can work on privately. Following any audition or presentation, you may receive feedback from the educator, director, auditors, or audience, but only you can give notes related to the misguided archetypical IM thought. Only you know what happened on that stage. And only you can release yourself, however slowly, from misdirected IM.

Personal IM when performing or auditioning can be an insidious deterrent to actual communion onstage. We must constantly remember to try and avoid our personal interruptions in favor of the character's thoughts. Our personal IM will always remain throughout to keep us sane and grounded but can be dampened in order to allow the free flowing of acting between partners that we all aim for.

6

IM versus Subtext

These two terms, sometimes used interchangeably, are actually quite different. Subtext (literally meaning "below the written word") requires lines in the script in order to exist as part of the actor's tools. Sometimes the subtext and the IM may be at odds, at other times they may be in complete agreement. But the thoughts in between the lines are IM and the lines themselves have the subtext. The written lines may be interpreted to have various shades of subtext. A simple "I love you" can mean a myriad of things. The actor may say the line differently in order for the audience to grasp the true meaning. So while the actor says, "I love you," he may really mean "I hate you," "I release you," or "I desperately need your support."

As actor, it is important to understand that each line has its own external subtext while your IM continues to race along internally. What you are really saying at each moment is as important as the IM-filled silences. And just as you devote time to shape and hone the line's subtext for maximum effect, so should you dedicate a portion of your rehearsal to the thought process that leads you in and out of that line and its subtext.

Subtext is below the lines. IM is between the lines.

Using the text of "I love you," an actor (playing the daughter) enters a scene where she sees her aging father in the hospital. The daughter has a running IM as she arrives in the room:

God, he looks so frail. Smell. Machine beeps. Freezing. Is he asleep? I should go. This may be the last time I see him. I was a terrible daughter.

When her line is said, the subtext of "I love you" is "I will never forget you." As the father smiles wanly, the IM of the daughter continues:

I hope he heard me. He smiled. This is the end.

If we change the IM, the subtext will also alter. This time as she enters she thinks:

He is such a hypochondriac. Always doing this—he just wants attention. Is he going to finish the Jell-O?

This time the line "I love you" has the subtext of "Are you happy now?" This time the smile provokes a different IM.

He hears everything. I knew it. Probably be discharged tomorrow.

This is an extreme example, as most IM and subtext are somewhat related based on the given circumstances of the scene and the through-line of the character. It also suggests that subtext and IM are intimately linked. If the daughter had no IM to get her to that line and its subtext, the line would ring hollow. Likewise, if the daughter had no subtext or point of view, all of the IM in the world could not make the line work. Subtext is public. IM is private.

Sometimes characters might be lying on the surface or deluded in their sense of truth. In this case, the IM and subtext may be wildly different, as they want to present a different public face while inside they are thinking contrary notions. "I love you" may take on a whole new meaning. Imagine a police procedural where you play a kidnapping victim. Your line, "I love you" to your kidnapper must contain the subtext of "I love you" otherwise harm may befall you. Obviously, within your private IM, you are disgusted with yourself for saying it, stalling for time, or looking for an exit.

Sometimes a character might have an IM that repeats "I love you" and when the line comes the subtext is simply "I love you." Utter honesty is that rare moment onstage where a character, most guilelessly, has IM and subtext agree. No pretense. No interpretation. The character simply says and thinks what he means. This usually occurs at the highest moments of emotion. So, when the teenage boy finally confesses to his sweetheart "I love you," inside his head peals the exact same phrase. IM and subtext are one.

Simple Script Exercise

In this exercise, actors are given one line of simple script, similar to "I love you." The actor must then create the scenario related to this one line. He must create the environment, the partner and her imagined response, the subtext, and the IM. The scene must contain at least 15 seconds of justified silence on either side of the line. The purpose then following the presentation is to examine the IM and subtext related to the conflict. Do IM and subtext conflict, agree, or closely correspond? This allows the actor to examine the concept that thinking and saying need not always agree. Perhaps the simple script contains only the dialogue, "You're here late." The actor may create a scenario where he is an employee sneaking into his boss's office to steal a drink from the bar. The employee expects that the boss will have left, as he always does, for lunch at 1:00. Today though the boss had some paperwork to catch up on. The actor enters the space and quietly goes to the bar in what he believes is an empty office. His IM percolates with thoughts of pulling one over on his stupid boss or needing a drink after a long meeting. As he begins to take his first gulp, he notices the boss staring wide-eyed at him behind his desk. The employee's IM is filled with thoughts of how to handle this or questioning why the boss is here. The dialogue "You're here late" is spoken with the subtext of "I wasn't expecting you" or "Please don't fire me." The employee may take the drink and return the liquid back into the bottle on the bar all the while thinking, "Forget I was ever here" or "This never happened," as he obsequiously backs out of the office and closes the door. Following the presentation, both actor and audience can examine subtext and IM related to their examples contained within the scene.

Actors usually understand the concept of subtext quite easily. The idea that we aren't always honest when we say something is not foreign. What is foreign is connecting the concept to IM. Rarely in our preparatory work do we take the time to examine what leads up to each subtext-rich line. And while we may pride ourselves for the sarcastic subtext dripping from our Lady Bracknell when she utters the famous line "A hand-bag?" from *The Importance of Being Earnest,* it only works when the IM before the line reacts, ponders, sputters, implodes, and finally releases into the line that drips with subtext.

In most cases, subtext can be enhanced and polished by more thoughtful IMing. Let us examine the IM silence prior to the line "A hand-bag?" from *Earnest.* The conflict is quite clear: Lady Bracknell is interviewing a young man to discern his suitability as a possible match for her daughter. The very proper Lady Bracknell

discovers that this young man was found as a baby in a train station. This is news of a most appalling nature to this woman of the highest social class. It destroys all possible chances of the young man, Jack, as suitor to her daughter.

> Lady Bracknell: Where did the charitable gentleman who had a first-class ticket for this seaside resort find you?
> Jack [Gravely]: In a hand-bag.
> Lady Bracknell: A hand-bag?

The playwright, Oscar Wilde, has added the stage direction "gravely" prior to Jack's line but has not assisted the actor playing Lady Bracknell with direction for one of theatre's most famous of lines. It is therefore open to unique interpretation. Read the scene purely as written, without dynamic choices, absent of IM. Now, add the subtext "You must be joking" to Lady Bracknell's response. Funnier. Stronger point of view. But now, add IM prior to her response.

Lady Bracknell may be wrestling with the news: *How can I tell my friends that Gwendolyn's beau was found in...* a handbag?

Lady Bracknell may be testing her failing hearing: *I don't believe I heard correctly...* a handbag?

Lady Bracknell may lose all composure: *Well, I'll be damned...* a handbag?

In each version the subtext remains "You must be joking" but the IM that takes us from Jack's grave confession as to where he was found, to Lady Bracknell's question, may be quite different.

Handbag Exercise

Provide the actors with the above information. Explain the conflict within the scene if they are not knowledgeable of the show. Then offer them varying possible subtexts for the line "A handbag?" These variations may be subtle ("I beg your pardon.") to extreme ("You must die!"). Whatever the subtext, the fun of the exercise is the time taken within the IM to get there. Have Lady Bracknell and Jack perform the three-line scene from above. The actor playing Lady Bracknell must delay her line until her IM gets her honestly to her subtext. Do not allow shortcuts where the actor jumps to the subtext without the requisite IM.

For more comedic possibilities, put an extreme time limit (over a minute) between Jack's line and Lady Bracknell's question. In this extended silence, have Jack and Lady Bracknell's IM serve as the "dialogue" before the subtext-laced line is uttered.

Most certainly an actor would understand that the IM and subtext work harmoniously and for comic effect in the above exercise. Ideally, an even further result is that students will forever be able to delineate between the non-synonymous subtext and IM. Through closer examination, the actor understands the very specific areas of these two concepts. To further understand the concept, the next exercise demands even deeper examination.

Subtext Exercise

Before attempting this exercise, you as instructor should provide a clear explanation of the concept of subtext and IM. Actors sit opposite each other verbalizing their IM before each line. They then say their line followed by its subtext. The actor then returns to IM. This pattern continues for both actors throughout the scene. It takes keen concentration to continue the scene with these varying goals, but the payoff is important. By carefully exploring the differences between IM and subtext, the actor will develop a keen understanding of these differing concepts. The goal is to make certain the actor understands that what he says and what he thinks may or may not agree.

As director, it is important to frame your notes related to these different concepts. If a line is not currently working, then you might ask an actor what their subtext is. You can then offer adjustments to the subtext. If that does not work, you may want to ask the actor to verbalize their IM prior to and after the offending line.

As educator, you may wish to coach actors to try various subtexts for a line to see which works for them. This also expands an actor's facility to make choices beyond his standard options. After exploring various subtexts, remind the actors how the IM must shift to prepare emotionally for the corresponding subtext choice.

Actors may wish to score their scripts with IM and subtext. This detailed approach further refines the concept of the disparity between subtext and IM. This sort of scoring more handily incorporates the standard objectives, tactic, and obstacles as it is evidence of what the actor wants in his IM and how he goes about getting it in the subtext. We can discern the more human idea of objectives as IM and subtext as tactic. So, just as in life, we don't think in standard objective form. We think with our convoluted, free associative IM.

Though inextricably linked, the subtext and IM for each scene are separate yet dependent entities. IM is hidden and personal while subtext is open and shared. An honest awareness of both concepts allows

you to have even greater command of your craft. The terms hold conceptual power that allows you to control your choices, your interpretation, and ultimately, your artistic process. The goal throughout this book is an expansion of possibilities within your current process. With new concentration on the interdependence of IM and subtext, you may examine moments and shifts within the scene from fresh perspectives.

Jacqueline, Actor

"Inner monologue is a concept I have known about for years, but it turns out I never truly knew what it meant and never realized the doors it could open in my acting. I have been told to think about IM every now and then by past acting teachers but have never spent a large amount of time focused on it. In the past, I would use it to help score certain parts of my scripts, but never knew I could use it as an active element in my work.

I began my real work with IM in a production of *The Three Sisters*. As Olga, I had to open the show with an emotional monologue that was full of twists and turns. Trying to grasp how to make the transitions truthful and real was very frustrating. Then it was brought to my attention how much we do this on a daily basis. I was shown how much groundwork I needed to lay for my character, and in order to make the transitions truthful, I had to be thinking like her the second I stepped foot on stage. It forced me to take the time to really get into Olga's mind and know every inch of what she might be thinking on this emotional day. When I worked out the details of where she was mentally at the top of the show, I was able to start playing around with her thoughts and questions before I even said my first line. I gave myself the time to really live in her thought process before I spoke her words. The opening monologue was transformed; it became much more active and then justified her sporadic change of topics. It was amazing how clear a difference it was when I was thinking like Olga and when I would switch to my own thoughts. I know it must have been night and day for the audience when I was actively thinking as the character and not as myself.

In a portion of an acting class devoted to *A Doll's House*, it was brought to my attention just how much I think on stage and how different my thoughts can be from the content of the script. I feel like I really honed into thinking as the character instead of thinking as

myself. It made my connection on stage with my partner wildly different and less selfish. I had to constantly be working on making my inner monologue the character's thoughts, which took a lot of concentration. The fact that we did the *A Doll's House* scene in a 'universal scene' style [author's note—universal scene is described later in this book] really helped me to stay open and gave me no time to get into my head and question my thoughts. It helped me to live in the moment as my character and be open to wherever the scene and my partner took me.

I believe that applying my deeper study of inner monologue to my scene work has made my characters richer and portrayed a lot more honestly. I have found myself, through the exercises and practices this semester, thinking like the character much more naturally and getting rid of the actor's thoughts. I still have trouble keeping my concentration and making sure my thoughts are always active, but I feel as though I am using it a lot easier. It has added a much needed element to my process, forcing me to dig deeper with the groundwork I lay with my characters. I have found myself asking more detailed questions, and it has made my relation to the character and my partner a more real life connection."

IM in Transitions

It was when I was coaching a transition within a scene in class that I first I understood the power of the IM. As a neophyte educator, I asked the student how she got from one train of thought to a seemingly disconnected new topic in the script. Her response was that she was not sure. The choices on both sides of the transition were fine, but the connection between them seemed disjointed. I asked her to talk me through the thought process of getting from one line to the next. What was discovered was that she took shortcuts. She said the first line and then spoke aloud a plausible IM, but she went forward with the line from the next unit before honestly coming to a natural place where the thoughts actually connected. She had not connected the transition through IM and logic. She had not made the transition truthful from one train of thought to the other.

This is a common occurrence. More often than not, an actor will rush through transitions and skip over the important transitional IM necessary to link two seemingly unconnected subjects. Transitions reveal when an actor may need assistance.

For example, I may have the line "I wonder what happened to her," and my next line in the script may be "I'm famished." Throughout the rehearsals, I have been stymied by these seemingly incongruous and unconnected thoughts. How to solve the dilemma? IM.

IM is transitional thought.

In the first line "I wonder what happened to her," I am speaking about a lost love from my bachelor days who was, according to the script, one of the kindest people I have ever known. I am speaking to my insensitive wife, whose jealousy is second only to her irritable temper. Below are possible IMs for transitional thought along with commentary about their plausibility.

"I wonder what happened to her?" *Ah well. I shall never know that kindness again. Oh, well, change the subject. I guess I'll talk about food.* "I'm famished." While the first part of the IM works, I am missing the actual transition itself and have taken a major short-cut with the overused and under-realistic IM that I should "change the subject."

"I wonder what happened to her?" *She is probably happily married somewhere. She deserves it. She was always so kind to me. To everyone. I didn't deserve her. We get what we deserve. There is clearly no escape. I shall be staring at the same unfriendly face for the rest of my life. Waking in the same bed. Listening to the same conversations. Looking across the table at the same restaurant. No escape. Might as well begin the inevitable.* "I'm famished." Despite the ode-like train of thought here, I have some interesting ideas that could certainly work. Two potentially problematic elements are that the thought process is purely negative (who wants to spend an evening of theatre with this character), and I have not used any reaction from my scene partner within the transition. Let us assume that my wife is not pleased by my wistfulness related to my former love. Perhaps her glowering could spur me on to quicker transitional thought.

"I wonder what happened to her?" *I miss her tender beauty. I must reconnect with her.* [Looks at his sour wife.] *Is she onto me? Act as if nothing is wrong. Take old sourpuss to dinner and call my lost love from the restaurant.* "I'm famished." The IM is positive, active, and related to the other. The main problem here is whether or not my plan to contact my love is part of the plot or is it merely a fleeting and unfulfilled plan like so many others I have within the play.

I have quite a few transitional IM possibilities to explore within rehearsals. I may seek counsel from my director or simply take a bit of time working through this transition in rehearsals, trying to connect the correct wires in concert with my scene partner's choices (she may choose to smile at me during this transition), my blocking (I may be facing toward the window), and the direction (he tells me I am "taking too damn long with that transition!"). Whatever the potential snafu, I have several possibilities to investigate within this transitional moment.

Anton Chekhov is a playwright who embraces the complex psychological state of his characters. His work is fraught with characters in turmoil, and their dialogue reveals their conflicted state of mind. Related to that, his characters also switch mid-sentence to a new and

seemingly unrelated topic. His plays are all about transitions, and finding the justification and motivation for these moments is both thrilling and challenging. As actor, the elation one feels when making that difficult transitional moment work is unparalleled. As director, crafting a production where transitions are clean and clear creates a sense of ease in storytelling. As educator, breaking down the transitions with your students is an excellent way to understand their personal process. Using text from Chekhov's *The Three Sisters* let us take a look at the opening scene where the eldest sister, Olga, is consumed in thought about her father's death exactly one year ago. I will place a "/" at every moment of transitional thought for Olga.

> *Olga*: Father died just a year ago, on this very day—the fifth of May, / your name-day, Irina. / It was very cold, snow was falling. / I felt as though I should not live through it; you lay fainting as though you were dead. / But now a year has passed and we can think of it calmly; / you are already in a white dress, your face is radiant. [The clock strikes twelve.] / The clock was striking then too. [A pause]. / I remember the band playing and the firing at the cemetery as they carried the coffin. / Though he was a general in command of a brigade, yet there weren't many people there. / It was raining, though. Heavy rain and snow.
>
> *Irina*: Why recall it!
>
> *Olga*: /It is warm today, we can have the windows open, but the birches are not in leaf yet. / Father was given his brigade and came here with us from Moscow eleven years ago and I remember distinctly that in Moscow at this time, at the beginning of May, everything was already in flower; it was warm, and everything was bathed in sunshine. / It's eleven years ago, and yet I remember it all as though we had left it yesterday. / Oh, dear! I woke up this morning, I saw a blaze of sunshine. I saw the spring, and joy stirred in my heart. I had a passionate longing to be back at home again!
>
> [Masha, brooding over a book, softly whistles a song.]
>
> *Olga*: Don't whistle, Masha. How can you! [A pause.] / Being all day in school and then at my lessons till the evening gives me a perpetual headache and thoughts as gloomy as though I were old. / And really these four years that I have been at the high-school I have felt my strength and my youth oozing away from me every day. / And only one yearning grows stronger and stronger....
>
> *Irina*: To go back to Moscow. To sell the house, to make an end of everything here, and off to Moscow....

Throughout her dialogue one can note Olga's struggle to pull herself out of her gloomy mood. Her struggle is apparent because of the changing of thought as new moments and images invade her IM. She talks about the past, present, and future. She has an inability to concentrate. She is alive with thought. Quite often we see a very heavy and plodding Chekhov production, when in reality, these characters are electric in their connection to IM. They do not want to give in to the mood. Like us, they are desperate to escape. Olga is an excellent example of this.

Sometimes transitions happen naturally onstage with little effort. Not every transition requires elaborate overthinking. Only those that offer particular trouble need to be deconstructed. In this stretch of lines, you may be able to easily connect the necessary imagery or thought to get your character logically to the next line. I have included my quick IM transitions.

"Father died just a year ago, on this very day—the fifth of May, / *We were getting ready for the celebration* your name-day, Irina. / *Image of the grey wet weather that day.* It was very cold, snow was falling. / *We were destroyed!* I felt as though I should not live through it; you lay fainting as though you were dead. / *Stop this immediately!* But now a year has passed and we can think of it calmly."

Later moments in this section of this opening sequence might not be quite as simple. It is here that you may need to examine the IM related to the transition. In my work as Olga, I know basically what she is feeling, but the moment below keeps tripping me up in rehearsals.

"It's eleven years ago, and yet I remember it all as though we had left it yesterday. / Oh, dear! I woke up this morning, I saw a blaze of sunshine. I saw the spring, and joy stirred in my heart. I had a passionate longing to be back at home again!"

I understand the basic change in thought. Olga is going from her memories of her past life in Moscow and makes a transition to how she felt like her old self this morning. I can make a simple transition along the lines of *I miss Moscow*. The thing that I stumble over is the line, "Oh, dear!" I do not feel that the simple transitional IM above is sufficiently emotional to let me justify both the text of the new line and the punctuation! I must explore other ways to get there. I will include some possibilities to get my Olga from "…yesterday" to "Oh, dear!"

I have to break down her thoughts and images to get there. I have to slow this moment down and examine her IM in order to make it work for my version of Olga. My first possibility is that I am awash

in my golden memories of my happiest times in Moscow. *I remember how it seemed the flowers were always in bloom. Then I truly had a purpose. There was hope. I haven't felt like that in—but today there seemed to be hope.* It almost seems to work, but it does not have the emotional weight necessary to get me to "Oh, dear!" and the quick change at the end glosses over the real issue. The reason for the change in thought.

In my next version, I will keep the Moscow thoughts but concentrate on the idea of the weather and how that can affect me emotionally. *It was always so lovely in Moscow. Everything was alive. But here it is so gloomy all of the time. Except today. Today even the weather seemed hopeful.* Again, it almost works, but am I really talking about the weather here? It also seems less about the reason I began speaking—father.

The whole reason I am speaking is to both remember and forget the anniversary of our father's death. This could become more present in the transition. *When we were in Moscow we were a family. Mother was alive. Father was happy. But now he's gone. No. No. It's been a year. No mourning. Today I am released. Today is a new day!* By adding father to the thought process, I was able to find an emotional way to get to the correct passionate place for the line "Oh, dear!" The resulting rehearsals reveal that this was indeed the correct choice for my Olga. Granted, I will have to reduce it to the essence so there will not be a large silent chunk of stage time while I think. But I needed to first think of it in its entirety in order to condense it. I may only really need to picture my father alive and happy in Moscow and then an image of his casket being placed in the ground to make the moment work in performance, but the groundwork of the fully "scripted" IM was necessary. And now, on to the next difficult transition.

Transition Exercise

Whenever a beat changes in a scene, you can feel the grinding of gears from the actors as they shift to a new subject. This common problem is solved immediately by IM. Whenever a beat changes, ask an actor to verbalize her IM. The transitional thought may be a quick image. It may be one word. A few sentences. But the actor should know how she got from one idea to the next. This exercise creates logic and reveals if an actor is cutting corners like "Oh, I should change the subject!" which is rarely used in life or in onstage transitions. The outcome forces the actor to understand the justification during each transition, making for a smoother and more logical scene. Actors may do this in

analysis work but rarely in practice. Directors can use this at major plot shifts or when new information is revealed in the script at rehearsals. Educators may use this at especially problematic moments when a scene loses focus.

How then does one handle a non sequitur within a script? A non sequitur is an unexpected, sometimes bizarre statement that bears no connection to the train of thought preceding it. So while the line from your scene partner is "Are you hungry?" your response may be "Thursday." This non sequitur may have been written by the screenwriter for comic effect, but it is up to you and your IM to create the internal "logic" to get to this illogical response. You may justify the line because your character is distracted with her own thoughts and has not heard the question correctly, singing her favorite tune in her head and the lyric she vocalizes is "Thursday," or she may remember that on Thursday she is going to her favorite restaurant. All of these are possibilities to explore.

If you justify her non sequitur by simply concluding she has faulty internal wiring so her response makes perfect sense to her, you have cheated yourself as actor. Don't end there. Part of the fun and mystery of characters with "faulty wiring" is figuring out how the wiring got messed up in the first place. Explore how that question causes that response. Become the character's electrician and discover how the internal wiring is connected.

Transitional work reveals itself: in rehearsals when the rhythm is off; in performance when an audience is confused by the character's motivation; in analysis when the actor ignores the change of thought. It is that moment when something does not quite feel right. You can't explain it, but something is off. Most likely it is the transition contained within the scene.

Break the moments down and examine the IM in order to fully embrace the use of IM within transitions. The mysterious linkage from seemingly unconnected lines of dialogue is entirely dependent on IM. IM contains the logic.

8

IM Alone Onstage

The most exciting thing for me as actor, director, or audience member is when a character is alone on stage or screen. This is where we become instant voyeurs into the true inner workings of the character. There is no pretense. There is no etiquette. There is no politeness. It is the character in truth.

In these moments, we who are watching become instant psychics of IM. We watch the actions of the character and begin to provide the internal reasons for their behavior. We begin to divine the character's motivations and actually start providing IM to connect the blocking and the manner in which the actor performs it. We perceive motivation.

Imagine this is the first scene of a movie or play. The character opens the front door and peers inside. He then locks the door and goes to the desk and pulls open the drawers. Papers fly from the drawers as the man searches for the exact piece of paper, which he eventually finds. He holds the paper to the light to read it. He takes the paper and tears it into little pieces, which he throws into the roaring fire. He unlocks the front door and exits.

Now, although I wrote only blocking or movements of the character, you probably began to assign motivation or the reasons for each separate movement. You began to create what the actor might have been thinking.

The character opens the front door and peers inside *to make sure no one is home.* He then locks the door *to make sure no one catches him* and goes to the desk and pulls open the drawers *to search for something that is not his.* Papers fly from the drawers *because he is in a hurry* as the man searches for the exact piece of paper *that he so desperately needs,* which he eventually finds. He holds the paper to

the light to read it *to make certain it is the exact paper.* He takes the paper and tears into little pieces *so no one will ever see it,* and throws it into the roaring fire *to destroy it forever.* He unlocks the front door and exits, *making certain that no one will know he was here.*

So while the actor performs the silent task, we cannot help but supply the IM for the character. We intuit what he is thinking. It is only when our supplied IM and the character's actions are at odds that we take deeper notice. For the most part, the above scene falls within the expected pattern for someone behaving suspiciously. This scene does not necessarily surprise us because his logic is set up from the moment the character opens the door and looks inside to see if the coast is clear. The audience has an implicit understanding of what the mood, stakes, and thoughts of the character should be. It is when the unexpected occurs that we begin to pay closer attention in order to figure out what makes this person tick.

Blocking Exercise

Give three actors the same simple blocking pattern. "Walk in. Go to the couch. Lift up the first pillow. Replace. Lift up second pillow. Replace. Pick up the third pillow. From under this pillow remove the set of keys. Replace the pillow. Exit." Allow each actor to create the scenario's backstory and motivation for this action. After all three actors have performed their version of the exercise with a full IM, ask the audience what each actor was thinking. You can alter this by having one actor say out loud the IM while another actor performs the duty. The purpose of doing this exercise is to recognize the importance of thought onstage as well as the enhanced role of audience in silent moments onstage.

In one of the initial chapters of this book, we explored Blanche DuBois's arrival to her sister's apartment in New Orleans. With no prior knowledge of this play, we hear in the scene with the landlady, Eunice, that Blanche is Stella's sister and that she has arrived from out of town. Once Eunice leaves to go and get Stella, the real excitement begins. Blanche is alone onstage where she clutches her purse, revealing her inward tension and obvious lack of comfort within the apartment. The playwright next writes of a dead look leaving her eyes as she surveys the apartment. Here we see that her lifeless or distracted demeanor with Eunice was just a façade, and this is truly who she is—someone who is practical and needs to take in the situation in order to gain an advantage. Just when we think we know who she is,

the playwright has a cat screech, which startles Blanche, causing her to lose her breath. The revelation here is how tightly wound Blanche is. Now she seems the epitome of the stereotypical Southern Belle—high strung and flighty. Next, the character spies a whisky bottle in a half-opened closet and springs to get it. This completely subverts the audience's expectations as to who this character is. Blanche fills half a tumbler with the alcohol and downs it quickly. Obviously this woman uses liquor to calm her nerves and has done so before. Perhaps many times. What she does next reveals that she does not want her sister to know that she is drinking, as she washes the tumbler. She then speaks her IM out loud, telling herself that she has to keep hold on herself, revealing that she is in a desperate situation and must push away whatever is consuming her. She then resumes her place at the table as Stella enters.

This little bit of alone stage time piques the audience's interest. Throughout this silent sequence, our expectations are constantly subverted. Each time we think we know who she is and what is driving her, she reveals another layer to the character. The character is a mystery, and the audience is drawn into her psychological state as they try to discern her IM. Williams could have easily had Stella at home, welcoming her sister. This alone time is important. As are all times alone onstage.

In Uta Hagen's excellent book "A Challenge for the Actor," she explores this sequence in a section regarding "particularization." She describes in detail an actor's necessity to endow each prop, scenic element, and environmental feature with a rich and textured backstory. IM can enhance this sort of work as Blanche gulps down the cheap whisky or is startled by the hungry alley cat. The actor must provide the IM that connects these moment-to-moment experiences. It is what the actor is thinking as she is alone onstage that guides the audience to an interpretation of the character. An actor should be connected inseparably to the IM in order to create an interpretation.

Alone Onstage Exercise

Using a character that actors are currently working on, develop an original solo sequence that reveals the character's IM through action. Have them block a sequence where the character dresses for the high stakes big party occuring later in the play. Have them create a silent scene where the character mulls over a decision while cooking. Perhaps have the character clean up the apartment while preparing for the dreaded first date. These sequences should intertwine the main purpose—dressing,

cooking, cleaning—with the inner emotional struggle of the character. Examine how a rich and full IM enhances and distracts from the task at hand. This sequence can reveal to all (actor, director, or educator) what elements can be massaged in order to get to the complicated inner world of the character. If the solo sequence allows the actor to perform the task without the obstacle of the chracter's IM, then assist them in expanding its presence in the exercise by offering IM suggestions or topics to think about when performing the task again.

Search for clues in the text when a character is alone, unguarded, or most honest. Those basic moments, like Blanche's confession while alone onstage, are the essence of the character's inner vocabulary. In contrast to her usual flowery language, when Blanche simply reminds herself to calm down she reveals the character's true IM. The actor must begin to think in the language or images of the character. Too often actors make characters as intelligent as they are. They create characters with similar senses of humor, ethical values, or morals. Examining time alone onstage is a way to avoid such similarities. An actor must adapt the language used in formulating the character's IM to truly immerse herself in the character. This includes the eschewing of all contemporary or colloquial references that are at odds with the text.

At the top of act 3 of *A Doll's House*, Mrs. Linde nervously awaits the arrival of her former lover, Krogstad. In this sequence you can note a character consumed by IM.

[Mrs. Linde sits by the table, and turns the pages of a book absently. She tries to read, but seems unable to fix her attention; she frequently listens and looks anxiously toward the hall door.]
Mrs. Linde [looks at her watch]: Still not here; and the time's nearly up. If only he hasn't—[Listens again.] Ah, there he is. [She goes into the hall and opens the outer door. Soft footsteps are heard on the stairs; she whispers.] Come in; there's no one here.

As you can note, the character is speaking her IM out loud. This is a common occurrence in solo moments onstage and is exactly as Mrs. Linde truly thinks. This makes your work in IM easier.

In Arthur Miller's *The Price* there is an extended opening sequence in which the main character, Victor Franz, enters his former home stuffed with old furniture and bleak childhood memories. For the first few minutes of the play, he interacts with the gramophone records and fencing equipment that were an important part of his upbringing. The character moves from piece to piece as the playwright describes the various interactions between prop and character. Victor stares at

a chair for a bit, he pretends to fence, he laughs along with the record he plays. It is not until much later that we realize these tragic and poetic interactions with elements from the past have real emotional heft. It is clear that the actor playing Victor must have a well-defined and connected IM, otherwise it is simply a series of movement patterns absent of any thought.

Props Exercise

Have actors choose some props or clothing pieces that might have a strong emotional connection to the character. The props might evoke both happy and sad memories but should have a backstory connected to them. Is this the bracelet your late husband bought for your anniversary? Is this the scarf she knitted for you before you broke up? Is this food made from a recipe handed down to you by your grandmother that you always cook to impress people? Whatever the story or the prop, invite the actors to have the characater's IM explore all possible connections. By exploring IM with this tangible element, they may become more confident when using IM onstage alone, with or without props. As educator or director, ask guiding questions to allow for deeper interaction with the prop that includes its history and necessity in the character's life.

Too often an actor (or director) rushes through moments alone onstage when, in fact, they should be massaged and explored. Silence is a powerful tool. Solo moments are highly theatrical as they have internal suspense built into them. Since there is no standard dialogue to guide the audience, they wonder what will happen next.

Too often an actor may feel naked onstage without the comfort of a scene partner. They feel vulnerable or conceited because all the focus is only on them. They are inhibited because they are unaccompanied. You are not alone onstage; you have your IM. Focus your energy toward your IM to stop your personal thoughts from interrupting good acting when alone onstage. Just as we do when alone, talk to your "fantasy" scene partner; your IM. By taking the focus off you and placing it actively within the conflict of the scene and your thought process, the self-conscious solo actor may disappear.

Using IM in moments of solitude on stage or screen allows for revelations of character motivation for the audience. These fleeting moments allow the audience to understand more deeply what drives a character to her ultimate goal. By sharing in private moments, an audience is immediately privy to the character's IM. Therefore, you must have one.

Kirill, Actor

"IM was a stepping stone for me. I have been training as an actor for many years and have somehow never come across the suggestion to actually incorporate IM into my acting. In the past I have focused IM simply on the character's thoughts during transitions and kept IM strictly as a part of script scoring. My goal onstage was to quiet the IM that naturally goes on inside of my mind while I work. Onstage, I viewed my IM as my enemy. It would be a director or judge of my work while it was happening. If I was struggling, my IM would remind me of it relentlessly, if I felt that the scene was going well, my IM would comment on it. Both of these would take me out of the moment as the actor. I worked to find anything I can do to silence my own IM in hopes that it would allow me to be present and active on stage. Sometimes this was more successful than other times, yet most often it would just steal my focus away from my work.

My first introduction to actively using my own IM while onstage occurred during the rehearsal process of *The Three Sisters*. While playing the role of Vershinin, I found myself having trouble connecting to the given circumstances of the play during certain scenes. This lack of connection led me to question my work until the frustration caused began to create tension in my scenes. The director continuously asked my cast mates and me about our IM, this spurred me to ask if I should actively use my personal IM while working on my scenes.

The idea of using my IM as a way into the character onstage was new to me. While it began to pay dividends right away, there were still times when it was a distraction. I began to use my IM by trying to assimilate the character's thoughts with my own. At times this was an easy and simple way to remind myself the given circumstances of the play, and sometimes this would be a distraction as I tried to force my IM to line up with the IM of the character. Though I found limited success using IM in *Three Sisters*, the experience taught me that it is possible to make your personal IM your ally on stage instead of your enemy.

My next step in incorporating IM came while doing scene work for *A Doll's House*. Experimenting with visuals and music helped me discover how my personal IM works. My IM tends to start with an image or a short moving image clip that then becomes the catalyst for a stream of short thoughts. Every time this happens naturally in life, it quickly creates honest emotion and connection to something that may not even be happening to me at the moment. The challenge is finding a way to use this knowledge in my work.

While rehearsing the scene, we were given an exercise in which an outside person stands in our line of sight and brings up random images for us to see while we are working. This exercise brought me some more limited success using IM in my work by emulating how my personal IM works already. I was able, on several occasions, to see an image and immediately connect it to my work. In those moments, the image would guide my choices and make them more personal and connected.

My biggest breakthrough with IM has come in just the last week while working on a scene for class. I have been having great difficulties of late connecting on a personal level to my partner and my work. I know that I have strong technique and have been using that to mask and protect myself instead of as tools to tell the story at hand. While working on the opening scene, my partner and I were having difficulties connecting to each other and to the given circumstances of the play.

We struggled for weeks and reached a point where our frustration would block any potential at progress that we might have made otherwise. Even though in rehearsal I was actively using IM to connect to my partner, the results were mixed at best. Oftentimes it would just get me stuck into repeating words in my head that did not help me connect at all. The breakthrough came while combining IM with a focus on only the other's reaction. I was reminded that my IM still has to put my focus on the other person and their actions towards me. Using the other's reaction as a way to focus my energy on my partner as a warm-up helped me connect to the character's IM without having to force it.

After a week of combining the other and IM, I was able to connect to my partner quicker and for longer stretches of time. My next goal is to keep this as consistent as possible to help ground my work in honesty and listening. I want to experiment with changing what I focus my IM on to see what can help me accomplish those goals with the most consistency. IM has helped me gain trust in my work and reminded me that I am enough."

IM in Objective/Tactic/Obstacle

The basis to most acting theory includes derivations of the concept of objective (also goal, need, or action), tactic, and obstacle. These major concepts are Stanislavski-based and were created to keep the actor motivated and continually working or in action. While some may consider IM antithetical to action-based pursuit, it is actually enrichment to these fundamentals of acting.

Objectives

The idea of objective in acting means the goal or pursuit of a character within the scene. What you want to achieve. You want to affect the other by changing them. Most acting theories stem from this axiom in order to create active and outwardly directed energy from the actor. You must affect the other by making choices that can alter the other. For example, an objective can be stated as "I want to distract her." The action or objective is clearly playable and has the test in the other. If the other is distracted, you have achieved your objective.

The objective creates an active and interactive dynamic to acting which removes inert, self-directed, or misplaced energy in any transaction onstage. An exchange implies the transference of energy. Therefore, in order to create good acting, there must be action. Action between two entities.

It is not oxymoronic to suggest that inner voice can assist in outer-directed action. Rather than an enemy to interaction, IM can enhance and deepen that inter-communication. Instead of ignoring the other, when directed appropriately, IM is the conduit and aide to this basic principle of acting theory.

As noted earlier, we ask actors to score their scripts for objectives and then want them to "stay out of their heads" when performing. There is an odd disagreement here. As directors or educators when we ask actors, "What do you want in that moment?" the IM offers the answer. Of course we always hope to respond organically and based on the other's stimuli, but the IM is there to remind and focus the actor's connection to objective.

As an actor example, my objective is "to convince him." I enter the scene fully invested in that idea. My IM is taking the temperature of my partner. Does she seem open to this idea or does she seem inconvincible? My line is "Please believe me." My subtext is clear: "Trust me!" I look at my partner's reaction to this interaction, and my IM notes that she is unmoved. She simply rolls her eyes. My IM processes this slight and reminds me to keep pursuing my goal.

IM is impulse. IM is process. IM is response. All elements of objective.

Overall, IM is the through-line, the overarching belief; the focused thought process that shoots your objective to the fore and to the other in every interaction. The goal is to silence the voices in your heads in order to interact. More often than not, your moment of communion or pure impulse acting is fleeting. And while all—whether actor, director, or educator—aim to extend, recreate or patent those moments, no one has been able to do so. Therefore IM is a necessary component to your process.

Objective Exercise

In this exercise have the actor identify their goal for the scene. What does the character want from the other? *I want to convince her.* Using only that phrase as IM, have the actor keep focused and repeating that phrase silently during the scene. Using objective as IM will certainly focus the actor on the task at hand. What it does not allow is much (or any) interaction with the partner. The actor is fully (if selfishly) pursuing the goal, but they are not receiving any information from the transaction with the other. Repeat the scene again with objective as IM, only this time remind them that the test of whether they have won or lost their objective can only be found in the other. *Have I convinced her?* The use of the singular concentration on the objective in the first run of this exercise will focus their IM quite powerfully on the goal, but the dual focus of the second is more akin to the active acting we aim for.

This concept of objective is what guides an actor through a scene moment by moment, but the overall goal or spine of the character

is called the super-objective. This is what drives a character's every decision. It is her core issue. Some may argue that super-objective is her id driving her basic selfish needs. Others may avow that it is based on psychological neuroses stemming from circumstances contained in the script. Others may mathematically determine that simply adding up the events of the character's behavior in the script reveals a clear overarching goal. Whatever your camp, most agree that there is a consistent goal in a character's journey.

Using the idea of super-objective, let us look at Blanche DuBois again. Examining the given circumstances of the play, we realize that she continues to search for something. Is it love of another since the tragic suicide of Allan Grey? Is it escape from all of the horrific deaths at Belle Reve? Is it respect after her fall from grace following her several trysts with the soldiers and a student? Your version of Blanche will be unique. For my version, I think that all of these actions have created a woman seeking a safe haven. A place where she can find security, trust, and peace.

Using Blanche's super-objective to focus my IM throughout the rehearsal process or performances, I can constantly remind myself whenever a distraction from my immersed performance strays due to whatever circumstance. *I want safety. I want safety. I need to feel safe again.* This acting shortcut can immediately allow me to connect into my character's ultimate goal. Perfect before any entrance, the repetition of the character's super-objective in IM can immediately refocus my responsibility to the character.

As actor, a character's goal is an important element in ensuring your work remains active and focused on the other. Your IM should always be actively pursuing something and should not be only self-directed. This traps you into playing a mood. As educator, it is important to constantly assist your actors to avoid selfish IM acting and push their work outward to focus on the other through objective. As director, actors playing the mood of the piece may at least be in the right emotional territory for the play or film but will need your assistance through objective to make their work active.

Tactics

The concept of tactic is the manner in which you achieve your objective. You want to affect the other through various types of behavior, all directed toward the objective. When one type of behavior does not work, an actor then engages in a new way to ensure success in the

objective. These various attempts employ tactics. So your objective may be stated as "I want to distract her," but I may do so by singing loudly, by pointing in another direction, or by engaging her in a different topic of conversation.

The tactics create unique and compelling ways to achieve an objective. While a scene may have an obviously prescribed objective, the actor's choice of tactic reveals the invention and imagination of the actor. Tactics are based on analysis of the scene in concert with the transaction onstage. So while an actor may have prescribed his tactics through scoring, those choices may alter or disappear when working with another. The IM may act as the arbiter of when to manipulate or discard the analysis in order to live more truthfully within the scene.

Using the earlier example with the objective "to convince her," I enter the scene invested in that idea, having also reminded myself offstage of my super-objective. My IM is still taking the temperature of my partner. Does she seem open to this idea or does she seem inconvincible? My line is still, "Please believe me." My subtext remains clear: "Trust me!" I look at my partner's reaction to this interaction, and my IM notes that she is unmoved. She simply rolls her eyes. My IM processes this slight and guides me to my tactic of joking with her in order to convince. She does not soften in the least to this way of working. My analysis has told me that I will convince her next through reasoning. But my scene partner unexpectedly begins to exit the room. Impulsively, my IM discards this tactic and pushes me to get up and block her exit in order to convince her. The process of working quickly and impulsively is tied to the IM.

IM offers schemes. IM offers choices. IM gauges success. All elements of tactic.

Tactic Exercise

This exercise should use an improvised scene combining two opposing yet basic objectives like "A wants to seduce B" and "B wants to escape A." Before attempting the improvised scene, have students write down a list of possible tactics that may or may not make sense in relation to the scene. Write the tactics on small separate pieces of paper. Tactics should offer a wide range of possibilities like "By hopping up and down on one foot," "By calming," or "By stroking his hair." Before choosing any tactics, have A and B go through a bit of the scene to understand the basic conflict. Once that has been clearly illustrated, have A and B choose tactics from the possibilities. The actors must

then retain their objective but filter it through their prescribed tactic. Once the tactic has been demonstrated, immediately instruct the actor to choose a new slip of paper and play that tactic. This should happen quickly and often to illuminate the IM process of ever-shifting tactic within the objective. This exercise is a fun way to hone the idea of tactic, but closer examination of the moment of looking at the slip of paper, processing the information contained on it, and the return to playing the objective with the new tactic should be examined. What went on within those split-seconds of reading the new tactic and the actual playing of it? The discussion could reveal the way in which IM and action are interrelated.

Tactics and expectations are separate concepts that are correlated. Expectations are entirely IM-based and in turn affect the tactic. The idea of expectations is that an actor has a probable response from an interaction with another. Using past history and expected human behavior, an actor always expects a certain reaction from the other. My objective and tactic is to "distract her by singing loudly," so my expectation is that she will divert her attention to me. When she does not, my expectations are not met, so I may have to change tactics.

This oversimplification of expectation gets us to the essence of another compelling use of IM when acting. The expectation implies a response both before and after each interchange onstage. My expectation-focused IM is silently telling me that he will be convinced (objective) if I do it this way (tactic) but when my expectations are subverted, I must quickly recompute my new approach.

At the end of each line there is an expected response. "Hand me the remote, honey." Your unspoken expectation is that he will do so. When he does so, you move on to the next moment of your life without conflict. If he does not, your expectations take you to analysis and tactic. *Did he not hear me?* Tactic—talk louder. *Is he mad at me?* New tactic—adopt an apologetic tone. *Is he lost in his reading?* New tactic—get up and get it yourself. The IM, expectation, and tactic are working interdependently.

Expectation Exercise

In this exercise, at the end of each line of a scene, have two actors speak their expectation-based IM out loud. For example, the script may be "How are you today?" A's IM is *I'm expecting her to say "Fine."* When B responds "I don't feel well at all," A's expectations have not been met, and A must rethink his approach. B's IM after her

line, "I don't feel well at all" may be, *I'm expecting him to say,* "*What can I do?*" If the expectation is met, B understands the situation and continue sans conflict. When expectations are not met, things are off-kilter and a new tactic must be used to get back on track.

In this exercise, be certain that the expectations-laden IM understands the given circumstances of the play as there is a major difference between expectation and hope. A hope she responds that she is fine when asked "How are you today?" but A's prior knowledge of B's hypochondriac nature means that A is expecting her to say "I don't feel well at all." Expectations met. The IM whispers, "*Of course*" and so continue onward.

Throughout the scene explore an IM entirely filled with expectations and see how the performance remains entirely concentrated on the partner's choices.

So as Blanche, my expectation may be that Stella will notice how good I look. My tactics may be posing for her, calling attention to her plump appearance or finally, by making her feel guilty enough to offer a compliment me. The IM connects it all.

While tactics are a common tool for an actor's analysis, both directors and educators can enhance the work of others by offering a deeper connection to an actor's tactics. As director, offering possible new tactics when a scene has become stale will renew on-camera vitality to the next take. As educator, guiding a student to new tactical choices can expand an actor's standard repertoire of expected tactics. The IM is the tributary connecting objective, tactic, and obstacle.

Obstacles

Obstacles are what prevent you from achieving your objective. The obstacles may be self-imposed or psychological barriers like self-esteem. They may be physical impediments simply based on proximity. Or they may be based on your knowledge of the history of the situation, like lack of sympathy from the other. So your objective and tactic may remain "to distract her by singing loudly," but the obstacle may be that she is hard of hearing.

Obstacles are the most rewarding and forgotten elements of the basic trinity of acting theory. They offer unique levels to the work, complications within the character, and emotional heft to any interaction. The IM may offer a reminder to the stakes of these obstacles throughout.

Using the earlier example with the objective "to convince her," I enter the scene invested in that idea, having also reminded myself offstage of my super-objective. My IM is still taking the temperature of my partner. Does she seem open to this idea or does she seem inconvincible? My line is still "Please believe me." My subtext remains clear: "Trust me!" I look at my partner's reaction to this interaction, and my IM notes that she is unmoved. She simply rolls her eyes. My tactic still changes, but my IM is replete with obstacles. *She never trusted me. She won't look at me. No one likes me.* IM heightens stakes. IM offers reminders. IM recognizes barriers. All elements of obstacles.

Obstacles Exercise

Identify all possible and plausible obstacles within a scene. They should be wide-ranging and offer true impediments within the given circumstances of the play. In the Sid and Florrie scene from *Waiting for Lefty*, those obstacles might be Florrie's brother in the next room, Sid's hunger after driving in his cab all day, the weather outside, Sid's brother joining the navy, the economy, their knowledge that their love is doomed, their family responsibilities, the impending strike, their bleak future, and so on. Write each obstacle on a separate piece of paper. As the scene is performed, hold an obstacle up for each new unit of the scene. Instruct the actors to focus their IM solely on that one obstacle for that section of the scene. Allow them to explore deeply the text and the obstacle. As they say the lines, their IM can flash images of their stolen kisses in hallways, the contents in his wallet, or her brother's watchful eyes. The desired response is a deepening of how obstacles infect every moment onstage related to IM. It is also hoped that the moments where IM and obstacle created an indelible moment can be examined. It is hoped that all of the obstacles identified flow throughout the scene but come to the fore at especially prescient moments.

Obstacles are tied intimately with the wins and losses of any scene. The obstacle is the barrier, while the wins and losses denote if the actor has overcome or fallen victim to the obstruction. The IM can assist in this concept.

Following each transaction onstage, you must assess if you have won or lost. Have you achieved the objective? If not, does the tactic remain the same? Was the obstacle too great for victory? All are standard and valid questions, but the only gauge that you have onstage is the IM related to impulse and the givens of the script. Wins and losses

are related to the moments of transition described earlier in this book and identify whether to forge ahead with the same choices or modify into a new train of thought. The answers are related to the script and justified by the IM.

After each exchange, you may take a metaphysical body count. *Did I win that war? Did I succumb to that obstacle? Am I victorious?* The question-filled IM allows you to take that victory lap by gloating, reconnoitering, and finding a different strategy, or soaring to new heights using that win or loss as momentum in the next section of text. Choices, by their very definition, imply a selection. This selection is housed in the IM.

Wins/Losses Exercise

In this exercise, ask the actor to focus their IM only on assigning wins and losses after each exchange. Assist them in focusing their thought process on this concept of overcoming an obstacle as a win and surrendering or the inability to overpower the other as a loss. So, in a scene where two characters want the same meal at a restaurant but there is only one portion left, the characters may use bargaining or bribery as tactics. Obstacles may include their lack of funds and their all-consuming hunger. Only by identifying if they have succeeded can they decide their next move. Quite clearly in this basic example, whoever gets the meal wins, unless the customers decide to share, which is a lesser win but is still a win.

Once the scene has been performed, steer that analysis to examination of when the actor was able to best assess moments of wins or loss. It may be after each line, it could be when a new tactic was introduced, it may be at the final moment of compromise. Whatever the moment, the actor can expand his repertoire of IM-enhanced acting to include a new element—wins and losses.

As Blanche, I may have minor wins throughout my scenes with Stanley where I humiliate him or mock his brutish ways. I must identify these moments of victory as they propel me to achieving my superobjective of finding a safe haven. I must also recognize my moments of loss as they push me further into my swirling IM that offers obstacles that are impossible to overcome. My ultimate goal of finding a safe haven has been destroyed by loss after loss. The obstacles have become too much, and it is apparent that I surrender as I am escorted off by the doctor at the end. The IM will most likely have a new set of obstacles to contend with in my new residence.

Objectives, tactics, and obstacles are the backbone for most acting theory. They were created to maintain an actor's active connection to the other. IM may assist without trapping the actor solely in her head. The goal throughout this book has been to enhance and expand the actor's toolkit to include alternate ways to achieve that illusive truth onstage. An actor may approach a scene in various ways—impulse, objective, expectations, wins, and losses, commitment to the given circumstances, or any of the various methodologies that the acting world offers. IM is a way to manage and organize these disparate theories in order to use the ones necessary for the project. The juggling of these various approaches to any scene or character rests solely with the silent and interior work of the actor. Of course, that interior filing system is housed in the IM.

Stephanie, Actor

"I have a love/hate relationship with IM use. It can sometimes be a huge help to get you out of your head, but it can sometimes get you so in your head you want to punch yourself in the face. You have to not let it consume you but use it as an aid to keep active.

I like to use IM when I first get the text and I'm figuring out the character. If you know the way the character thinks, you're golden. That means you know their opinions on certain topics and behaviors and how they act to get what they want. However, when I'm putting the text on its feet, I use that as my homework. Constantly thinking of what I wrote for my IM doesn't work for me. I find it hard to be saying lines while I have all this extra stuff in my head while trying to listen to the other actor and still stay in the moment. The thing that I find most helpful is 'the thought before.'

The thought that you have before you say your line, that makes you connect to right frame of mind. So if you know the subtext of the line that you are saying, you then think the thoughts before that to get there.

If I had a line 'So, you're going back to that bar tonight huh?' and I decided that my subtext is 'You're going to see that Jenny girl at the bar again aren't you?' I decide that my thought before is 'Can't wait to see you lie about this!' I think the thought before and then say the line 'So you're going back to that bar tonight huh?'

I like writing all over the script each thought the character has before they speak. It's best to keep it really simple. Especially for comedy, I like to think of a thought before that makes me laugh when I say it out loud before the actual line.

Emotional scenes do not come easy for me. I have to really be in the moment; I can't turn it on like a switch. So I use IM to get out of my head in that case. For instance, I had to do a scene where I was a pregnant lady giving up her baby for adoption. So before I went on

stage when I had a minute to prepare, I would repeat one line of my IM in my head over and over again. 'I'm giving up my baby, I'm giving up my baby, I'm giving up my baby, I'm giving up my baby' this repetitive nature got me out of my head. As for everything in acting this worked for me. Might not work for everyone else."

IM Out of Your Head

As noted throughout this book, when used incorrectly, a devotion to IM can trap you inside your head. Thinking like the character certainly, but in no way sharing that internal work. That sort of selfish acting/thinking belies the entire motivation for IM work. IM is used to deepen your external work by making a connection internally. All of the internal analysis is wasted if an audience cannot discern that work.

Quite honestly though, the concept of IM does emanate and remain head centered. But in our quest to replicate human behavior...are we not, at times, trapped in our heads? I do not suggest that we have no immediate interaction with another, but we do spend a fair amount of time daily "in our heads." We are intimately connected to our IM. To ignore this fact is to ignore reality.

Acting may be broken down to this basic transaction: receive information and respond to it. There are also certain moments between receiving the information and responding to it when a character must process the information in order to make a decision. The moment between the act of receiving and responding is incontrovertibly tied to IM. While listening and responding are active moments, so too is the processing,

In many real-life instances, though, we do respond without thinking. Our IM is not necessary when a friend yells, "Where are you?" We will shout, "Here." Change the person yelling, "Where are you?" to an enemy and the response becomes complicated. We employ IM. IM is the processing of the received information before the response. It is active, and it is one part of our interactions in real life.

Onstage, at times we need IM, and at times it is a hindrance. Just as in life.

The best way to share that work is by finding pathways to stay active both on stage or screen while also remaining linked to the IM. Just as in real life, you can multitask and listen to your partner while also having a strong interior point of view. Although you are concentrating on ways to release yourself from your head, it might be wise at this point to examine how you interact in real life. Examine the way your personal IM works when talking to another. While your coworker recounts last night's activities, examine your thoughts. While you remain active in the conversation, are you thinking about your lunch plans, the thing he has caught in his teeth, or that phone call you have to return? While you converse, you still retain a connection to your IM.

Granted, multitasking is difficult and sometimes reduces your attention to the separate tasks, but in your quest to replicate honest human behavior as an actor, you must act as you do in life. Divided. And while this chapter is devoted to ensuring you are out of your head, the analysis and refinement of this multitasking work can be done solo by simply observing your transactions with each human being you come in contact with.

In this observation, you will note that there are moments when IM disappears and you remain fully engaged in the conversation. In the heated moments of a great debate with another, you respond solely on impulse. Sporadically spurred on by her arguments, we respond immediately minus the IM. Almost like our "peak moments" on stage or screen. But then, in the midst of the debate, she says something that doesn't make sense, hits below the belt or changes your point of view, and the IM returns. Your most trusted friend—the IM—is never far from any interaction.

Debate Exercise

Choose a topic that both you and your partner feel passionately about. Find something that you feel knowledgeable about and can talk about "without thinking." The subject can be innocuous or politically charged. The topic is not the important part; the ability to talk fervently is what matters. With the issue decided, choose the side on which you fall. Even if you both share the same point of view on the topic, choose a side to advocate for in order to debate. Begin to debate the topic. The hope here is to avoid moments of reflection but rather allow yourself to let spill your ideas, concerns, and solutions related to the subject. The objective is clear—to prove your point. The tactic is obvious—by debating. The obstacle is also evident—his opposition

to my point of view. So no need to worry about that, simply debate. Let the debate take shape as it will—polite opening remarks, heated exchanges, and changing shifts of subject. Once the debate ends, examine your process throughout. (This is what we want at all times—first, do the work and later, process. Within exercises or performance, avoid IM that examines the process.) You may note that at times when the debate seemed to plateau, you may have checked in with your IM to find a different entry into a new detail of the issue. When your fellow debater got off track, you may have visited your IM about when to find the appropriate time to steer him back to the subject at hand. When you felt yourself going on too long, your IM may have told you to edit. No matter what the moments of IM that returned, more important are the moments when you were engaged in the free-flowing exchange of ideas. Those moments when IM is there only as backup rather than primary driver of thought.

As actor, you must aim for those moments of pure interchange while allowing the times when IM resurfaces to act as check-in points rather than as deterrents from the debate/conflict at hand. As director, remind your actor that "getting out of your head" can now imply not disavowing IM but rather using it as the springboard it is for deeper acting through action. As educator, it is important to guide the actor to remain active while also using their IM as friend when necessary and not the judgmental enemy described in an earlier chapter.

Physical Exercise

The actor must physicalize his thoughts abstractly instead of thinking them internally. Have two audience members read the scene while the actors listen to the dialogue and connect their IM to physical movement. At moments when the actors may want to use IM (most likely at transitional or reactive moments), they will transform their internal thoughts into external movement. When an actor heads to his IM, she will instead outwardly and through conceptual movement, physically inhabit her inner state. This exercise demands that the actors be fearless, as they must work outside of their normal comfort zone.

For example, a character may be placed in a situation that requires an immediate response. As the character wrestles with the decision about what to do, he is literally wrestling with himself. The agitated inner state of the character is physically manifested in the writhing actor on the ground.

Like the earlier obstacle exercise where various obstacles are "thrown" at the actor, it is important to assist the actor in finding

ways to both embrace and distance herself from IM when necessary. It is difficult to achieve this harmony. An actor may find herself embracing IM when the scene lacks logic or contains low stakes that disregard the given circumstances. An actor may find it necessary to distance herself from IM when the scene becomes more about her thoughts than about her partner's reaction. This delicate balance of use and avoidance can only come through rehearsal, intuition, and vulnerability.

Vulnerability is one of the key factors to good acting. There are two types of vulnerability and both may be connected to the IM. The first type of vulnerability is personal. Your job as actor, director, or educator is to not let your personal life's issues negatively impact your work.

You may remain impervious to any obstacles as you walk down the street in real life, but as you take off your coat to start your work in the rehearsal room or on set, you must metaphorically remove your emotional armor as well. Personal vulnerability is what you bring to the process to make you the emotional vessel for the needs of the script. Your personal vulnerabilities sometimes impinge upon this job by creating roadblocks based on fear, insecurities, and past experiences. You may avoid conflict in your personal life and therefore in your characters. This is entirely antithetical to the profession you have devoted yourself to. You have a responsibly to offer the audience catharsis, to act out their problems truthfully and wholly emotionally. You must offer them a truthful human experience that allows them to examine their own lives. If you allow your personal issues to distract from that truthful human expression, you have let the audience down.

More often than not, the IM is a conduit to this sort of personal invulnerability. It may interfere with such thoughts as "They're better actors than me," "I can't do this part," or "Don't get so close to me." The IM can also release you from such thoughts. A calming and relaxing IM can be as powerful as a deep cleansing breath to remind you that your focus is on the other and not on yourself. The IM can keep you safe to dare, reminding you "Just do your own work," "This is what rehearsal is for," and "It's just pretend."

The other sort of invulnerability is the actor type. In this instance, the actor may avoid the deeply personal and less powerful thoughts associated with the obstacle-filled IM and either strut about, impervious to the other, or even use the IM to shield himself from any exposed thinking. Robert Cohen's *Acting One* has an excellent exercise in

which actors repeat to their partners "I can be hurt by you" and other variants, until that vulnerable state is achieved. Adapting that mindset internally may also be achieved through an IM that allows the actor to be susceptible to his partner.

Not every character has the same issues or backstory that you have, and your impervious personal demeanor must alter when in rehearsal and performance. So, while you may have trust issues offstage, when performing your personal self must allow the other to affect you. When acting, you must trust. Being a vulnerable actor implies that, when at work, you personally open enough to do your job and also equally open when it comes to sharing a scene. No matter what your issue offstage, vulnerable actors, both personally and professionally, are demanded onstage.

As actor, vulnerability implies an open, willing, and available emotional state ready to explore any emotional territory required by the script. As director, it is important to set up an atmosphere within the process to allow an actor to risk. As educator, helping an actor decipher a way to consistent vulnerability is a goal. The IM can assist.

The focus on another is the foundation of your personal and theatrical interactions. While some may gripe that IM reduces such focus, the IM is a necessary and inevitable contributor to human communication. It acts as the referee for nearly every interaction, whether id-, ego-, or superego-based, with a fellow human being. Massaging and exercising the ways in which IM infects your stage life can offer freedom rather than entrapment from your overactive brain.

Focus on the Other Exercise

This exercise is the best way to force the actor to react impulsively to the scene partner. Actors must make all IM choices related to their scene partner. No predetermined exchanges should be allowed. All choices are based solely on the others' response. If they frown, turn away or begin to shout, the actor must respond by assuaging, confronting, or mollifying the other. By focusing their choices on the reaction of the other, the actor makes purely impulse-related choices. This kind of reactionary IM ensures listening and responding.

This may seem, on the surface, to be an elementary acting concept and surrender the contribution of the IM principles. On the contrary, for the actor who remains head-centered, the freedom gained from the lack of self-reflection can offer a counter-balance to the heady IM. For others, it may offer a truer revelation of how naked one feels without the IM to offer comfort.

Humans and their replicators (actors) must find a harmonious balance between intention and interference. The IM and the action live in real-life harmony, so too must they when performing realism. Rather than deny IM, you must embrace and gauge its use in your imaginary circumstances.

Single Word Exercise

This is an exercise in simplifying the IM process. Have an observer assigned to each actor in the scene. The individual observer will whisper one word that will serve as the simplified IM as the actors perform the scene. This word should be dynamic, active, and full of emotion. A word like "destroy" whispered into the ear of the actor will spur him on to emotionally charged choices. When the word begins to lose its power simply have the observer change to an equally strong word like "crush." If the one-word prompt inspires choices that are too similar have the observer whisper an antithetical IM like "protect." By getting down to basics, the actors usually make bolder choices. Again, this exercise frees the actor and can overcome the sometimes-plodding pace of an actor concentrating too heavily on IM.

As mentioned earlier, it is rare that your IM consists of fully formed, logically and grammatically correct sentences. Just as there are various types of learners, there are various types of actors. Therefore, some may be visual actors. They are the type that respond most easily and instinctively to visual stimulus. Their process onstage may be a kaleidoscope of various images that cause visceral reactions to spur them on to new thoughts/images as the character.

As with any method aimed at the same result, not all will get there similarly. So, while the heretofore-verbose process of IM may not work, remove the need for words and replace with pictures. Score a script with various images if that is how you best respond. Have an image offstage or camera left that will spur you to deeper acting. As always, whatever works for you.

Image Exercise

Collect evocative imagery that represents the emotional state of the scene or the obstacles the actors face. These images should cause an immediate and emotional reaction. For Blanche, collect an image of an old woman heavily painted with makeup, a picture of a graveyard, or a swirling tornado wreaking havoc. For Stella, choose a sonogram of a tiny baby, a painting of a person being torn in half, or an ape in the jungle. For both characters, collect a picture of a dilapidated

plantation, two little girls running in a field, or the gathering clouds of a lightning storm. Whatever is chosen, there should be a large supply of imagery to evoke an emotional reaction in the actors. These images now replace the actors' IM.

As the actors perform the scene, observers should hold up these images at key moments. Rather than letting the actors' choices guide the scene, these evocative images set the tone. These pictures are their IM. Despite any previous choices and even defying logic of the scene, guide the actors to allow the imagery to be their controller to the stakes and objectives within. These images should guide the actors to new and exciting choices, unfettered by head-centered IM.

This new way of "thinking" can release any actor from being inside their head and can allow him a new access to IM. Some actors will be relieved from not having to guide the scene and will revel in the new freedom they find in having the images guide them. No matter what the result, the examination of the process will reveal a new possible tool for the actor's process.

Music Exercise

Similar to the imagery exercise, create a playlist of music (hopefully sans lyrics) that reveals the inner workings of the scene. This music should be of various styles and tempos. It should instantly conjure a feeling, not necessarily out of nostalgia or identification but rather through mood or atmosphere. Using the various songs, have the actors allow their choices to be guided by the music. The music is their IM.

As the actors perform the scene, the music should offer the way in which the scene should be played. Change the music whenever the actors seem to have settled into their "underscored" scene. Most certainly the music will affect the mood, but it will also affect the tempo of line delivery, forcing them to think more slowly or quickly depending on the internal rhythm of the scene/song. The music should be played at a volume that overtakes the dialogue, so delivery of lines or "acting" becomes less important than how the music-driven IM shapes the interactions in the scene. Despite previous choices or logic, the actors now think like the composer, they will have their thoughts driven by another's work.

Like the image exercise, the music becomes the IM that will reveal transitions, objective, and obstacle. By introducing the external factor of music or imagery as the internal mechanism for the character's thoughts, you have expanded the actor's tools. Rather than offering

simply mood to the scene, you as educator must guide them to con-
nect thought (albeit from an alternative source) and action.

Some learners or actors may be tactile. Similar outward-based exer-
cises related to props (like an open liquor bottle or a soiled handker-
chief onstage during the Blanche and Stella scene) may offer similar
dividends. No matter what the medium, the ideal result is to connect
an actor with externally based IM.

In cartoons, a character usually has a thought bubble over his
head when revealing his innermost thoughts. This accepted device
allows us his private "good grief" moment shared solely between
character and audience. Similarly, the IM can create a bond on stage
or screen. The audience's inference of the actor's thought process
creates an unspoken interpretation of the actor's choices. The audi-
ence's response is never incorrect and can offer a way to hone a more
streamlined process for the actor.

Audience Exercise

Actors will perform a short scene and immediately receive audience
feedback. The audience will offer their opinions about what it seemed
that the actors were thinking. Whether correct or not, the actors will
immediately perform the scene again making the adjustments to accept
the audience's point of view. This process will continue until audience
and actors are in total agreement about what is being thought onstage.
Keep the interactions short within this exercise. Do not allow actors to
explain their choices, rather let the audience guide them to the ultimate
IM interpretation.

By allowing the audience to guide their choices, the actors remain
secondary in the thought process. This can continue as the actors
hone their work. The audience may even wish to offer options of what
they could or should be thinking. Actors will model those choices for
them.

The desired result is that having others guide the actors' work can
eliminate the head-centered process they may have been relying on.
Freed from making choices and simply fulfilling the ideas of another
can offer independence from a reliance solely on IM.

Universal Scene

For several years now, I have been working on a way to approach a
scene that will make actors less guarded about their choices and more

open to the response of another by having a group of actors perform the same scene. The result is that IM will be used in the scene instantaneously as a place to check in occasionally rather than a place to hide. This universal scene should have two characters and should be long enough to contain several major units. It should be open to various interpretations so that an actor may enter it from various vantage points. Certainly all scenes fall within this last criteria, but it is best to offer a scene where characters may be driven from opposite directions like selflessly or selfishly. One scene I have used in the past is the Krogstad and Mrs. Linde scene from act 3 of *A Doll's House* referenced extensively in the scoring chapter. This scene offers various possibilities regarding the character's motivation and IM. Is Mrs. Linde manipulating the entire situation? Is Krogstad truly won over by the end? There are very few truths in the scene—they are, rather, inferences that we the readers may interpret as truth.

Using a similar scene, have the actors memorize it independently of each other. Do not allow them to share their choices with each other except in the classroom under the coach's tutelage. This will ensure that there are no preconceived interchanges or expected reactions from the other. It eliminates thoughts like "If you do this, I'll do this." It forces an actor to be vulnerable to whatever is "thrown" his way.

Ask the actors to come in on the first day with the first several units memorized. Decide on the ground plan for the set and discuss the moment before as a group. Do not veer into interpretation, simply note the facts of the scene like Krogstad received a note or Mrs. Linde is expecting the return of the Helmers from the party upstairs. Have students wait offstage, poised and ready to enter the scene at a moment's notice. Their directives are simply that they are to make strong and distinct choices and that whoever enters the scene sets the new tone for the exchange.

As the first two actors begin the scene, you will note their awkwardness of never having rehearsed together. Lines may be forgotten and moments will be blurred based on this new idea of actually speaking without planned response. No worries, they are simply getting used to the concept. As they settle into a rhythm and logical exchange, change one of the actors for another and see where his new choices take the scene. How does the current actor give over to the choices of the new actor? Does she fight to remain in her interpretation or does she allow the other to steer the scene's emotional territory? Or does she simply allow herself to be vulnerable enough

to react and hence justify a new direction for her character based on this new stimulus?

This new way of approaching a scene where an actor may not rely on planned blocking, consistent choices, or established exchanges forces the actor to be vulnerable and open at every moment. The IM then simply becomes a place to offer actors security and to guide them back in the scene when they are fearful or lost, or it may offer the momentary imagery needed to get to the emotions needed in the ever-shifting scene. Whatever its use, the head-centered IM is diminished to its rightful place within active processing.

Putting the full scene on its feet will take several class sessions. Actors will become acclimatized to this new way of acting and will begin settling in to a few interpretations for their characters. Force them to narrow it down to two widely varying ways to approach their character so that they can begin to enter the scene with a new energy each time they are tagged in. For most of the times while running the scene, the educator will direct the new actor in. This should be a smooth process and should not in any way stop the scene. The scene should continue and lines should overlap as the old actor exits and the new actor enters. The new actor enters the scene in a new location physically and with a new energy so that the remaining current actor can adjust to this new partner. Tag in new actors whenever a line is dropped, a connection is lost, you see resistance, or when the wrong sort of IM enters the scene.

You will note for a bit that at this moment of changing partners there will be a momentary hiccup where the actors do a brief internal "dance" where they are guardedly figuring out where the scene will be going. This is the negative, enemy IM resurfacing. Urge them to lose this unwanted IM and guide them to open and vulnerable acting where they can trust their partner, feel secure in their knowledge of the lines and realize that given circumstances will never allow them to fail.

When you finally have the full scene up on its feet, your actors have settled into two interpretations that are vastly different, and the momentary hiccups have disappeared when each new actor enters the scene, you may offer them longer moments onstage with their part-ners before switching them out. Do the music and images exercise within these universal scenes. Anything to allow them to trust, be vulnerable, and work with the correct character-based IM. As the work on the scene progresses, let the actors enter the scene whenever they wish. By the end, they may simply enter every few lines, forcing the remaining actor to be open to anything coming their way.

When this sort of scene study works perfectly, the result is that of unbridled interpersonal connections that allow the partners to communicate wholly and consistently with various partners in various ways. Residually, it builds ensemble, but primarily, it empowers the actor to trust his or herself no matter what happens onstage. It also makes preplanned choices less precious and more fluid. And in our quest to create a fleet of open and vulnerable actors, it places the IM in the correct subordinate spot in the human interchange contained onstage.

One Actor / Many Choices Exercise

In this exercise using the universal scene, have one actor stand in front of all of the other actors playing the other role in the scene. So, you may have one Krogstad and ten Mrs. Lindes. Go through the scene by having each Mrs. Linde say one line of the scene directed to the one Krogstad. Krogstad must react to the Mrs. Linde saying the line to him. Then the next Mrs. Linde says the next line, taking the scene in a new direction to which Krogstad must react. The purpose is to create an actor who must react fully and commit to the choices of the other using IM as back up rather than as a safety net.

A variation of this exercise may be that the group of actors playing Mrs. Linde may jump to any line in the scene. The sole Krogstad must not only jump to that spot in the script but also to the emotional state in relation to the choice the Mrs. Lindes have determined. While difficult, this exercise shatters any choice for an actor to presuppose. While IM may resurface as a guide to the script, the tempo and difficulty of the exercise should force the actors to less head-centered work and more emotionally invested reaction.

The concept of the universal scene aims to balance the use of IM to our realistic usage. We use it to varying degrees when needed. So, in the universal scene, when I, as Krogstad, approach the Helmer's front door, my IM is wild and abundant before entering. When I first see Kristine, my IM is less so as I interact verbally with her. During the scene, I use it infrequently but as a check-in point to determine if she is being honest, the flash of the letter she left me, or an image of what our imagined wedding might be like. Just as in our real life, our IM screams at us when we are about to meet an old flame, reminds us to tread lightly based on past experiences, and flashes forward to what sex might be like. We can see that IM has its purpose and necessity in life and on stage or screen. It is used in a variety of ways, and we must understand and appreciate its part in our daily life and our actor process.

From the father of modern psychological acting, Constantin Stanislavski on, major theorists have referenced (or, in some cases, avoided) IM in their work. IM may impact the actor either positively or negatively depending on the method of delivery or the actor's own way of learning. Stanislavski's affective memory aims to connect IM to truthful acting by recalling past personal events. Lee Strasberg's controversial emotional recall enhances this idea, while detractors of this theory note that the actor's personal IM may eclipse the character's thoughts. Michael Chekhov's psychological gesture and Uta Hagen's inner object seem born from the IM of the character. The given circumstances of Stella Adler are constantly at the fore through IM. Although Sanford Meisner's approach seems to avoid IM as deterrence to immediate interaction, this chapter is comprised of varying IM possibilities that may live within the idea of spontaneity.

While all of these remarkable theories are useful, all actors are different. The goal as educator, director, or actor is always to find a way to achieve the most honest, deep, and heartfelt performance. Different collaborators, different scripts, and different variables demand wide-ranging approaches, of which IM is one. IM is an augmentation to your standard approach.

Merging the head-centered IM and instantaneous interaction, just as you do in life, is the goal of this book. There are times when the character's IM is necessary and appropriate. It is then that it must be summoned for the actor. There are also times when it is unnecessarily cumbersome. It is then that it must be calmed. Knowing when to use it appropriately is a skill that must be exercised.

Similarly, the actor's personal IM must also be exercised in order to know when to use and when to discard. At times it may be summoned to recall a note from the stage manager or quieted to avoid thoughts of the audience within the performance. In any case, it must be working to assist rather than interrupt honest interaction.

IM out of your head can be defined as a thought process aimed toward only the other. Focusing on her reaction. Listening actively. Ready to process when necessary. Ready to respond immediately.

11

IM in Script Scoring

An actor is provided a script. The analysis, breakdown, and notations of the scene create the score. This score is a foundation with which the actor enters the scene. Once in the scene, the scoring waits in the background as the actor interplays with his partner, who also has her own score. The exchange contained within will shape the scene. The scoring may be needed, altered, or discarded depending on the scene created by the alchemy of actors, directors, and educators in action.

Scoring is a necessary and fundamental element of preparation. It forces the actor to fuse instinct and intellect into written analysis. It showcases the actor's thought process and highlights his investigative skills related to the play's structure and character analysis; it showcases his imagination in choices.

Usual scoring includes a breakdown of dramatic units or thoughts, followed by identification of tactics, objectives, and obstacles. I include IM in scoring to help the actor understand the thought process of the character. IM scoring (just like traditional scoring) alters whenever you encounter a live human being on stage or screen, but the foundational work you have done through analysis awaits to assist in any problem.

Just like traditional scoring, IM scoring is not meant to trap the actor into a literal memorization of their homework. It is merely meant as a springboard for human interaction. Think of it as a game plan that must alter whenever the opposing team enters into your field. The scoring examples contained in this chapter are the actor's collected foundational work of psychological, historical, and script analysis. It is meant to propel them to deeper thoughts within the interplay between actors.

While the actor may have written numerous ideas related to her IM in the scoring, it may never actually be used. This is similar to traditional scoring. What this psychological scoring does is to fuse logic and the actual text in the script to create the thought process of the character. It is foundational. It creates the logical connections from line to line so that when there is the inevitable interplay where IM is not necessary, the logic has already been established. The scoring allows you to play.

I asked a few actors to score the Mrs. Linde and Krogstad act 3 scene from *A Doll's House*. I gave them no instructions on how best to score the scene, as I wanted their various approaches to offer multiple scoring options. I also asked each of them for a brief explanation as to why they created their personal IM scoring approach.

As actor, the completed score will allow you to examine your choices and fully flesh out the character's thought process. For director, sharing in this sort of work allows you to see if the actor is fully including the obstacles and given circumstances and may also reveal where the problems lie in rehearsal. For educators, this intimate thought process allows entrance into the level of your student's analysis work.

Krogstad Scoring

Actor, Kirill: My main focus while doing this score was keeping it playable. After experimenting the last few weeks with IM during the scene, I started to lock in to a method that helped me instead of distracted me. I found that my inner monologue mostly thought in brief thoughts. My brain may have the full thought somewhere on the inside, but my IM might only "say" a few words for that entire thought. That is something that is reflected in the way I wrote my IM in my score. I also realized that a lot of my inner monologue is visual. I often see an image, sometimes from my own life and sometimes random, that then sparks my whole thought process. I also wanted that to be reflected in my score. Outside of acting, this process is a repetitive process with the same image reappearing over and over, but this did not happen while rehearsing this scene so in my score, I only used each image once in the score.

(Author's note: Kirill has provided evocative imagery throughout his scoring. Some reflect the time period and some the mood.)
Why does...? I haven't seen her since...? How old is she now? What is she doing here? What does? I don't want to talk to her. No, I can't. She still looks so... Why? Fine. I am not going in there.

Krogstad [in the doorway]: I found a note from you at my house. What does it mean?

No. I don't want to. Trap. Ambush. Who else? Talk? Us? Why?

Mrs. *Linde*: I must speak with you.

With me? No. I'm done. I don't need. Wow how could she?

Krogstad: Indeed? And in this house?

No. No No No. I don't buy it.

Mrs. *Linde*: I could not see you at my rooms. They have no separate entrance. Come in; we are quite alone. The servants are asleep and the Helmers are at the ball upstairs.

Really? A dance? She didn't tell...? He doesn't? Yet? At a dance?

Krogstad [coming into the room]: Ah! So, the Helmers are dancing this evening. Really?

Really? She Doesn't know? Then why did she...? What does she want from me?

Mrs. *Linde*: Yes. Why not?

She really doesn't know. Was I wrong?

Krogstad: Quite right. Why not?

Let me test her. I will not let her get over me.

Mrs. *Linde*: And now let us talk a little.

Talk? Talk? Who is she to ask me to talk?

Krogstad: Have we anything to say to each other?

No we don't.

Mrs. *Linde*: A great deal.

We do? I will not let her win this one. Not this time. Not like the last...

Krogstad: I should not have thought so.

I don't want to put myself through...

Mrs. *Linde*: Because you have never really understood me.

Understood? I never...what? I can't believe she just...

Krogstad: What was there to understand? The most natural thing in the world—a heartless woman throws a man over when a better match offers.

I still can't...She did that...to me.

Mrs. *Linde*: Do you really think me so heartless? Do you think I broke with you lightly?

You did. You did. You did.

Krogstad: Did you not?

Yes I know you did.

Mrs. *Linde*: Do you really think so?

Yes I did. How could I not? But...what about?

Krogstad: If not, why did you write me that letter?

Makes no sense? Why would you...?

(Author's note: Kirill has provided an abstract image of a swirling abstract entity that seems to represent his version of Krogstad's inner state for the entire scene.)

You will note that Kirill has used clipped and disjointed phrasing for Krogstad's IM. As a visual learner, he also included photos for inspiration at transitional points within the scene. He also has IM going during all lines of dialogue, and his implied subtext rarely mirrors his IM.

> Actor, Zev: For my IM scoring, I have chosen to write in italic text within the script itself to attempt to score the thoughts as they layer into the scene at the same time that the script is moving. The thoughts are sometimes in full sentences and sometimes just words. They have a bit of rhythm and emphasis through punctuation and capital letters. I found this method to be somewhat successful. What I found the most trouble with was actually finding accurate words. My mind truly thinks in ideas, which are more abstract than strict vocabulary. In honesty, I found using my English vocabulary to be quite limiting. I think a true scoring would involve more images and sounds and physical feelings. For example, I'm not sure how I could score the empty feeling in my chest when I truly contemplate loneliness or the rush of heat when I panic. Also, I found myself limited by the word processing program. I would have loved to be able to literally write the words ON the text at times, change sizes and orientations, or add pictures, and sounds. While this would be possible in a fancy graphics program, I am not a sufficient visual artist to render the images in my head. I'm not sure that I have a great answer to this issue, however, despite its drawbacks, I did find using just words to still have value in illuminating the through-line of my character.

Why did she write me this letter?! Why am I here? Why does it need to be here? Why tonight? It's Christmas for heaven's sake, I should be with my children, but I love her, why tonight? Why here? Does she know about what I've done? Has Helmer found my letter yet? Why did she write this letter? Why is she back? Do I still love her? Will it be difficult to see her?

> *Mrs. Linde* [looks at her watch]: Still not here; and the time's nearly up. If only he hasn't—*There she is. My god she is still just as beautiful. I love her. I'm so close. This must be a trap. She knows. I want her back. Those eyes.*
> [Listens again.] Ah, there he is. [She goes into the hall and opens the outer door. Soft footsteps are heard on the stairs; she whispers.] Come in; there's no one here.

Trap Trap Trap. She's so beautiful. Calm down. This can't be right.
Krogstad [in the doorway]: I found a note from you at my house. What
 does it mean?
Trap trap. Does she still love me? Trap. Helmers. What does she
 want?
Mrs. Linde: I must speak with you.
Krogstad: Indeed? And in this house? *Helmer. Nora. Trap.*
Mrs. Linde: I could not see you at my rooms. They have no separate
 entrance. Come in; we are quite alone. *Trap. What does she want?*
 The servants are asleep and the Helmers are at the ball upstairs.
 Helmers! Dancing? My plans?!
Krogstad [coming into the room]: Ah! So, the Helmers are dancing
 this evening. Really?
Mrs. Linde: Yes. Why not? *Don't give yourself up! Calm down.*
Krogstad: Quite right. Why not? *Does she know? She doesn't know.*
Mrs. Linde: And now let us talk a little. *Why? Pain. Lonely. Her fault.*
 Life wreaked. Her fault.
Krogstad: Have we anything to say to each other? *Pain. Hurt. Her*
 Fault. What else will she do to me?
Mrs. Linde: A great deal.
Krogstad: I should not have thought so. *Pain. Loss. Empty Chest.*
 Alone. Her fault.
Mrs. Linde: Because you have never really understood me. *WHAT?!*
 You! SELFISH!
Krogstad: What was there to understand? The most natural thing
 in the world—a heartless woman *YOU, PAIN.* Jilts a man *ME,*
 ALONE throws a man over when a better match offers. *PETTY*
 WOMAN. HEARTLESS WOMAN. PAIN. LONELY.
Mrs. Linde: Do you really think me so heartless? *YES. YOU ARE.*
 YOU DON'T SEE IT? Do you think I broke with you lightly?
 PAIN. LONELY. HATE. It was easy for you. It was SO HARD
 for me to get over you, and you had NO TROUBLE. HOW DARE
 YOU!
Krogstad: Did you not? *I Know it was easy for you. It TORE ME UP*
 inside. EMPTY. JEALOUS.
Mrs. Linde: Do you really think so? *YES! HEARTLESS. LETTERS.*
 Her eyes. That face. TEARS. LIAR!
Krogstad: If not, why did you write me that letter? *LIAR. LIAR.*
 HEARTLESS.

In Zev's score, you can see the stakes and emotion. This is an
entirely different approach than Kirill's, as he chose to blame and
hold Kristine accountable from his entrance. Zev's lack of trust and
internal pain is obvious. Kirill's scoring contained many questions,

which allowed some possibility of reconciliation from his entrance. It is clear that Zev's Krogstad has no such hope.

Actor, Andrew: I first worried that my IM was too short. In hearing others mention their scoring, I noted that theirs sounded much longer than mine. But I don't think or speak very verbosely. So, of course mine wouldn't be as long as theirs. Mine is more succinct and to the point. I believe, in places, mine could even be shortened. I think that after more and more work, it could be boiled down to simple phrases or even one-word thoughts to convey the message/feeling/thought/emotion. On my hard copy, certain words are underlined, as those were the ones to focus on when the thought process felt too exaggerated or lengthened. Why say 12 words when you can get to the point in two? With all of the other things happening onstage, a lengthy IM becomes problematic for me and draws me out. I start to wonder if I'm just thinking thoughts for the sake of thinking them instead of focusing on my partner. I find it difficult to listen and IM simultaneously. Therefore if I'm IMing, then I'm not really present in the moment. For me, it works better to take in their words, grab my one-word IM propulsion and then respond. (See Table 11.1)

For Andrew, the IM process may not work as well as others. In his scoring, he has kept the actual script and the thoughts separate in the two columns, which could symbolically represent a divide in the thought process. In the score itself, he often repeats variations of the actual text with his IM as opposed to revealing a richer and more intense inner life. And while our IM and actual dialogue often mirror each other, in a scene with such high stakes, past history, and hidden agendas, it seems uncomplicated. As he hints in his introduction, IM may not be the method that works for him.

Mrs. Linde Scoring

Actor, Carolyn: My interpretation of Kristine is that of a woman whose subconscious is wildly divided between desperation to achieve what she needs and the logic of what she is attempting to do. I chose the following format because it reveals several important details about Kristine's thought process, shaping her IM: first, that what she chooses to say out loud is only a fraction of what she is struggling with in her mind; second, that her voiced reactions and comments are completely surrounded and at times overpowered by her IM, and third, that what she does say to Krogstad is a direct product of what is going on inside her head. I chose not to include Krogstad's lines because I did not want

Table 11.1 Andrew Scoring

	Andrew Scoring
Mrs. Linde [looks at her watch]: Still not here; and the time's nearly up. If only he hasn't—[Listens again.] Ah, there he is. [She goes into the hall and opens the outer door. Soft footsteps are heard on the stairs; she whispers.] Come in; there's no one here.	What does this mean, why would she ask to see me, ten years without a single word and now this. I knew she was connected to the family but what does that have to do with us meeting here? She said it was very urgent, its horribly cold out tonight, I shouldn't even be making this walk, I could disregard her as she did to me so long ago. There's the house, forget it I should just go home. No. I will see this thru. I will find out what she wants, and I will find a way to have my job back.
Krogstad [in the doorway]: I found a note from you at my house. What does it mean?	
Mrs. Linde: I must speak with you.	
Krogstad: Indeed? And in this house?	
Mrs. Linde: I could not see you at my rooms. They have no separate entrance. Come in; we are quite alone. The servants are asleep and the Helmers are at the ball upstairs.	She looks different, ten years will do that. Still Kristine though. Why is she whispering? Is this a trap of some sort? Let's get to the point, don't let your guard down Krogstad.
Krogstad [coming into the room]: Ah! So, the Helmers are dancing this evening. Really?	
Mrs. Linde: Yes. Why not?	
Krogstad: Quite right. Why not?	
Mrs. Linde: And now let us talk a little.	Ha! Absolutely necessary?? After oh so long, so much silence, leaving me without even a word, and now it's imperative that we talk. This must be a trap of some sort.
Krogstad: Have we anything to say to each other?	At a dance?! After all of this, Helmer knowing that his wife is a criminal, and they go to a dance?
Mrs. Linde: A great deal.	She obviously doesn't know about all of that, don't let her on.
Krogstad: I should not have thought so.	Now you want to talk! Where was the talk when you walked out on me? I didn't even get to state my case.
Mrs. Linde: Because you have never really understood me.	Really??
Krogstad: What was there to understand? The most natural thing in the world—a heartless woman throws a man over when a better match offers.	Ha! You didn't give me a chance to understand. You didn't give me any explanation at all, you gave me a letter that ripped out my heart.
Mrs. Linde: Do you really think me so heartless? Do you think I broke with you lightly?	Seemed like it.
Krogstad: Did you not?	What else was I left to think?
Mrs. Linde: Do you really think so?	
Krogstad: If not, why did you write me that letter?	

to interrupt the flow of Kristine's subconscious with thoughts from outside her head, but her IM, with its observation and commentary, as well as the fluctuation of emotional intensity, reveals each response from him. The formatting of Kristine's IM also highlights the inconsistency of her emotional state; while she is sometimes calm and logical, she often panics and spins out of control. These emotional highs and lows are manifested in the structure of her thoughts. She is sometimes concise, sometimes verbose, and sometimes incomplete. She often attempts to calm herself and steer herself back on track, but she also has moments when her thoughts spiral out of control, becoming fragmented, disconnected, and irrational. The pace of her IM also parallels the stakes of the scene. When she feels she is in control or has a valid point to make, her IM is often more linear and cohesive, thinking in complete, detailed thoughts, almost a reciprocal conversation with herself. When she senses she might fail or fears she is running out of time, her IM comes much faster, often in brief bursts of thought, allowing her subconscious less time to process and rationalize the new information or stimulus. Through this style of IM, the link between thought and response is revealed, and the influence of IM on both action and dialogue is made clear.

Breathe. In just a few moments, your life will be different. Things can be different. He'll understand. Breathe. Oh. Oh. I can't believe I'm here. Sitting here. Where is he? I thought he would be here by now; that he would see my note and rush right to me. What time is it? I can't look. I don't want to know. Where is he!!?? Still not here; Oh my god. I've been sitting here for hours—it feels like hours— this is humiliating. Not coming? No. No. Breathe. Yes. I can hear them up there. Oh, how much time have I lost? He's got to get here now. We are going to get caught. Oh no! Listen. The Tarantella? Is that it? and the time's nearly up. No. That wasn't the song yet. Not yet. We have just a little more time. Please Nils. Get here. Get here. Please. Oh no. I know what it is. He's still angry. No, no, no, no, no, no. If only he hasn't—let his anger get the best of him; ignore my invitation. He has to be a bigger man than that. I know him. I know he is. He'll come. Oh god, what if he doesn't come? This is my last chance. I can't go back there. I can't. I won't. He'll come. He'll come. He's got to come. Oh. Oh. Oh my god. There. Look. That coat. That same old coat. Didn't his wife ever try to get him a new one? Better. I'll be better. Oh look. Him. Here. Oh, thank you god. Ah, there he is. thank you god. I knew he'd come. I knew it. I knew he would come to me. Come for me. I knew it. Oh, look at him. He looks awful. So angry. So defeated. Did I do that? No. No.

Calm down, Kristine. One thing at a time. Look at him. Sad. Just focus. Why isn't he coming in? Why is he just standing there? Sad. What is he waiting for? Does he expect me to beg? I WON'T! Stop. Calm down. One thing at a time. Come in; there's no one here. *We are safe. I promise. You look so scared. I could hold you. Touch. Hands. Just to see you are real. This isn't a trap. I'm not going to trap you. Why won't he look at me? I invited you here honestly, I swear. Yes! My note. I knew you'd come. Thank you thank you thank you. I knew you'd come. Oh god. Breathe.* I must speak with you. *If only you knew how much I want to talk to you. Look at you. You are broken. I can help. This is important. What should I do? Take his coat. Same old coat. Embrace him. No. Stay where I am. Stop. You look so sad. Please, look at me. Why won't you look at me? There. Oh my god. Those eyes. Sad and distant. Far away eyes. Here. Be here. With me. Yes, I know. Choice. And you know this place well. If only you knew how alone and trapped I am.* I could not see you at my rooms. *I hate it there, living where I don't belong. Please don't look at me. Where I'm not wanted. A home of convenience. Temporary. Like everything else. Why do I always end up living where I don't belong? I'll belong again. But not there. Not where I live now. I don't want you to see that. You can't see me where I live.* They have no separate entrance. *I know this isn't private either, but you are safe. For now. Until the music stops. I need you to see. I need you to hear me. I know. I know everything and I can help.* Come in; we are quite alone. The servants are asleep and the Helmers are at the ball upstairs. *Proof. Proof we are safe. That's why we're here. I need you to see. I need them to see. I am helping. I have a plan. Just come in. Come in. Please. Oh, you don't know I know. I'm sure. You think Nora could never focus on the dance with you in the back of her mind. I see you know where your power lies. But you must listen. I know too. I have power too. We can work together. Will you tell me? Will you trust me enough to share it? But I know, you see? Yes. Upstairs. Can you hear? Yes. Why not? You think she shouldn't be able to. She shouldn't have the strength. Women are stronger than you know. We are. Tell me. Tell me what you are feeling. I know. I can help. I know why you think Nora should be home. Should be here scrambling to figure out what she should be doing to fix her problem. The problem you started. But this is where you are wrong. You don't know. She is. But she is scrambling. Twirl, little girl. We scramble. Oh, if only you knew how much we scramble. No. Focus. Breathe. Make this work. Yes. Yes. Yes. Listen. And now let us talk a little. Please. Listen. Sit.*

I promise. Look at his face. Oh, don't play that game with me. Of course we do. We have years and mistakes and broken memories to talk about. We both do. A great deal. *Learn, confess, understand one another.* Stop it. Don't you dare. Stop trying to hurt me. Because you have never really understood me. *I am not the only one who has broken someone. I could never get you to see. To see how torn I was. How sad and humiliated. How can you say that? How can you look at me, see my face, and say that. You don't believe that.* No! No! Money? Stop it. *You cannot think that I ever wanted to leave you. I loved you.* Do you really think me so heartless? *Money. Yes, fine. The money, but I didn't just brush you off like dust from the pile, Nils. Please. Please understand.* It crushed me. Do you think I broke with you lightly? *All I wanted was you. I wanted to be in love; simple and selfish and protected like so many other women I see.* He's not listening. I'm losing this. Breathe. Focus. You must. *All I wanted. How can I get you to listen?* No. No! Please. *All I wanted.* Stop. Stop trying to hurt me.

Carolyn's effusive scoring is the opposite of Andrew's minimalist approach. In approaching the scene with such depth of thought, one fear is that she could veer too far into the trapped-in-your-head acting we want to avoid by remaining actively focused on the other. Her IM seems clearly directed to Krogstad's reaction, but I imagine she would have to shrink these full thoughts in order to maintain the scene moving forward.

Actor, Sarah: My inner monologue for Kristine is as close to a stream of consciousness as possible while still remaining cohesive and understandable. This format seemed the most streamlined and most like a thought process. No breaks or separation from one thing to the next. One thought always leads to another. There are more complete sentences in this example than in my own thoughts. I tend to begin a thought and not finish it, having already gained the meaning. But for Kristine, I think she thinks more in complete thoughts, only leaving off to begin to speak. She only speaks after carefully digesting the information and deciding what information to divulge. She's reserved and articulate and doesn't waste words. Even when flustered.

I think that if this were to mirror my personal IM, there would be fewer words, more photographs, and possibly melodic excerpts. I'd like to experiment with the addition of written music and sound bites since our work in class after doing the music exercise. I'm beginning to understand my own IM works in sound bites and tempos as opposed to whole thoughts. The defining of my own thought

process will help me differentiate between my own thoughts and my characters.

(Author's note: Sarah has included several images of the environment that may affect her scene.)

Images and Sarah's justification:

Dress: What I imagine Kristine's normal outfit to look like.

Building sketch: What I imagine the building being similar to, I think this would be closer to the building that Helmer works in. But their house would be similar in stability and austere simplicity.

Table: This is what I picture the furniture to resemble. Something simple but elegant.

Family Portrait: This is what I imagine Kristine imagines when she thinks about her family. Something past tense, before her mother was sick.

What is taking so long, if he doesn't show up, I don't know what I'll do.

I knew I shouldn't have assumed he would take me back. I don't know that yet. I don't know anything. Maybe he's just late.

What time is it? Still not here; and the time's nearly up.

Why am I doing this to myself. This is not who I am.

If he doesn't show up it will be because he's scared.

If only he hasn't—*back down before I even get a chance...*

Is that him, is it the Helmers? Ah, There he is.

Thank God, he came.

OK, I just need him to listen for a minute.

I...don't want...to scare him, I just, he should come in before you start talking about all this. Come in; there's no one here.

He looks tired. So do I.

God. So much time has passed. He still looks so handsome.

It's not about that. You know what this is about. Now just come in here so I don't feel ridiculous please, this is difficult enough. I must speak with you.

Why won't he just come in, the maid is going to wake up if he doesn't just come in the room. Does he think I want to have this conversation here in this house. I could not see you at my rooms. They have no separate entrance.

I might be desperate but I'm not stupid. Besides where I'm staying is a disaster and completely beneath my station and yours. You can't see me there.

Please just come in so we can talk. Come in, we are quite alone.

Does he think I'm lying? The servants are asleep and the Helmers are at the ball upstairs.
Ok, now at least I've got him in the room. I can...
What why does he care? Yes. Why not? *He was always a little spacey,*
maybe he thinks that with the letter...
I guess he doesn't know I know about the...that can wait, first I need to. And now let *us talk a little.*
Please don't reject me...So he's mad...at me...
For the past?? For now...maybe he just thinks I ignored him the other day... A great deal.
If he even knew how much power he has right now I can't let him know.
Ok so he is upset, he just has no idea what happened when we parted. I assumed he knew. Because you have never really understood me.
I wish he would let me just tell him what I have to say he's so proud....
He must be...
he can't really think that how could...
Do you really think me so heartless? *It broke my heart to have to...*
Do you think I broke with you lightly? *How could he think that? I guess...*
Maybe I gave him reason. I didn't tell him anything I just assumed he knew....
Sarah has chosen to break up her scoring into thought patterns in order to fully understand Mrs. Linde's thought process. She clusters together sections of thought in order to best help her remember the various trains of thought within. Like others, the IM here is disjointed, but she aims to organize the disorganized thought pattern. Her use of "ok" and "spacey" concerns me as they are not appropriate for the time period and may draw her out of the scene if she actually thought that onstage. Sarah's Mrs. Linde is far less emotional than Carolyn's and seems entirely pragmatic and empathetic to Krogstad's reticence.

Actor, *Jacqueline*: I formatted my inner monologue in a way that read clearest to me. I tried to type out my stream of consciousness as realistically around the actual dialogue as possible. I took out all of the stage directions to avoid confusion in my reading of it. I believe that if I were to skim this IM script at a later date to prepare for scene work, it would give me a quick, clear way of delving right into the character's way of thinking and color of the overall scene. I tried to offer options of things to play within each line. So

that, depending on what my partner offered, I could use any of the choices I came up with.

I have never been so nervous in my life.
I might faint from the nerves.
My hands keep shaking.
He's going to show up.
STAY CALM!
Breathe!
You can do this!
I can't wait to see him.
I wonder how he's going to react.
I must get him to be on my side!
My nerves are KILLING me.
He's going to show up.
He will show up!
What time is it?
Is he going to come??
Stay calm!
HE WILL COME!
Where is he??

Mrs. Linde: Still not here; and the time's nearly up. If only he hasn't— Ah, there he is.

My heart is melting.
I have to stay confident.
Stay CONFIDENT!
I can't believe he came.
I knew he would come!
He looks upset.
I missed him!
I need him.
My heart is pounding out of my chest!!

Come in; there's no one here.

He won't look at me.
I need him.
He has to believe me.
Does he hate me? He looks older.
He still melts my heart.
He must believe me!
I need him to forgive me.
He hates me.
Why is he looking at my like that?
Stay strong.

Krogstad: I found a note from you at my house. What does it mean?

> *Don't be scared.*
> *Let's forget the past!*
> *Trust me! Trust me!*
> *He doesn't trust me.*
> *I wasn't expecting to miss him like this.*
> *He hates me.*
> *I wish he would smile.*
> *Let down your guard.*
> *You remember me!*

Mrs. Linde: I must speak with you.

> *Listen to me.*
> *Stay and be open-minded!*
> *My hands are shaking.*
> *Look me in the eyes!*
> *Remember me!*
> *I want to hug him.*
> *Stay strong.*

Krogstad: Indeed? And in this house?

> *Don't look at me like that.*
> *Don't hurt me.*
> *Don't leave!*
> *Don't be silly!*

Mrs. Linde: I could not see you at my rooms. They have no separate entrance.

> *He won't come near me.*
> *His eyes are sad.*
> *Just trust me.*

Come in; we are quite alone. The servants are asleep and the Helmers are at the ball upstairs.

> *Come to me.*

Krogstad: Ah! So, the Helmers are dancing this evening. Really?

> *I have real work to do on you.*

Mrs. Linde: Yes. Why not?

> *Please believe me.*
> *Let your guard down.*

Krogstad: Quite right. Why not?

Keep it together.
Hold on to the power.

Mrs. Linde: And now let us talk a little.

Love me.
Come to me.
Trust me.
Don't look weak!
Stay confident!
You know yourself!

Krogstad: Have we anything to say to each other?

Let down your wall!
Listen to me!
Stop playing dumb!

Mrs. Linde: A great deal.

I need to stay calm and make him want me the way he used to.

Krogstad: I should not have thought so.

I remember you.
You stubborn man.
You listen to me!

Mrs. Linde: Because you have never really understood me.

I'm not going to let you make me feel horrible.
You must understand me.

Krogstad: What was there to understand? The most natural thing in
the world—*Please don't hurt me*
a heartless woman throws a man over when a better match offers.

I cannot believe you could say that me.
How dare you!

Mrs. Linde: Do you really think me so heartless? Do you think I broke
with you lightly?

I can't.
I know myself!

Krogstad: Did you not?

You sound like a fool.
Ignorant fool!

Mrs. Linde: Do you really think so?

You don't mean it.
Stop doing this.
Is this really how it's going to be??

Krogstad: If not, why did you write me that letter?

Damnit!
You asked me.

Jacqueline's use of possibilities below each line offers a less linear approach and allows her to summon the IM necessary. She has scored her script in a way where she has offered two types of options depending on her partner's choices. She has IM related to herself and IM related to Krogstad and may use any or all of the options depending on how the scene goes when on its feet.

By offering options to scoring IM, you may find the best way to analyze and prepare your script for rehearsal. You may discover that some combination of the alternatives presented may formulate your personal process for scoring. You may also invent the best way to present your personal thought process in combination with the thought process of the character.

In and Out Exercise #2

I use this exercise to ensure that actors can connect with each other through both text and intuition. This exercise is best used as a warm-up after the scoring has been completed and the scene is on its feet. In this exercise, have the actors face each other and perform the text of the scene. Ask them to maintain eye contact throughout. At an appropriate time, ask them to stop saying the text but continue the scene silently. Make sure that in the absence of words, they do not immediately begin indicating the emotion though exaggerated eye rolling and emphatic head nodding. Allow them to connect through real and honest eye contact. At another moment, ask them to return to the text. The hope is that they will be able to pick up the scene at the correct place together. Go in and out of silence and dialogue for the duration of the scene. This exercise is a great way to connect partners, place the focus on the other, and infuse the silence with IM.

This exercise offers compelling ways to connect partners in silence. The silence and intimacy of the exercise breaks down walls of the actors and allows them to get closer to the communion necessary for great acting. It combines the analysis of the scoring, the active IM, and the objective, while placing the text as a secondary component. The focus is merely on the other.

Each new project offers unique challenges to the actor. Similarly, the scoring process must also adapt to each new assignment. As actors, your process must constantly evolve; so too your scoring. The need for scoring for actors, directors, and educators is clear. Through the addition of IM to traditional scoring, an actor may reach new heights and plumb new depths.

Zev, Actor

"This semester's explorations of IM illuminated a large number of gaps in my work as an actor. I found parts of the technique to be particularly useful in the context of scene work exercises, and other parts useful in the actual scene itself. As an exercise in the classroom, the work with IM is most useful in making it obvious when the actor has not filled in the specific subtext or true motivations of any given moment. Simply running the scene and speaking the IM frantically out loud makes that clear. There were times running my scene in which I found it very easy to let my IM just flow out, and other times in which I had little to say, or I could tell that I was saying things just to be saying something. It's a dead giveaway that I had not truly studied and understood that moment.

There were two other IM exercises that I found VERY helpful in my work. The first was an exercise in which someone else stood behind me and spent the entire scene whispering my inner monologue in my ear while I spoke the lines and lived in the scene. This was an extremely freeing exercise, as I did not need to control my IM. The choices in the scene were entirely up to my acting partner and the person whispering in my ear. It was also fascinating because the person whispering brought up elements of the character and the scene that I had not thought of and that were absolutely relevant. It was almost like getting a glance at another actor's paradigm of the character and allowing it to further inform my own. This was freeing as I did not need to make any choices or control the IM, was helpful in my own character study as it helped to offer more options for informing the movements that were not as strong for me.

The second IM exercise that resonated with me was the run-through of the scene in which we let either picture images or music tracks represent our IM. In both exercises the image change or music track would be the whole IM for as long as the image or song was present.

The choice was completely external and no longer my responsibility. I found these exercises, particularly the music exercise, to be the most freeing and informative. What was so freeing about the experience was that all of my focus was external. My sensors were outward and actively looking for stimuli. This active outward focus is something that I have actually been able to take into my acting as a whole. I had never truly understood what that felt like until this exercise. In the music exercise, specifically, I was shocked to see how long I could easily maintain one idea actively. The song choice informed the choice of that part of the scene, but the individual ups and downs in the music itself kept every moment live and active no matter how long the song (or unit) lasted. It revealed to me how many stimuli are outside of me during a scene that can be enough to FULLY inform a scene truthfully, and keep it active no matter how long a moment, unit, or scene is. All I need to do is be relaxed, ready, and outwardly focused enough to receive them.

In the actual scene performance, the most useful element of IM work is its ability to clarify and motivate the larger transitions between units and thoughts. I've found that when I have a major transition between units that I cannot intuitively make, I can simply score the IM that gets me from one place to the other. Usually in moments like these, there are actually three or four smaller transitions that get me from the last moment to this next line in the script. What this does is literally script the lines of my IM that get me to the next line in the script. In my scoring, I will actually write these lines into the margin. I then have a dependable way to honestly get to a place of speaking my next line for a better reason than simply because it is the next line in the script.

The one major shortcoming for IM work is the difficulty of scoring it. While one can simply write out a script of the inner monologue a character might have during a scene, writing the scoring misses out on many major strengths of IM exploration. First, it can be extremely limiting, in that it literally scripts out every thought that you 'should' have as that character, leaving no room for those thoughts to be motivated and in any way controlled by what your scene partner is doing live, in front of you, in that particular performance. Secondly, it misses the real strengths of the IM work that is done with images and music. These more abstract and freeing exercises have no good way of being written down. How can you put into words a concept that you were only able to understand and integrate once words were removed from the experience? Furthermore, with the addition of

the exercise in which another person decides your IM for you in the midst of the scene, there is no way to score that which will be decided or informed by outside elements in the future, live moments of performance. IM-based activities have the power to completely remove the actor from their head, and truly experience what it means to be actively present and listening."

12

IM in Drama

Around the turn of the twentieth century, the expansion of psychological theory (most importantly Freud and Jung) led to more psychologically complex dramas appearing onstage. While the public learned more about their unconscious desires, playwrights infused their work with unique theatrical devices that showcased these new concepts. While these plays may appear a bit fundamental when read today, their importance of understanding IM both for audience and actor cannot be undervalued.

One could argue that classical theatre's use of aside and soliloquy are the first true examples of IM onstage. I will cover those in a later chapter and instead concentrate here on modern American drama. I have chosen titles in both the film and drama chapters that are either seminal or popular examples and are usually readily available.

The first play is Alice Gerstenberg's *Overtones*. First produced in 1915, the one-act play examines two women (Harriet and Margaret) who are envious of each other. What makes the play unique is the use of two IM-based figures (Hetty and Maggie) who interact and comment on their live counterparts. Gerstenberg calls the incarnate characters the "cultured self," while their personified IMs are called the "primitive self." These primitives are clearly id-based and confess what lies under the strictures placed upon them by society. Gerstenberg's stage directions and first few lines of dialogue set up the convention:

[Harriet's fashionable living-room. The door at the back leads to the hall. In the centre is a tea table with a chair on either side. At the back, a cabinet. Harriet's gown is a light, "jealous" green. Her counterpart, Hetty, wears a gown of the same design but in a darker shade. Margaret wears a gown of lavender chiffon while her counterpart, Maggie, wears a gown of the same design in purple, a purple scarf

veiling her face. Chiffon is used to give a sheer effect, suggesting a possibility of primitive and cultured selves merging into one woman. The primitive and cultured selves never come into actual physical contact but try to sustain the impression of mental conflict. Harriet never sees Hetty, never talks to her but rather thinks aloud looking into space. Hetty, however, looks at Harriet, talks intently and shadows her continually. The same is true of Margaret and Maggie. The voices of the cultured women are affected and lingering, the voices of the primitive impulsive and more or less staccato. When the curtain rises Harriet is seated right of tea table, busying herself with the tea things.]

Hetty: Harriet. [There is no answer.] Harriet, my other self. [There is no answer.]My trained self.
Harriet [listens intently.]: Yes?
[From behind Harriet's chair Hetty rises slowly.]
Hetty: I want to talk to you.
Harriet: Well?
Hetty [looking at Harriet admiringly]: Oh, Harriet, you are beautiful to-day.
Harriet: Am I presentable, Hetty?
Hetty: Suits me.
Harriet: I've tried to make the best of the good points.
Hetty: My passions are deeper than yours. I can't keep on the mask as you do. I'm crude and real, you are my appearance in the world.
Harriet: I am what you wish the world to believe you are.
Hetty: You are the part of me that has been trained.
Harriet: I am your educated self.
Hetty: I am the rushing river; you are the ice over the current.
Harriet: I am your subtle overtones.
Hetty: But together we are one woman, the wife of Charles Goodrich.
Harriet: There I disagree with you, Hetty, I alone am his wife.
Hetty [indignantly]: Harriet, how can you say such a thing!
Harriet: Certainly. I am the one who flatters him. I have to be the one who talks to him. If I gave you a chance you would tell him at once that you dislike him.
Hetty [moving away]: I don't love him, that's certain.
Harriet: You leave all the fibbing to me. He doesn't suspect that my calm, suave manner hides your hatred. Considering the amount of scheming it causes me it can safely be said that he is my husband.

Overtones is a melding of social commentary, psychological musings, feminism, and IM. While it may appear obvious, and at times

primitive in its use of the theatrical device of the talking conscience, its importance of theatricalizing this novel concept for both audiences and actors cannot be underrated.

Following *Overtones*, in 1928 was the Pulitzer Prize–winning drama *Strange Interlude* by Eugene O'Neill. Its controversial discussion of aborting a baby in order to save it from possible insanity was divisive enough, but O'Neill also layered on a technique where characters could speak their innermost thoughts privately. Other characters onstage were unaware of the IM-based lines while the "real" dialogue continued normally.

Characters glide back and forth between public and private dialogue throughout the show. Whenever O'Neill wants his characters' IM to be verbalized, he merely indicates in the stage direction that the character is thinking.

The audience is made keenly aware of the characters' IM by its unique style. The character's IM differs from the standard realistic conversation in the real-life dialogue sections of the play. O'Neill understands the disjointed and fractured quality of innermost thought, and theatricalizes it to allow an emotional connection to the character's inner turmoil. Just as ours is, the IM dialogue for each character when they are "thinking" is sporadic, unfinished, and fragmented.

While the device of speaking IM was revolutionary, the manner in which the dialogue was performed made the style easily mocked. O'Neill wanted his IM dialogue to be intoned as his characters looked off into space. At the first use of IM dialogue in the play, he directs the character to speak in a monotonous tone. Rather than our casual and shorthanded IM manner, the monotone adds pretense within this unique exploration of IM. This makes the inner thoughts of grand importance in the play. This style was mocked (hilariously) in the 1928 film *Animal Crackers,* where Groucho interrupts the action to have a "strange interlude."

Most other examples of IM in drama take the form of first-person narration where an actor directly addresses the audience. This is a way for the playwright to develop a closer relationship to the audience through personal interaction with a character by informing them of important information and directing their loyalties to other characters. Normally narration is not true stream of consciousness but rather a character reporting her feelings. So, while not truly IM, narration is a form of private thought unheard by others.

A famous example of this is Neil Simon's *Brighton Beach Memoirs*. The main character, Eugene Jerome, talks sporadically to

the audience, giving them pertinent background information about the time, location, and other characters. Eugene uses his narration to guide our allegiances, comment ironically on the action, or introduce the audience to his family members and their foibles. He assures us (the audience) that we will like his brother when he first introduces us. Clearly his relationship to the audience is one of kinship.

Another model of the use of the narrator is the role of Tom Wingfield in *The Glass Menagerie* by Tennessee Williams. Tom addresses the audience similarly to Eugene Jerome. Eugene is a fictional version of the playwright Neil Simon and acts as guide to his "current" life throughout. Tom is a fictional version of the playwright Tennessee Williams but acts both as a current participant in the dialogue scenes and as someone looking back on the past in his first-person narration discussion with the audience. He informs the audience of the events they will see or have seen and how those events affected him in his "current" later life.

Narration Exercise

Using a character from a project that you are working on, interrupt the dialogue of your scene and talk directly to the audience—at an opportune (or inopportune) moment—in rehearsal or in class. Only do this with permission of all involved. Examine how your induced and unscripted IM informs the stakes, motivations, and allegiances of the script.

In this exercise, explore your relationship to the audience. Why do you talk to them? What do you want? Why interrupt now? The answers to these questions can lead you to a deeper understanding of narration in drama.

So while rehearsing a scene from *A Streetcar Named Desire*, stop the action as Stella and talk to the audience about your dilemma. Should you choose Stanley? Should you choose Blanche? How can you overcome this awful situation? Ask the audience for advice?

The problem with most first-person narration is that, unlike IM, it is usually not acted or directed with a strong point of view. Usually an actor simply tells the audience the information or reports their reaction to an event with little emotional connection. Narration of events is dramatically inert and is tantamount to simply reading the script.

This can easily be solved by refining the reason the character is telling the story. The character must have a deeper emotional connection to the narration. Is she telling the audience in order to win their allegiance? To prove the truth of the story? To avoid blame? A stronger and

more active investment in sharing their personal feelings is necessary. Similarly, defining who the audience is can enhance the dramatic effect of first-person narration. Often there are low emotional stakes in narration because the audience's role in the drama has been reduced to mere bystanders rather than active participants. Is the audience the jury who will decide the fate of the character narrating? Are they undecided voters who will sway the election? Will they help the character resolve to take action in his revenge? At the very least, they should be regarded as completely unaware of the situation and must be guided through the story rather than told it. By creating a different power structure, the status of the audience is raised to an active and necessary partner in the dramatic conflict. Of course the dramatic conflict within narration is akin to IM as a character privately wrestles with her thoughts.

The psychological understanding and theatrical embracing of IM by playwrights and audiences has become an expected device. Plays now commonly break the fourth wall as characters interact with their audience to tell audiences how they truly feel. No longer is direct address or the declaration of true feelings by a character a unique occurrence. Audiences have become sophisticated enough to understand IM in drama.

Directors must therefore have a deeper understanding and point of view related to this concept. The director must define the reasoning for narration in the production. In most cases, directors simply allow actors to tell their side of the story. The actor and audience interaction can be sharpened through keener direction that focuses the motivation for first-person narration.

As actor, you must understand the point of view of the character. Are you speaking from the present or past? Are you professing your true feelings or are you lying to the audience? Should the audience side with you or should you alienate them? What is the motivation for your IM in this play? These are some of the questions you must ask when performing direct address or IM in any play.

As director, you must understand how to assist the actor to best negotiate the playwright's intention. Is the character actual or representative? Is the character being honest? What was the original intent of the playwright and how does that inform your production? How does the meta-theatrical world of today inform your choices? These are some of the questions that can facilitate exciting conversation in rehearsal.

As educator, you must understand how to challenge the actor to unique choices that examine all points of view. Has the actor

considered that his character is not telling the truth? Are there other sides to this character? Why is the character telling the audience this? These are some of the questions that can inspire the actor to compelling and unexpected choices that enhance the scene.

Of course, IM in drama is not relegated only to theatrical devices like *Overtones*, *Strange Interlude*, or narration. IM continues throughout the drama. IM is also affected by things like dramatic structure. You must possess a keen analysis of the text and understand the dramatic form in order to gauge each character's IM.

Looking at the play as a complete entity is not the domain of only the director. An actor must be able to appreciate the form in order to inhabit the world of the play. Understanding the standard dramatic form is necessary so that you can calculate stakes, immediacy, and emotion related to your IM. Is the IM as fevered in the exposition? Do the stakes of your IM match the moment in the show as a whole? Most likely the IM will not be nearly as active in the opening sections of a play when the characters are in stasis as it is surrounding the climactic moments of a show. Using your script analysis skills on standard dramatic forms (styles are covered in a later chapter,) you may understand that your IM must acknowledge where in the dramatic arc this scene falls.

By understanding a play's structure and your character's function in its overall construction, you may shape their IM accordingly. Wisely analyzing a script may reveal information from the playwright or screenwriter that goes well beyond the dialogue. In your investigative work to create the most compelling IM, evaluating all clues is essential.

IM in Film

From the earliest silent films, title cards or intertitles interrupted the photographic action to let the audience know of sound effects (like "Boom!" when dynamite exploded), dialogue (as characters silently mouthed lines like "My hero!" when rescued from a railroad track), or in some cases, an early form of IM (like when the villain glares into the camera and thinks "I'll get my revenge."). These silent films offered an entrance into the first primitive forms of IM on film.

In her dissertation "Figures of Silent Speech: Silent Film Dialogue and the American Vernacular," Torey Liepa writes of Thomas Ince's 1911 silent film *The Dream* in which the main character's inner thoughts are presented in a dream. In the absence of dialogue, Ince used intertitles and imagery as an extension of IM. This sophisticated device in a silent film was an early attempt to create a cinematic version of IM.

With the advent of talking pictures, movies used the device of narration similarly to theatre as a standard way of allowing the audience to introduce other characters and allow the story to be told from a first-person point of view. The intended result was the same: draw the audience in, lead them to this character's way of thinking, and streamline the information necessary to understand the plot.

What makes cinematic use of IM unique from theatre is that the narrator may comment on scenes in which they participate. Unlike the obviously public and privately demarcated *Strange Interlude* device, film allows the narrator to comment directly on the choices they are currently making. Sometimes they interrupt the action in a filmed new location or they may simply narrate their feelings under the action in a voice-over. So while they are in the scene, they actually may judge themselves or others for the choices they are making.

Of course the question is raised, from where are they narrating? Are they looking back on their life? Screenwriting the moments we get to see? Whenever IM is used in film, uncertainty comes in as to when the narration is being "recorded." Just as in theatre, a point of view is necessary.

Like *Overtones*, film can take the use of IM, or a public and private self, and divide it into real and imagined characters like in David Fincher's *Fight Club* or Charlie Kaufman's *Adaptation*. In these films, the main characters use their inner voice to inspire or control them. Like *The Glass Menagerie*, film uses the device of narrating a story that happened in the past from the present to allow distance from the original episode like Bob Clark's *A Christmas Story* or Terry Gilliam's *Fear and Loathing in Las Vegas*. In each film, the reason for telling the story has a different motivation but the idea is the same—to allow the audience to share private thoughts with the main character.

It should be noted that a majority of the films referenced in this chapter have a literary pedigree. They may be based on or adapted from books or stories written in first person and therefore have a close tie to the literary device of first-person narration. It is incumbent that your character's narration have a strong historical point of view. Narration voiceover is the character coming up with the narration, not merely the chracter reading her diary. Most film narration has little immediacy and sounds like an infomercial for the character's life rather than the private and personal reflection of the character. Examine cinematic narration as the cousin to IM that it is.

One film that plays with the IM device in three unique ways is Woody Allen's *Annie Hall*. While the film uses the standard voiceover narration technique favored by most filmmakers, in one scene Alvy (Woody Allen) stops the scene he is in and talks directly to the camera. In another scene, two characters' IMs pop up like subtitles to let us know what the characters are literally thinking. Annie (Diane Keaton) judges herself for talking so pretentiously while Alvy cannot get over Annie's attractiveness. While their dialogue may be mundane, their true inner thoughts are alive. In another scene, while Annie and Alvy make love, Annie leaves her body and shares her boredom with herself. The screenplay calls this inner character Annie's Spirit and Allen describes her as a ghost. This one film uses three different devices to film IM in unique ways.

To reiterate that a character's IM must match the way he or she thinks, one only has to watch a double feature of Amy Heckerling's

Clueless and Mary Harron's *American Psycho*. Both films use the technique of narration that goes a bit deeper than purely providing information. We see the inner workings of each narrator's mind. Whether it is the main character Cher in *Clueless* avowing that she will make-over her soul or Bateman the serial killer in *American Psycho* describing how his bloodlust makes him feel lethal, we enter into the inner workings of a character and see how very different a character's IM can be in these vastly different films.

Of course, throughout an entire film, the IM of the character is revealed in each second onscreen: the way in which the character listens and processes the information in his reaction shot, the way in which his close-up reveals a clear pattern of thinking or the wide shot as the character moves about his space. In each situation, the camera captures in great detail the true IM work of the actor.

The intimacy of the medium is a compelling argument for IM. The close-up uniquely reveals the "dead" eyes of an actor, as the camera is unforgiving to those who are not connected to a rich inner life. Film demands IM. Assistant professor of Media Acting at Michigan State University Mark Colson notes, "IM is very important to film, in that the camera tracks your every move. If you are not connected to the scene or your character, it is painfully obvious because your eyes don't lie. If your thoughts deviate from your character and the moment, the camera catches this. . . . Nowhere to hide. The same is true with listening on-camera. Listening in film has to be *more* engaged, because once again, if you check out of the scene for a single moment, the camera will catch it. In theatre we can check out for a moment or two, thinking about the next costume change and no one is the wiser. Not so in film. You must stay connected, engaged and actively listening one hundred percent of the time."

Listening Exercise

Find a scene where you spend a majority of the time merely listening to your scene partner. Set up a camera to record only you in close-up. Perform and record the scene. In playback, watch your listening skills. Are you really listening? Are you pretending to listen? Are your receiving? Are you processing? Are you alive? Is your IM clear? Is your IM honest and not indicated?

With your analysis of your performance fresh in your mind, rerecord the same scene with the adjustments included. In playback, are you able to see an obvious or subtle difference? What is unexpectedly captured on camera and what is revealed?

This extended listening exercise is akin to reaction shots in film or television. It reveals the intimacy and subtlety of IM work in stark close-up. It also reveals when an actor may be indicating "thinking." Examining film work in such detail, focusing only on IM, can reveal honesty in performance. Filming any performance (theatre or film) in close-up may be the clearest way to engender discussion about IM for actor, director, or educator.

Continuity

Another element where film differs from theatre is the usual non-sequential filming of a script. In theatre, actors are afforded the luxury (usually) of creating a full character's arc and playing out the journey of the character's dilemma chronologically. The IM follows a logical progression. For most cases in film, this is not so.

IM is a valuable tool for the film actor to immediately tap into the scene and its placement in the overall story. An actor can, through practice, use IM as the connective tissue to assist in filming out of sequence. Charting the character's thought process in chronological order is the first step for the film actor. Using that homework as the basis for entrance into any scene, the actor can immediately summon the requisite emotional state by reminding herself of the character's IM right before the camera rolls. By using the IM as the tool for the through-line, an actor can rouse the desired response no matter where the scene may fall within the script or the shooting schedule.

Filming one scene from various angles usually provides the actor much downtime between shots. In this downtime, as the next shot is perfected by the crew, the actor can sometimes lose the momentum or focus that was present when filming earlier. The IM can provide easy entrance to return to the exact emotional and psychological state when asked to shoot the same scene hours later from a new angle. Charting out the IM for the entire scene allows the actor to be prepared to film any moment no matter how brief or where in the actual sequence of the scene.

The IM can actually provide the continuity so lacking in most film shoots. It can assist the actor in organizing the character's thoughts and allows a streamlined approach sometimes absent in the film actor's process. As director, talking with the actor about the IM for each scene when rehearsing can allow compelling coaching right before the camera rolls. A director, who understands the IM of the

character, can assist the actor to get to the desired state through careful and thoughtful IM coaching right before he yells, "Action."

Film is a medium where an actor must be connected to a strong IM. More than theatre, actors are demanded to ignore immediate distractions when performing. Just out of camera's range there is whole world that the film actor must pretend does not exist. The IM of the character can block out the camera's proximity and intrusion on the actor's work. A strong character IM may also block out the crew and director just inches from an intimate scene.

Film places unique demands on the actor that must be understood. The actor's process must be adapted for this recorded medium. IM can assist.

Reality Television

Reality television has also had a great effect on what can be described as a form of IM's use in media. The use of a confessional booth, or safe place in which the participants may confess to the camera and tell us what they were really thinking during moments taped earlier, has become a mainstay for nearly any reality show. The device was first used on MTV's *The Real World* in 1992 as a way to reflect on what had occurred during the week's taping.

Now confessionals allow the participants to fight for our loyalty, tell us how they will flip the game on its head, or apologize for their actions. The tone of these solo interviews is supposed to be the character's authentic self, where he can finally tell us the truth, absent of the competition just outside the walls. Confessional sequences are home to many tears, rationalizations, and justifications. Whether this is the truth of the character being revealed or simply another scripted moment is debatable, but the audience is meant to assume that the character is being completely honest while sharing his secret thoughts.

This confessional device has been usurped from reality television and is used occasionally in sitcoms like *Modern Family* or *The Office*. The sitcom in mockumentary form uses the conceit of an unnamed film crew that follows families or coworkers, documenting their every move. The actors are sometimes aware of the crew and give knowing looks to the camera at appropriate times. Confessionals in sitcoms are the moments when characters sit down with the film crew and tell them the truth about their actions. This pseudo-IM is a chance to see

the character's truest self although it can be argued that they are still dishonest to impress the film crew. The basic structure is that these confessionals are a chance to gain a deeper knowledge of what makes that person tick.

Confessional Exercise

Using a character that you are currently working on, create confessional improvisations following interesting moments in the play or film. At the end of the scene, turn to the camera or create a confessional booth off set and let us know what you really felt during the scene. How did she make you feel? What about him bothers you? What are your true IM feelings? Film these confessionals privately so that you understand the camera as the medium for honest reflection.

At a later point, share these confessionals with others to examine your motivations and understanding of the events within the script. Confessionals are a good way to sort through what is the truth and what is simply inferred in the script. (They could also make great promotional videos for the project.)

Just as in drama, film has a connection and history with IM, and one must become aware of its conventions to understand the playing style. Voice-over, confessionals, close-up listening, continuity, and the camera's proximity are unique elements in film work. Film's exclusive intimacy demands a connection to a true IM.

Despite the medium's exclusive challenges, the film actor should incorporate all earlier acting IM considerations. This is the case for all future chapters within this book. The earlier part of the book's examination of IM used onstage are the foundation for the various versions of acting covered in the later portion. Despite the new challenges of singing or speaking verse when acting, the foundations remain the same: transforming your personal IM to that of the character.

IM in Classical Theatre

As mentioned earlier in this book, classical theatre contains its own versions of interior drama that are the theatre's earliest and most recognized use of IM. From ancient to modern times, the idea of sharing a character's private thoughts has been used to allow an audience entrance into the inner workings of a character's true motivations. While never truly labeled IM, the use of these devices has been part of the theatrical lexicon for centuries. We will divide these devices into three categories: apostrophe, soliloquy, and aside. Each method has its own definition and rules.

Apostrophe

In classic Greek drama, the use of the literary device "apostrophe" gave an early glimpse into understanding the playwriting device that offered a private moment in a public performance. Apostrophe literally means "turning away," and this method was used when a character interrupted her interactions onstage and shared a moment with an absent "partner." An apostrophe is a speech to an abstract quality or inanimate object as a living organism. It may also be a speech to an absent person (or people), either living or dead, who is not onstage. The overarching defining principle is that it is a one-sided conversation as the "partner" may not answer. The apostrophe is used as a rhetorical device in moments of high emotion.

An apostrophe is a perfect moment to rail against fate, misfortune, or the Gods. The apostrophe personifies qualities or concepts in speeches where fate is a fickle woman, misfortune is a greedy thief, or Gods are unfeeling judges. It is a chance to look at the rubble from a

war and seek its meaning. It is a chance to question your late mother about how you got into this impossible situation. It was also our first recorded use of IM onstage.

From the earliest moments of playwriting, it was understood that characters had various selves. In Sophocles's *Oedipus the King* there are three personas of the title character: the king trying to save a beleaguered city speaking to the chorus, the husband dealing with his family drama when speaking to Jocasta, and the private interior Oedipus who, upon learning his true lineage, reveals his interior thoughts in an apostrophe:

> Ah me! ah me! all brought to pass, all true!
> O light, may I behold thee nevermore!
> I stand a wretch, in birth, in wedlock cursed,
> A parricide, incestuously, triply cursed!

In Oedipus's IM, he has cursed the idea of light or truth as an actuality from which he wants to escape. The apostrophe is used in moments of extreme passion, when a character seems powerless or wants to control something he cannot. The apostrophe continues today as a poetic literary device.

Soliloquy

Shakespeare used apostrophe throughout his work. In *Romeo and Juliet* one needs only to be reminded of the personification of the "happy dagger" or Juliet's famous "wherefore art thou Romeo?" plea to an "absent" Romeo. For our purposes, we will examine Shakespeare's soliloquies, those most private of moments, when a character is alone onstage and shares his innermost thoughts. Soliloquies are pure IM.

Much has been written about whether soliloquies are delivered to the audience or maintain the fourth wall, as the character wrestles alone with his own problems. Whichever camp you fall into, the basic idea is the same. It may be a character struggling with a dilemma, making sense of the last scene, or coming up with a plan—but the character is not interacting with another onstage. Soliloquy's Latin root, "talking by oneself," confirms that.

The addition of the audience into the equation as a sounding board for the soliloquizing character does not diminish the form's connection to IM. The character is not editing her thoughts in soliloquy. She is not careful in what she says. She is sharing her truth with the

audience as a way to come to a decision. She is not merely narrating, like Eugene in *Brighton Beach Memoirs*. She is in active and complicated thought. While the actor's objective may be to seek advice from the audience, the audience acts as a conduit for her IM.

In Shakespeare's *Hamlet*, the lead character asks the most famous of questions. Whether you believe that the character is speaking to himself or that he is seeking an answer from the audience, it is evident that he is struggling with a conflicted IM. Read the soliloquy again with your newfound appreciation of IM to see what it reveals:

> To be, or not to be: that is the question:
> Whether 'tis nobler in the mind to suffer
> The slings and arrows of outrageous fortune,
> Or to take arms against a sea of troubles,
> And by opposing end them? To die: to sleep;
> No more; and by a sleep to say we end
> The heart-ache and the thousand natural shocks
> That flesh is heir to, 'tis a consummation
> Devoutly to be wish'd. To die, to sleep;
> To sleep: perchance to dream: ay, there's the rub;
> For in that sleep of death what dreams may come
> When we have shuffled off this mortal coil,
> Must give us pause: there's the respect
> That makes calamity of so long life;
> For who would bear the whips and scorns of time,
> The oppressor's wrong, the proud man's contumely,
> The pangs of despised love, the law's delay,
> The insolence of office and the spurns
> That patient merit of the unworthy takes,
> When he himself might his quietus make
> With a bare bodkin? who would fardels bear,
> To grunt and sweat under a weary life,
> But that the dread of something after death,
> The undiscover'd country from whose bourn
> No traveller returns, puzzles the will
> And makes us rather bear those ills we have
> Than fly to others that we know not of?
> Thus conscience does make cowards of us all;
> And thus the native hue of resolution
> Is sicklied o'er with the pale cast of thought,
> And enterprises of great pith and moment
> With this regard their currents turn awry,
> And lose the name of action.

Throughout the soliloquy, Hamlet makes mention of his inner mental turmoil. His greatest enemy is his rational thought process. His suffering mind is split between the options of life and death. His puzzled will is hampered by rationality. His cowardly conscience does not allow him to take action. While the soliloquy is certainly about death, we see its driving force is his conflicted IM.

Aside

Hamlet's soliloquy is interrupted by the entrance of Ophelia, so any further interior thought by Hamlet would be qualified now as an aside. An aside requires another character (or characters) to be present onstage. An aside is a remark from a character either shared with the audience or to oneself. It is "inaudible" to the others onstage and can be a parenthetical digression from the action or a chance to share information unknown to the others. Characters may be mistaken in an aside, but they are sharing their version of the truth.

Shakespeare used asides throughout his plays. He used them for comedic effect for Viola disguised as a man in *Twelfth Night:*

Pray God defend me! A little thing would
make me tell them how much I lack of a man.

And to dramatic affect in *Macbeth* when Macbeth reveals his ambition:

If chance will have me king, why, chance may crown me,
Without my stir.

In both cases, the characters reveal their true inner voice.

Let us explore an aside in Molière's *Tartuffe.* Asides in this sort of comedy reflect the tone and style of the play and its time period. One imagines a high society audience composed of gossipy and back-stabbing elite who were mocked by Molière through the use of asides. While the character confides in the audience, he is also revealing the audience's hypocrisy and "lofty" ideals of the neoclassical movement. The aside draws the audience in as confidante while also satirizing them. Whether through innuendo or blatancy, the aside is used by Molière as a double-edged sword.

From the first entrance of the counterfeit religious zealot Tartuffe, we, the audience, are told what is true about this gentleman by the maid, Dorine. She confides in us in an aside:

What affectation and what showing off!

From his entrance, Dorine tells the audience that we are in this together, so it is fine to laugh at this hypocrite, Tartuffe, as a way to distance ourselves from his ridiculous pomposity. The irony is that Dorine is merely a maid. The rest of the characters in the play are of similar class and wealth as the audience of the time. Those characters are duped and mocked for their complicity in the con. The lower-class maid is smarter than the rest. In this case, the aside may be used as a way to soften (or sharpen) the satire.

How then does an actor play an aside? The debate continues related to whether an aside is a private thought not breaking the fourth wall or a shared moment with the audience. Let us just assume that, for our production, we are speaking asides directly to the audience. In Dorine's line above, we may use this line as a chance to warn the audience about Tartuffe, to mock Tartuffe to gain their laughter, or to gauge their beliefs about this man. Whatever objective you come up with, the audience is again sharing the character's IM. The audience acts as the character's conscience. And, unlike Tom's narration in *The Glass Menagerie,* Dorine is sharing her inner thoughts within the action, not interrupting the action to comment from an outside perspective.

As actor, educator, or director, we owe it to all involved to see what works best for the current project. As actor, do I feel my soliloquy works best when I look into the audience's eyes for answers? As director, do I think the asides work better as inner comments shared under a character's breath? As educator, should I not prepare the actor for any situation they may encounter?

Apostrophe/Soliloquy/Aside Exercise

Using the examples contained in the book, perform the apostrophe from *Oedipus,* the soliloquy from *Hamlet,* and the aside from *Tartuffe.* Perform them in varying ways.

For *Oedipus,* look to one specific spot for your scene partner "light." Then perform it lost in the thought, talking to yourself, and not pinpointing a specific spot for "light." For *Hamlet,* perform the soliloquy to a group of people looking at them directly with a clear objective. The objective must be related to the audience. Following that, using an objective related to yourself, perform the soliloquy as a chance to wrestle internally to find an answer to the problem while talking to yourself. Using the short aside from *Tartuffe,* explore the text as a joke to the audience and then as Dorine's private thoughts to herself.

Following your performances of these forms in various ways, examine what felt best and why. The outcome may vary. Some may

feel foolish looking at a specific spot for an imagined scene partner in *Oedipus*. To some, Hamlet may feel freed when sharing his turmoil with an audience. Dorine may become entirely too introspective when whispering her aside to herself. Whatever the outcome, the actor must be prepared to answer the style of the production in which they are cast.

Too often in classical theatre, your IM when performing is consumed with making sense of the text, either for yourself or for the audience. You may spend your time worrying about the period etiquette or the correct posture. You may be consumed by thoughts about your itchy wig or constricting corset. These are, for the most part, not the thoughts of the character but the thoughts only of the actor. All of these thoughts are valid rehearsal thoughts. That is what rehearsal is for—to assimilate and understand the time period in classical theatre so that you may live honestly. A vital and active IM can release you from such wasted brainpower in performance.

More than in any other type of theatre, the classical actor must do the research. Otherwise there are gaps in the pretense. An actor must have done the research to invest in the proper time period, be entirely comfortable with costumes and props, and invest in preparation time before his entrance. All of this and more must be carefully crafted in order to leave his current time period and live fully in the time period of the project once he enters the stage or once the camera rolls.

As mentioned earlier in this book, an actor is not expected to think in iambic pentameter IM but rather with an appropriately respectful understanding of the language and manners of the time. So also must the actor's mind not be so corseted by the time period that he forgets these people have primal urges and needs. So when Romeo first sees Juliet, his IM probably would not include today's slang about the sexy woman across the dance floor but so too would his mind not demurely avoid sex.

As with all IM work, the balance is something that the rehearsal period reveals. The balance of period-appropriate thought process coupled with real desires is achieved personally. Perhaps your IM can contain base and contemporary slang without drawing you out of the play's setting. Perhaps that is your way to get to the less polite and removed portrayal that makes your Romeo relevant to today's audiences. As always, whatever gets you to the best performance is what works for you, but as with earlier exercises, you owe it to yourself to explore many options.

Apostrophe, soliloquy, and asides are very specific theatrical devices. They each contain a unique entrance into classical IM along with definite guidelines about their construction. What is more malleable is how an actor may choose to focus them in performance. One goal as actor, educator, or director is to experiment with the production to see which combination makes the most successful portrayal of the thought process of the character.

Sarah, Actor

"My discovery with IM has been the ability to allow something else inside my head besides my own personal thoughts. I didn't honestly understand the IM concept until an exercise using music.

I have a strong background in music. All of my immediate family sings and plays instruments as their main source of income, and I have my undergraduate in vocal performance. I'm not sure why it never occurred to me that I could underscore my emotions or the thoughts in my work. During an exercise in class, music was played over the sound system, and we were supposed to let that music affect the scene and us. So if the music was militant, so were we; if it was mournful and romantic, so were we. When I heard the music being played, there was almost a translation in my mind of the emotion from words to another more symbolic/biological language. I inherently understood and felt instead of thought and showed, leaving me open to another's mindset and making all my spoken words honest and responsive.

Music has always been the easiest form of catharsis for me. It has often provoked dormant, avoided emotions to come up and out without the impediment of the judgmental words in my head. I often feel guilty or embarrassed about any emotion that I feel and pride myself on being the stoic, together one of almost all the groups I associate with, including my family and very close friends. I often associate any sort of strong feeling with being dramatic. I almost always laugh at myself when I cry. So I've got some stuff going on in my head that prevents me from giving and receiving freely in the moment. I learned during this exercise that music shuts all that up.

This exercise helped me connect to myself as well as another individual because the music allowed me to stop listening to my own thoughts long enough to be affected by someone/something else. I had not known that my personal IM was a white noise preventing me from hearing anything else until the music stopped it. My personal

IM is extremely scattered and rapid and often interferes with my ability to communicate without a script, never mind the amount of information that must be dealt with onstage. The music acted not only as a damper for my thoughts but somehow shaped and funneled them into the other person. It was not only the inhibitor but also the vehicle. I felt that I was able to use the music to pace my character's thoughts, and then to send them directly and intentionally to my scene partner. This exercise opened up a whole new set of scene goals for me later in the class. My goal since then has been to find ways to stop my personal IM without the use of music.

This is still something I struggle with. When I am able to have an open communication where I am truly affected by my scene partner, it doesn't last long or is broken by my insecurity in being vulnerable. Since this class almost a month ago, I have been lucky enough to be put with a scene partner that not only shares my issue but has been extremely supportive and understanding of this work. We have concentrated solely on communicating honestly for longer and longer amounts of time.

I've started referring to this ability to shut my personal thoughts up and only listen to another with a character's IM as 'a muscle.' In order to flex this muscle for longer and longer amounts of time, I have to meet with my scene partner regularly and not just run the scene but discuss how a run went, what we're having problems communicating and when the other is not being honest. This is exhausting but more rewarding work than I've ever experienced working on a scene. The mental availability that IM takes truly is a muscle you have to flex. Some days I am less strong than others, but the biggest change since the beginning of this class is that now, at least, I am always aware of when I am being honest and when the white noise is preventing me from listening.

Some days are better than others, but when I am able to allow myself the luxury of truly being open and available mentally, the ease and honesty IM allows is so simple and human it surfaces all my careful lies and removes them like stitches. Now that I understand the concept of quieting my thoughts to allow something else to penetrate my psyche, I don't want to work another way."

IM in Musical Theatre

The house lights go down. The orchestra begins playing. The curtain goes up. And downstage center, a lone figure is revealed in a spotlight. She looks off longingly into the distance; waiting to begin her song. Isn't that awful? Not the lights, the curtain, or the figure—the waiting. Why is she standing there waiting? Why doesn't she fill that underscored silence with IM? She, like too many musical actors, spends her time consumed in thoughts of pitch, rhythm, and audience rather than the character's thoughts.

Worse than that is the pretense of thinking. You have seen it—a musical theatre actor staring off with a soft gaze looking into the middle distance, forehead scrunched in thoughtless contemplation, head shaking in vapid earnestness, and while the actor has the appearance of deep thought, in reality it is quite the opposite.

The act of pretending to have deep thoughts while singing can, at times, be more frustrating than a simple lack of IM. A review of a Broadway revival of *Jesus Christ Superstar* from *The New York Times* notes:

> Mr. McAnuff's staging is rich in portentous looks, actually. Mr. Nolan's serenely suffering Jesus is often to be found at or near the lip of the stage, peering into the middle distance with his piercing blue eyes, as if stoically watching his destiny unfolding on an HDTV screen at the back of the theater. Ms. Kennedy sometimes joins him in this pastime, as do some members of the chorus. If a musical were to be judged by the amount of time its characters spent gazing meaningfully into the audience, this production would be trumps.

The actuality of an actor staring doe-eyed into an audience too often occurs when he lacks a strong connection to IM, which is even

more surprising as musical theatre offers the most concrete conduit to IM—the music. Whether in underscoring or accompaniment, the musical score is, for the most part, the composer's vision of the character's inner life and provides the acoustic thought process of the character. It is the true soundtrack of the inner life of a character.

Underscoring is music that occurs during dialogue or book sections of a musical. It is close to the underscoring of a scene in a film. The major difference is that the film's score is created after the actor has performed. The score in a film is written to showcase a recorded performance while, in the case of musical theatre, the underscore is live and can affect the actor. Similar to the earlier music exercise, the underscoring for scenes acts as an aural manifestation of the IM that mimics the mood and tone of the scene. Actors should use this music that accompanies the dialogue as entrance into the thought process of their character.

Accompaniment is the music within the song that offers the actor a unique opportunity to surrender her thought process to others— the composer and lyricist. An actor in musical theatre must not only understand and interpret the words of the song but must also have a sensitivity and understanding of the musical accompaniment. Reading the actual musical score enhances the personal scoring process covered earlier in this book.

The music most surely sets the tone and mood for the scene, but it also pulsates with the rhythm of the character. It crescendos as our thoughts crescendo. It changes key as our thoughts change. An assimilation of music into thought should enhance rather than distract from a fertile IM.

Recording Exercise

With your enhanced understanding of the IM process, choose a musical theatre solo and listen to your favorite recording of that song. Choose a song you are familiar with. During the first moment, listen to the solo song in silence. Allow yourself to think of this recording as your personal IM. That voice in your head is now the voice from the recording. Surrender your IM to this recording. The goal of the exercise is not to mimic or replicate the choices of the recorded performance, simply a chance to experiment with the idea of dual consciousness.

Once you have listened to the full song, go back and listen again. This time, intermittently join in singing with the recording. Allow yourself to fluctuate between singing along and listening. This will emulate your fluctuating IM and reveal when moments are of highest

tension or emotion or are those of more personal private thoughts. Allow these moments of song and silence to come and go with as little force as possible. Once completed, sing your version of the song with only accompaniment and no other recorded vocals. Make the song your own but allow the discoveries of the other attempts to filter in as IM.

Solo

Let us deconstruct the solo described in the opening of this chapter. The solo in musical theatre implies that one person is onstage singing about an issue, solving a problem, pining for a lost love, or a myriad of possibilities. It is most similar in structure and guidelines to the soliloquy. The solo contains the debate about the inclusion of audience from classical theatre as well. Let us, for sake of argument, agree that in our musical, your solo will be sung to yourself as a character lost in thought. The audience will not be included in your solo, and just as in life (except perhaps when sitting on a beach or atop a mountain), you will not be staring off into the distance. If you do include the audience, they must be part of our world. They must be part of the drama onstage.

Your focus is that contemplative inward gaze but when working out a problem alone, you sometimes talk out loud or pace to assist in your collection of thoughts. In the musical though, there is sense of theatricality to it. You break into song during moments of high emotion—standard text or IM cannot allow you to simply think it; you must sing about it. You come down center and work out your conflicted IM through song.

Even the unscored riffs and vocal pyrotechnics so common in pop and rock musicals have a relation to IM. Those moments should be when the character embellishes his IM through an even more passionate moment than contained in the notated music. A riff may be an actor showcasing a uniquely individual moment where he believes the character is feeling something beyond the written score. The actor may augment the score through riffs when he feels his version of the character has a better way to express it. Too often, these riffs contain purely the actor's IM that is clearly shouting "Look at what I can do!" and offers very little relation to the character and drama at hand. The mix of vocal freedom and skilled technique must remain about the character or else it is little more than a vocal competition.

In this experiment, your non-audience focus has been decided, and you must next examine the issue within the text of the song. First stripping the song of any music, treat the song as soliloquy and act the piece as a monologue. Discover (without the assistance of the music) the text of the solo. It is the character's IM. It is perhaps poetic. It perhaps repeats phrases over and over. And you note that each repeated phrase has a different weight based on the character's IM. You understand that this character may think more expressively than in a non-musical script, perhaps enjoying his own clever rhyming scheme. The lyrics alone are only one part of the character's thought process.

Once you have understood the lyrics, listen only to the music (minus the lyrics). What is the story that it tells? What is the picture it paints? What does that crescendo reveal about the character's thinking? What does the agitated and staccato accompaniment reveal about the inner working of the character? Sometimes in your IM you think musically. Musical theatre is an example of that in its purest form.

Finally, put the music and lyrics together. This is when the thought process of the character is revealed in its entirety. The moment when your fully explored text and music combine should reveal the integrated IM for the character. You have married the traditional elements of given circumstances and text of any script along with the new element of the music. This unique union of drama, text, and music can allow for some of the deepest acting and complicated choices one in our profession can make. If you allow the music to enhance your standard IM choices, this matchless combination may enhance and reveal compelling choices far out of the actor's norm.

Solo Exercise

Using the guidelines outlined earlier, prepare a new song. It should be a solo for the purpose of this exercise. First, simply interpret the song as monologue sans music. Figure out what the character is saying. Score it as you would a traditional monologue. Rehearse the piece in this manner, exploring various options related to the given circumstances of the musical from which it comes. Make sure to include the IM throughout—especially the moment before you begin talking. If you believe that this solo is pure IM, explore the unsaid. What else is this character thinking about? What other IM is pulsing below the lyrics?

Next, explore only the music. Listen to the story that is being told throughout. What does it reveal about the emotional state of the character? What is revealed during the modulation? What must he be thinking in order to soar to such emotional heights?

Next, combine text and music enhanced by the given circumstances. What is revealed? How does the IM enhance the text? What are the unique challenges you recognized in musical theatre?

Torch Song

A standard musical theatre subject is a "torch song," or a solo about unrequited love. Your torch song is about how the man you love takes you for granted and doesn't even notice that you are part of his life. This subject is explored in everything from "The Man That Got Away" from *A Star is Born* to "And I Am Telling You I'm not Going" from *Dreamgirls*. Standard choices may be to whine about the situation, complain about your offstage non-lover, or feel sorry for yourself. All are inactive and fall into the trap of acting the mood of the song rather than the active and forward-moving problem-solving contained within your daily IM. When faced with a problem, you actively try to escape a mood rather than give in to it. Granted, your IM may contain self-defeating language or offer less than optimism, but it is always active. The same must be true for the acting of the solo. The text may say "He doesn't love me. He never will." but your IM between the lyrics must be actively and positively seeking a way out of this unhealthy situation. If you don't seek a way out, you will be trapped in the mood. The mood is most certainly a result of the musical score that accompanies your verbalized IM (the lyrics). More importantly, the music is an entrance into the tone of your IM. The music may be yearning or bombastic, so your IM must match that. The music may be in a minor key, and that too should affect your IM. If you are not actively thinking while singing, there is the threat of emotional inertia. While the score churns forward, the actor remains left in the same emotional state. In turn, your torch song must have a more complicated problem-solving IM.

In the first landmark musical, *Show Boat,* the disgraced singer, Julie, tries out a new song at a night club late in her career. She has had a hard life since her white husband, Steve, abandoned her, stemming in part from the problems related to her mixed race. She sings a torch song that is not necessarily related to the plot. The song called "Bill" is a plaintive number about a woman who loves a lout of a man. This moment could interrupt the plot, unless the actress playing Julie infuses her interpretation of this throwaway song with a conflicted IM connected to her absent lover. On one level, she is rehearsing a standard torch song, but on the more important level, she is

bemoaning the loss of her husband and her past life. While "Bill" is being sung, Steve is being thought.

The IM solo certainly expands beyond the classification of torch song. One need only listen to the lyrics and music of the arrhythmic yearning of "Something's Coming" in *West Side Story*, the bipolar musical phrases and disjointed thoughts of "Rose's Turn" in *Gypsy*, or the pulses of frustration that underscore the title song in *Sunday in the Park with George* as Dot stands frozen, posing for a painting. These songs reveal how a composer and lyricist collaborate to musicalize the inner workings of a character's IM. In each of these songs, a character reveals his deepest thoughts while alone onstage or unheard by another character. While these famous examples of IM in song are solos, IM is used throughout musical theatre in all moments of acting.

IM should be used in duets. Annie and Frank should be thinking about their unreconciled relationship in "Anything You Can Do" from *Annie Get Your Gun* and Mrs. Lovett is clearly thinking about getting closer to Mr. Todd, while Sweeney is thinking of revenge as they sing "A Little Priest" from *Sweeney Todd*. If IM is not involved, the songs are simply comedy numbers that interrupt the story.

IM is used in trios. The men in "New York, New York" from *On the Town* or the women in "I Want It All" from *Baby* have a larger emotional life than simply the lyrics and music. While on the surface they are singing about the wonders that await them (either a new city or motherhood), their IM allows them to deepen their personal connection to these adventures.

Ensemble

In fact, IM should be used by chorus numbers. A thinking ensemble only enhances the experience. A threatening chorus daring us to attend the tale of *Sweeney Todd* is made more threatening as they connect to their personal memories of this demon barber. The complaining shantytown residents of Hooverville in *Annie* should have a clear connection to Hoover's broken promises in order to bring heft to any musical theatre moment.

As actor, even if your director and fellow cast members don't engage in such conversation, what would happen if you included IM in your chorus role? As director, what if you expanded generic group direction to include conversations related to the chorus' individual

IM? As educator, how can we best empower our students to experiment beyond the standard approach to an ensemble role?

Ensemble Exercise

Take a group number from any musical and experiment with the use of IM. For our purposes, let us explore "The Telephone Hour" from *Bye, Bye Birdie*. Discuss with each ensemble member possible IM throughout the song. IM is especially evident when the ensemble members are waiting or listening, and this song has many moments like that. What is Harvey Johnson thinking when Debra Sue or Penelope won't talk to him? His IM could yield comic gold. Each member of the ensemble has an active thought process, just like we do when on the phone, and these possibilities must be explored in rehearsal. This sort of work and discussion can be a part of any ensemble rehearsal process.

Dance

Even without lyrics, IM continues in musical theatre throughout the song and infuses another aspect of this form with IM—dance. Song and dance are both enhanced by IM. The dance break (when the lyrics stop but the music continues) is fused together by the IM. You need only look at one of the most famous of dance sequences on film, Gene Kelly's performance of the title number in *Singin' in the Rain*. As Don Lockwood (Kelly) finishes up his singing portion of the number, he truly unleashes his inner thoughts as he begins to dance to celebrate his joy of having finally bonded with the girl of his dreams. We see his exuberance as his splashes from puddle to puddle and recklessly enjoys the rain.

Just like the earlier chapter "IM Alone Onstage" (chapter 8), we have inferred the character's IM here. Physically, we see him disregard the shelter of his umbrella, hop on lampposts, and try to make the biggest splashes possible in the rain-soaked streets. In each of these dance moves, we make the connection to the glee contained within the character's IM. He feels joyous, he feels like a kid, and he feels like a new man. We see (still in a wordless sequence) Don notice a policeman, realize his reckless behavior, calm himself down, and continue on down the street unheeding of the rain. We supply all of these character's thoughts through his dance. Through choreography alone we have gained entrance to the character's IM.

Too often, the dancing actor spends his time onstage remembering his choreography, checking his spacing related to the rest of the ensemble,

or making sure he is in synch with the orchestra. Infrequently do we notice the ensemble member acting and especially IMing when dancing. How many layers can a chorus member offer with the addition of IM to the "We're in the Money" dance from *Forty-second Street*? Yes, you are entertaining the audience as a tap dancing member of Julian Marsh's new show, but you are also a depression-era chorine desperate for the show to succeed so that you may know where your next meal is coming from. Similarly, your Kit Kat Girl in *Cabaret* understands her days are numbered as the Nazis slowly overtake Berlin. She performs with a dual level of understanding of both her role as a dancer in the nightclub show and her role in German society. Both of these ensemble members contribute to the story of the show by offering an enhanced dancing IM that elevates ordinary chorus entertainment into a cohesive and necessary expansion of the main story. IM for the ensemble can deepen the musical experience.

Dance Exercise

Listen to a song. The song should not have lyrics. What does the music make you feel emotionally? Listen to the highs and lows and let it paint a picture within your head of the character and her desires. Then, write a monologue based on your findings. This should be an IM of the character's private thoughts. It should contain high emotion. It should make you want to move. Next, read the monologue over the top of the music, seeing how it affects your emotional state. Next, play the music again, but have another actor read your monologue while you just begin moving. Let the music and thoughts affect your physicality. In the final version, simply think your monologue (now your IM) and dance. Combine music, movement, and thought!

As actor, it is important to synthesize the unique elements of dance and music into your normal approach to IM. The score of the musical must enhance the scoring and playing of the scene as actor. As director, too often we allow our actors to focus on (the safety of mere) entertainment rather than story when, conversely, our most compelling evenings in the theatre have been challenging or risk-taking. Is it not possible then to marry entertainment with thought-provoking theatre? The provocation of thought for both actors and audience can be equally as entertaining. As educator, bear in mind that students will come across nearly every possible approach to musical theatre during their career. And while the directors' approaches are different, the actor must be flexible enough to go along with these directors.

Musical theatre, like classical theatre, has its own set of rules, but the interpretations of those conceits vary widely. We must all be prepared for any variation.

After reading this chapter, the opening paragraph, hopefully, needs revision:

The house lights go down. The orchestra begins playing. The curtain goes up. And downstage center, a lone figure is revealed in a spotlight. She stands thoughtfully; engaged and ready to begin her song. She synthesizes the cues of the composer and lyricist. She dances her inner most thoughts in the choreography. She shares her work with the audience. She is a musical theatre actor who enhances her work with IM.

16

IM in Comedy

When an audience roars with laughter, an actor becomes "schizophrenic." Actually even more schizophrenic than he is normally. In an earlier chapter, we explored the idea of a double consciousness where an actor is aware of the reality of contemporary life while also investing in the "reality" of the play. The idea of "schizophrenia" is an undeniable conceit necessary for an actor to invest in his profession.

Comedy complicates the matter by adding a third level of discourse to the actor's dilemma. Actors must switch between living in the moment of the scene, understanding they are acting, and (unique to a comedy) gauging the audience's reaction. In comedy, the audience makes this balancing act between "reality" and reality more difficult due to the immediacy of the audience's reaction. An actor is trying to believe the unreal is real (the theatrical world he is "living" in), understanding he can't fully believe in this play-acting, and ultimately calibrating his performance based on an outside stimulus (the audience watching his "world").

This Pirandello- or Charlie Kaufman-worthy dilemma confounds even the best actors.

While the audience guffaws, the actor sits onstage stuck between delaying his next line until the laughter crests and living truthfully in the circumstances. The skill involved is uniquely an issue of comedic acting but akin to the idea of holding for applause in a musical. The meta-theatrical line an actor in a comedy walks is dangerous and more pronounced than normal. He understands he is shaping the performance while also living it. The IM helps keep the actor aware of all parts of this task.

The comedic actor must invest in his IM in those silent moments when the audience is laughing and the play seems to be on hold for

a bit until the laughter subsides. Your IM assists you in holding for laughs while you examine the banana peel that made you slip, search for the person who threw the rubber chicken, or examine if anyone else heard the whoopee cushion. These simplistic examples are honest moments of IM that can keep you active and invested in the story while the audience laughs.

IM can even build upon a laugh if played correctly. The audience chuckles with understanding as they intuit your thoughts following a particularly humiliating sequence. Listen to the audience cackle during your slow burn as you silently put all of the pieces together. Listen to them laugh through identification as you silently look to heaven following your disastrous date. IM is your friend when holding for laughs.

Setup: What is worse than an audience laughing?

Punchline: An audience not laughing.

Those instances when an audience refuses to grant you a giggle while the moment worked like gangbusters in past performances, knocked them off their chairs in the rehearsal room, or had them doubled over in laughter in your head are perhaps the most impossible moments to quell your unwanted personal actor IM. This was covered a bit in the chapter about IM as enemy (chapter 5). In those moments when you fail onstage in a comedy, your IM immediately comes to the fore to offer self-criticism: "I told you that wasn't funny," blame: "They are a terrible crowd," or analysis: "Maybe if you delayed the punchline a moment longer." All of these are valid thoughts, but they usually happen while performing in the moment and push you further from investing in the onstage dilemma. They start a snowball effect in comedy that accelerates as you lose laugh after laugh and gets you thinking more and more with an IM that is focused on you as actor and not as character. Your laugh dilemma soon becomes much more important than anything your character is struggling with.

The schizophrenia described earlier in the chapter can easily become unbalanced. You no longer have the healthy double consciousness of knowing you are in a play while investing in that falsity. In a failing comedy, you pull out of investing in your character in the world of the play to lick your immediate wounds as actor in the very real world. Your prime reason for creating this false universe of the play (the audience) has now become your prime reason for destroying the illusion. They decided your theatrical world wasn't funny.

In these moments, an actor must work even harder to listen. She must listen to both sets of her schizophrenic scene partners (fellow actor and audience). She must then become acutely aware of the moments when an audience wants to laugh but can't due to the speed of the scene, the disruptive fellow audience member, the distracting costume, or a myriad of reasons. The actor must be skillful in comedy to balance commitment to both worlds without the exclusion of one. The laughs may come with a heightened reinvestment in her comedic situation. She must also invest even more deeply in the character's IM to make sure that what she rehearsed is alive and authentic. That is why comedy rehearsals are terribly important. It is here that she invests in the situation of the script most deeply in order to be able to let her future scene partners (the audience) in during performance.

Devoted attention to making the scene work truthfully and logically is most important in comedies. You always strive to do so, no matter the genre, but in comedy nothing loses a laugh quicker than when an actor sacrifices truth and logic for a quick laugh. As actor, the comedic rehearsal contains the chance to test the boundaries of how far you can stretch a joke before it stops being funny. As director, you must help the actor create the boundaries of what retains the integrity of the style and tone of the show in order for the actor to analyze without you in performance. As educator, giving the actor tools to best assess why something didn't work is imperative to creating a good comedic actor.

It seems that I am also implying that a healthy dose of IM that is analysis-based be part of the comedic actor's repertoire. I do. Often an actor in a comedy must deal with unforeseen situations based on the audience's immediate response. An actor must make lightning fast decisions that retain the integrity of the show while still seeking the best way for this audience to get the laugh. So the communion moment written about earlier between two actors living fully in the moment is now overly complicated by the addition of the audience and their response. That too must also be factored into finding those rare moments when it all works. The laughs are honest, logical, and based in some form of recognition or identification from the off-stage partners (the audience) while the onstage scene partners live fully invested in the moment. Living in the moment in a comedy now includes holding for laughs...the normal performance schizophrenia plus one.

Audience Laughter Exercise

In this exercise, you must create a situation that they believe will make the audience laugh. Rehearse the scenario without an audience until you think you have crafted a "can't miss" laugh riot. Now perform it for an audience.

Following the performance, first examine each element of the routine through self-analysis. What worked and what didn't? When did you have the audience where you wanted them and where did you lose them? Why? Were you playing desperately for laughs? When the laughs didn't come, what happened to your IM? Where was your IM in the entire situation?

Following that frank examination, ask the audience for their feedback. Allow them to analyze first with their initial reactions and then through your questions. Once you feel you understand why things worked or didn't, perform the piece again with adjustments. Understanding that the audience now has knowledge of the mechanics of your comedic scenario, does the piece feel honest? Stale? Examine the second performance similarly to the first. This may yield some interesting discussions related to the unique demands of comedy.

Too often a comedy is destroyed by an actor not living authentically in the situation. He understands where the laugh should be and destroys all innocence leading up to the moment honestly. He has anticipated or expected the laugh rather than playing the honesty of experiencing the character's situation. At these moments, it is helpful to be reminded about vulnerability and comedy.

Think back to the great comedians of the past: Buster Keaton, Charlie Chaplin, or Lucille Ball. Their approach is utter guilelessness when entering a comedic scene. Their innocence creates a bond between audience and actor in a heightened situation. Their vulnerability as the comedic complications pile upon them, eventually overwhelming them, is completely honest. These great moments like Lucy's reaction to a speeding conveyer belt of chocolates immediately bond audience and actor through identification of their lack of expectations in the situation. It is here where comedic actors may reinvest in the given circumstances of the scene to regain their lost laugh.

An excellent way to remind actors of this innocence is the development of a persona whose IM is completely innocent. Their approach to the world is one of discovery and not one of expectation. Glenys McQueen-Fuentes in her essay "Theatrical Clown—A Theatrical Exploration of the Inner Self" suggests creating a personal clown.

This persona is a non-cerebral totally naïve child who examines life from an entirely innocent point of view.

To remind you that an actor must live honestly in the moment, you may adapt this concept for your IM purposes. It connects your emotional and physical impulses through a less cerebral approach where your personal clown must react with childlike innocence to the catastrophes awaiting. McQueen-Fuentes avers that the childlike clown experiences everything immediately with a strong physical connection, making instantaneous and honest responses absent of any mature IM.

With a nod to the innocent Pedrolino archetype of Commedia d'ell Arte, the clowning work of Jean Cocteau, and a keen understanding of what makes you tick, develop your personal clown. The character you create should avoid preconceived notions and have total innocence related to any invention or conceptual thought. The IM should reflect this.

With your newfound innocence, explore your room as if for the first time. Try to fathom what a doorknob is, how a drawer works, or examine that "stranger" in the mirror. Your personal clown is a chance to play the opposite of your standard choices. If you are constantly making choices that are overly complicated and unemotional, your personal clown should be the highly emotional town simpleton.

Personal Clown Exercise

Create a short silent scene as your innocent self or have the audience shout out suggestions about what to explore. In this scenario, it is important that you explore anything you encounter as new, fascinating, and mysterious. Your IM should be equally simplistic. Perhaps your personal clown only thinks in interjections or hums lullabies as IM. Whatever your IM, it should be naive and open. It is hoped that the freedom and simplicity of this way of thinking may spur you to an open approach to comedic scenes.

With a reinvestment in innocence and receiving the information for the first time, examine a scene like Paul and Corie's first scene in *Barefoot in the Park* by Neil Simon. We see that the comedy comes from Paul's discovery of the problem-plagued apartment, while Corie spends her energy covering up the problems. Both characters live openly in the moment and operate innocently and vulnerably. What can be gleaned is that comedy works best when coming from a place of utter investment in the vulnerable, the here and now, and the first

time. The character's IMs are related to dealing with complications of the plot.

The IM in comedy becomes more and more complicated as the characters begin to keep more and more plates spinning and the problems mount. In a comedy, a character usually operates from a place of positivity. The IM should reflect that. In *Barefoot in the Park,* rather than thoughts of *He hates the apartment so I hate him*, you adjust to keep it positive and moving: *Hope he doesn't notice the hole in the ceiling. Let me distract him*!

The main point here is that the responses to the ridiculous situation be tied together with a through-line of logical IM. Logic in various comedies can have multiple definitions but must all agree within the scripted world. The internal logic of the play must match the internal logic of the characters. A play where every character breathlessly enters an apartment after climbing five flights (plus the stoop) in *Barefoot in the Park* creates a slightly more heightened reality than our own. The reality created in the film *Anchorman* allows a character like Ron Burgundy (Will Ferrell) to thrive in an alternate universe where gang fights between competing reporters happen. Logic has various permutations in comedy. The characters in *Barefoot in the Park* and *Anchorman* live in their comedic versions of reality, and their IM must reflect the laws of their universes.

Complications Exercise

Use a comedic scene that has been rehearsed. As you perform the scene for this exercise have the audience call out various complications. These complications should offer the actors chances to discover, circumvent, or embrace the problems. For example, the door is stuck, you have a run in your stockings, or your phone keeps beeping. The complications for this run of the scene should be logical, relatively minor, and easily navigable. Once your logical run is completed, examine the ways in which the character's IM dealt with the problem.

Then run the scene again. In this rehearsal, the complications called out by the audience may be more outlandish and may leave the logical reality of the scripted scene. For example, the doorknob is scalding hot, your legs won't do what you want them to, or you must pet your invisible cat throughout the scene. The reason for doing so is to test the actor's ability to work within new complications that impact the boundaries of the comedy's universal logic. So, while you may be doing a scene from the realistic *Barefoot in the Park*, you may be asked to justify and embrace a new thought process that includes a world with invisible animals. Are you able to adjust your IM to not comment or

avoid such outrageous new complications? Does your IM include an acceptance of this illogical universe?

Comedic actors are a special breed. They are extroverted enough to thrive on an audience's response while also truthful enough to balance the high stakes, ridiculous situations, and mistaken identities required in the various styles of comedies. It is here that an actor must showcase his ability to be versatile with his IM. As with all IM, the tone should match the type of comedy that the actor is acting in. Highbrow comedy where wordplay is the fashion might benefit from a similarly erudite approach, while lowbrow comedy where slapstick is the form might benefit from an IM full of "Three Stooges" sound effects. Whatever the vocabulary, comedic IM usually benefits from a quicker pace, higher stakes, and a lack of recognition of solution to conflict.

Double Take Exercise

The silent double take only works if motivated by IM. So, while an actor may technically look twice at something, it is only through the IM motivating the look back that we as an audience laugh. The IM may go something like "What was—? What the *&@#$?"
 Prepare a double take with a clear IM. Know what you are looking at and what you are thinking. Perform. Balance the technique of the double look, including accuracy and speed, with the ingenuity of the comedic IM. Once you have perfected that, do a triple and quadruple take. Note the adjustments you must make when expanding to still make the skill and honesty work together.

The IM for a farce, comedy of manners, and situation comedy all operate and concentrate on different levels. The IM within a farce may concentrate on how best to hide the problems from the other characters, and while you are slamming doors and dressing up in disguises, your IM percolates with new ways to solve the many issues at hand. Your IM in a comedy of manners might remind you to put your pinky up when having tea in order to fit into this high society world to which you don't belong. Your IM in a situation comedy may remind you that, despite being saddled with a crazy husband, you know he is doing it for the good of the family. The IM changes depending on the style.

Andrew, Actor

"During the first semester of graduate school, one of my first classes was Psychological Acting, with a focus on the works of Anton Chekhov, Henrik Ibsen, and Tennessee Williams. For the class section on Ibsen and *A Doll's House*, we emphasized experimenting with the use of IM to concretely connect to our characters. This wasn't a completely foreign theory for me. I'd heard of IM in my previous acting experience, understood the concept, and had even played with it in bits and pieces, but hadn't made it the core of my work. For our scene study, I really wanted to give IM my best attempt, despite my nagging feeling of 'Am I doing it right?' Personally, and for most of our class, the idea of doing it RIGHT was a huge stumbling block. But herein also lays the answer to IM: it isn't about doing it *right,* but figuring out how it can best supplement your work and energize your own acting.

My individual discovery came when I realized I was over-complicating things. One assignment was to type out a scene script that had been scored using IM. Several other students in class talked about the length and depth of their IM. *Am I doing this right?* immediately entered my mind. In comparison to their IM, mine was very short and concise. Succinct. But I was doing it right! I don't speak or think at great length; I find the most boiled-down, direct thoughts and words. Therefore, by expending my energy on creating long, complicated, thought-out IM, I was doing myself a disservice and giving myself more to think about than necessary. I was obscuring my own process. In realizing this I was able to switch gears and begin to distill my IM to the most powerful and significant words for me to use.

I found that while using lengthy IM onstage, I lost presence. I recognized that I have difficulty being present onstage and simultaneously working in my mind. For example, IM is a constant process of working in your mind—you have to keep the IM moving to help

drive your character. I learned that I cannot do this while actively listening to my scene partner. I can only imagine the glossy look that comes over my face as the audience sees me retreat into myself when I fully focus on lengthy IM passages. When attempting IM in this way, I lose my presence onstage and completely stop paying attention to my scene partner while I think about what I *should* be thinking about. This then becomes problematic and draws me out even further. I start to wonder if I'm just thinking thoughts for the sake of thinking them instead of using my energy to focus on my partner and be present in the moment.

In reducing the IM to specific words, thoughts, and feelings, I could better propel my character while still staying engaged with my partner. Through our classwork, we also used images and music to affect our scene work, and these two items were particularly helpful in giving me ammunition from which to pull for my IM. I believe, in places, my IM could even be further simplified. After more work, it could be pared down to effortless one-word thoughts used to convey the message/feeling/thought/emotion. By adjusting my IM to single-word ideas and thoughts, I was able to give myself a guiding focus. I used my script study outside of class to find the larger thought for entering the scene and decide when and where that thought was reduced and then evolved through the scene, usually during unit changes.

I wasn't one hundred percent successful with IM, but I think it's a skill that can be built up over time. I was able to find the specific way that IM works for me, but due to the time limits of the class, I wasn't able to fully implement it. I did find a way to do it right for me. Given more time, and specific focus to IM, I think it could be a very useful tool."

IM in Style

Finding the correct acting style for any play is like a dinner with prospective in-laws. You spend your time finding the right tone, observing the etiquette of the household, exploring the boundaries of conversation topics, looking for the moments of shared compassion, and examining what makes them laugh, and all the while, your IM is racing to see if you fit in. *Do they like me? Have I gone too far? Did I just lose them? Should I share that story?* And the biggest question—*are we compatible?*

Throughout the dinner, you observe the inner dynamics of the family and the universe that they have created. You notice the decor of the house, the menu, and the inside jokes and try desperately to discover your entrance into their good graces. Your IM may note to avoid a political discussion from an off-handed remark they make. Your IM may censor the joke you just thought of, as it may not be appropriate for this group of people. Mostly, your IM acts as detective piecing together the clues of how or if you can fit into this household.

The household for any actor is the production of the play or film. Your expectation when approaching any visit to the in-laws (as with a play) is that it will be a logical, realistic evening where everything makes sense. You read a play expecting it to be a standard view of real life. That is your default. You expect that neither a wholly tragic nor a comedic version of people's lives will be contained within the script. This is rarely the case. Something unique to each script surfaces and the participant must learn to deal with the unexpected. You begin reading, and you note certain elements. You realize "Oh, this is a comedy." "This has direct address to the audience." "This is satirical in tone." "This is really dark." All of these discoveries beyond your default expectation help define a style unique to any script.

Just as you sit in the home of our prospective in-laws with your IM noting, "Oh, they're really religious." "They're conservative." "They have a really dry sense of humor." You realize the way in which you must act in order to fit into their universe. So must the actor when approaching the style dictated by the script. Every play has its own style, and while your implied expectation is realism, even realism has various definitions. So, while the in-laws may be Republicans, there are various definitions of Republicans, each with their own style and rules. When reading any script or in any moment like the in-law dinner, your IM is there to guide you to clues to find the right style.

While the playwright provides the text that dictates the style, the director and actors settle on the playing of that style based on their work in the rehearsal room. To continue (ad nauseam) with my in-law metaphor, the family dictates the style, but your visit to their home adapts that style based on your contributions. So while the script remains constant, the new contributors define their unique style of playing it. It is with this knowledge that you must enter any rehearsal process—ready and prepared to define and adapt to the style of any project, but also ready to be a contributor to that style.

Are We Compatible? Exercise

Have actors identify and portray characters from various plays of differing styles. You may wish to offer a list of suggestions. Once the actors believe they understand the style, have them interact in pairs. Ask them to improvise a simple conversation introducing themselves to each other while remaining invested in the rules of their personal style. Examine the ways in which the actors of varying styles interact. How did a simple conversation reveal the boundaries of a personal style? In what moment was it most evident? Did they adapt their way of playing in order to interact effectively? You may notice that a rigidity and devotion to a personal style may reveal incompatible acting styles.

Slowly combine the groups of two to create a larger pool of actors of varying styles. Ask them to mingle. Allow them time to interact with each member of the group and examine how the styles shift based on the actors' interplay.

When the exercise is complete, ask the actors about how their IM as character and actor worked in discord or harmony based on opposing styles. What were they thinking when approaching each new character? How did their IM guide them to a harmonious interaction? Why did their IM tell them to end certain conversations? Each answer may offer insight into how IM and style intertwine.

Most of this book has approached the use of IM in a realistic vein with detours into musical and classical theatre as well as direct address or comedy. Hopefully it is clear how IM can be used in these various realistic permutations. It is the introduction of the word "style" to the actor lexicon that strikes fear in many. Style implies an altered version of our default.

Style is also a word used interchangeably with genre, but much like IM and subtext, these words mean different things. Genre is the larger classification like drama or comedy, and style is the type like farce or comedy of manners.

So while the genre is a comedy, and you can adapt your IM accordingly, the style of comedy should also impact your way of thinking onstage. As noted earlier, comedic IM as a genre is generally lighter in tone and swifter in thought while the style of IM for a farce, comedy of manners, or situation comedy all operate and concentrate on different levels.

In the example below, I have scored Oscar Wilde's comedy of manners, *The Importance of Being Earnest*, to showcase the comedic IM enhanced by the use of style. *Earnest* has the added issues of time period and etiquette. Just as in the chapter titled "IM in Classical Theatre" (chapter 14), the actor must try not to think of dialect and decorum onstage in IM unless they are the thoughts of the character. So, let's assume that our actors playing Lady Bracknell and Jack understand the time period and any thinking about etiquette is a requirement of the scene rather than a distraction by the actor. My IM scoring for both characters is included in their respective lines but, of course, continues throughout.

> *Lady Bracknell*: You can take a seat, Mr. Worthing. *Will he be a suitable match for my daughter?*
> *Jack*: Thank you, Lady Bracknell, I prefer standing. *Was that wrong? Should I have taken a seat?*
> *Lady Bracknell* [Pencil and note-book in hand]: *He ignored my invitation. I shall note that.* I feel bound to tell you that you are not down on my list of eligible young men, although I have the same list as the dear Duchess of Bolton has. We work together, in fact. *Has he really no idea who the Duchess is? Noted.* However, I am quite ready to enter your name, should your answers be what a really affectionate mother requires. *We shall see.* Do you smoke?
> *Jack*: Oh dear. *What is the correct impression I want to make?* Well, yes, I must admit I smoke.

Lady Bracknell: Acceptable. I am glad to hear it. A man should always have an occupation of some kind. There are far too many idle men in London as it is. *My husband being one.* How old are you?

Jack: Shall I tell her the truth? Twenty-nine. *I should have accomplished more!*

Lady Bracknell: One year older and it becomes unseemly. A very good age to be married at. I have always been of opinion that a man who desires to get married should know either everything or nothing. Which do you know? *I have got him here.*

Jack [After some hesitation]: *Oh dear. If I answer incorrectly I shall lose my Gwendolyn.* I know nothing, Lady Bracknell.

Lady Bracknell: Hmmmm. Perhaps I have underestimated him. Perhaps he can fit into our circle of friends. I am pleased to hear it. I do not approve of anything that tampers with natural ignorance. Ignorance is like a delicate exotic fruit; touch it and the bloom is gone. The whole theory of modern education is radically unsound. Fortunately in England, at any rate, education produces no effect whatsoever. If it did, it would prove a serious danger to the upper classes, and probably lead to acts of violence in Grosvenor Square. *He nods with approval. Good for him.* What is your income? *Gwendolyn needs a respectable home.*

Jack: Between seven and eight thousand a year. *She's writing something down. Please let me be acceptable.*

Lady Bracknell [Makes a note in her book]: *That may do.* In land, or in investments?

Jack: In investments, chiefly. *Please. Please. Please.*

Lady Bracknell: That is satisfactory. *Barely.* What between the duties expected of one during one's lifetime, and the duties exacted from one after one's death, land has ceased to be either a profit or a pleasure. It gives one position, and prevents one from keeping it up. That's all that can be said about land. *He seems to enjoy my lectures. As do all.*

Jack: I have a country house with some land, of course, attached to it, about fifteen hundred acres, I believe; but I don't depend on that for my real income. In fact, as far as I can make out, the poachers are the only people who make anything out of it. *I just made a joke. She's not laughing.*

Lady Bracknell: Nature? A country house! How many bedrooms? Well, that point can be cleared up afterwards. *I shall not visit.* You have a town house, I hope? A girl with a simple, unspoiled nature, like Gwendolen, could hardly be expected to reside in the country. *With animals.*

Jack: Oh dear. This is not going as planned. Well, I own a house in Belgrave Square, but it is let by the year to Lady Bloxham. Of course, I can get it back whenever I like, at six months' notice.

Lady Bracknell: *Who?* Lady Bloxham? I don't know her. *I know everyone who should be known.*

Jack: *Oh dear. Make something up that sounds respectable.* Oh, she goes about very little. She is a lady considerably advanced in years.

Lady Bracknell: *No matter.* Ah, nowadays that is no guarantee of respectability of character. *Oh dear.* What number in Belgrave Square?

Jack: *I know what's coming.* 149.

Lady Bracknell [Shaking her head]: *Pity.* The unfashionable side. I thought there was something. *Oh, well, I have had worse dilemmas to overcome.* However, that could easily be altered.

Jack: Gracious. Do you mean the fashion, or the side?

Lady Bracknell [Sternly]: *Insolent fellow.* Both, if necessary, I presume.

Throughout, I have maintained the positive choices, lighter tone, and quick thought process necessary for comedy, but my IM has shifted to elements of decorum, fashion, and society—the style of IM for comedy of manners. This is the same for any style. The genre dictates the type of IM and the style dictates the vocabulary.

You may define a play as melodrama—but included in your equation for IM should be the question "Is this melodrama comedic or dramatic?" Let's say you are doing a dramatic melodrama with heightened emotions that are aimed at tugging the audience's heartstrings. Your genre IM (drama) would be darker in tone with an appreciation of the stakes of your decisions while your style IM (melodrama) would be sentimental and emotionally charged. And so it goes for any realism-based genre and style. An adaptation of IM to fit the style.

IM and the Isms

When you move out of realism, style and your IM move beyond your standard/default way of logical thinking. When entering this territory, unique strategies for IM (and indeed all approaches to acting) must be employed. In this new terrain where there are new rules for human (or nonhuman) behavior, you must again become detective for clues within the text. These clues assist in creating the universe of the play and affect the acting choices and ultimately the IM. Creating an IM that enriches the style of the piece is imperative.

Style and most important, "the Isms," are difficult for any actor to navigate. This is where the arbiter of style most firmly rests with the

director. The director must have a firm hand in stylistically creating the universe to ensure all actors live and IM in harmony.

In the difficult-to-traverse territory of the Isms, your traditional approaches no longer make sense. Logic and rationality may be overthrown for the incomprehensible and the illogical. How then does the actor and his IM make the text understandable internally? Should he? One could argue that in a play written in an Ism style, any attempt to connect the lines to a logical through-line is antithetical to its purpose. It can also be argued that creating a unique logic for a style in order to make internal "sense" of this piece is necessary. Opting for an IM devoted to the message of the form and style of the Ism is necessary.

There is definitely overlap in the possibilities for IM in nonrealistic styles. It is important to uphold the tenets of the genre when applying IM, but that does not mean there is only one approach. The tenets do not limit or define the IM, and there are several possible ways to think about IM that coincide with the style of the Ism. Admittedly these styles are advanced in their demands of both actor and director, but they are worth exploring and adapting in their unique possibilities for IM.

Expressionism

Since an expressionistic world is seen strictly through the eyes of one protagonist, the IM of that character will probably vary greatly from the other characters in the same world. For the protagonist, he might find himself struggling with his inability to connect with his fellow human beings. Protagonists in this style often speak in lengthy monologues, filled with choppy language, running lists, wild emotional shifts, and segments of repetition; speeches that seem to already drift back and forth between the inner and the voiced.

As an exercise, experiment with keeping the IM lucid and fluid, steady and rational, and allowing the voiced to represent the panic of being trapped in an expressionistic world. Maybe the character uses IM as the only real sense of self, where his thoughts keep him tied to humanity in a world where most people seem to have lost theirs. In this, an actor might use IM to examine her place in the world as well as to analyze her interactions with others. Another possibility is to identify where the spoken monologue and IM merge, and then as the spoken continues on, maintain and repeat those merged sections as IM over and over until another overlap appears, then continue and

repeat that section as IM, and so on. This activity might expose areas when the character is able to honestly voice her reality (the merged sections) and when she attempts to disguise or excuse it because the reality is too hard to face.

Conversely, ancillary characters in this style are often given representative labels like "Banker" or "Waitress" rather than names, so this element of their character can offer insight into how they might experiment with IM. There are a few possibilities for exercises here. One is that the actors try to contrast the depth of the IM with the superficiality of how their characters function in the world. In this, they could use IM to explore their frustrations, limitations, or senses of alienation forced upon them by their role in the world. Maybe the character's IM reveals a keen awareness that society has not granted them an individual identity, yet their IM is fighting to create one.

Another possibility, truer still to the Expressionistic style, is to allow the IM to become almost stuck—a broken machine or a skipping record—to coincide with Expressionism's telegraphic and robotic style of language. This approach to IM might also become physicalized in the actor. How does that sense of being stuck or broken manifest in the body if it starts as IM? It has to come out or be released somehow. Allow actors to experiment with physicalizing this IM, first nonverbally and then with the added, spoken IM.

A third way for these characters to explore IM is by beginning with the label assigned to them as a name. Maybe the IM of "Banker" becomes a running list of tasks that define and build that identity; the things he must accomplish or succeed at in order to be of value to the world in which they live.

Whatever the approach, using IM to explore Expressionism should acknowledge the main characteristics specific to the style—mainly, a world that is controlled or dominated by machines, a myopic and highly subjective protagonist who feels lost and trapped, dehumanization of all other characters, and the overall deterioration of family and home.

Symbolism

IM in this style might best be represented exactly as it sounds—in a series of symbols. This style is metaphorical, emblematic, and often heavy handed. Exercises for experimenting in rehearsal can either enhance or work against these elements, and both are valid choices. While actors are usually encouraged to avoid acting based on mood, it

is important to remember here that Symbolists often strived to evoke specific moods, and even further, moods tied to the mystery of our most trying human emotions: suspicion, fear, doubt, dread, doom, futility. The drama was often found in attempting to understand or overcome the haunting nature of these moods and the mystery of the human spirit to continue on despite the trials. Ultimately, the IM for this style is best when limited to short bursts of language or even simple outbursts of words and images. The images and symbols might change with the IM, or they might remain but alter slightly.

For example, suppose an actor chooses the symbol of a horse to represent his character. His IM might consist of outbursts that he connects with this symbol: speed, grace, beauty power, loyalty, or fragility. Where are these elements present in the character? When and why do they shift? Is one more often used than others, and if so, what does that reveal about the character? The investigation lies in how these sudden outbursts interrupt or enhance the IM.

Further, the IM could be limited to variations of the symbol: timid horse, wild horse, lame horse, winning horse, or rabid horse. The symbol itself should be a clear, strong one to which the actor feels directly connected. This way, adding variations to the symbol might yield specific shifts and a new vocabulary for exploring the style. So rather than "Where does my character make that transition?" an actor can ask "When does the horse run wild?" This language will continuously reinforce the character and its world as symbols. This approach also incorporates the element of metaphor indicative of Symbolism.

Another possibility might be to use concrete images and symbols during rehearsal to spark changes in IM. The image exercise from earlier can be adapted to explore Symbolism; not just images that evoke mood or emotions, but also symbols that appear in the mind of the character as the IM is working. These might be colors, animals, landscapes; they should be specific and abundant so that the IM can change. If an actor is forced to limit the amount of vocabulary he can use to voice his IM, he might be inspired to add greater dimension and detail to the symbols and images available to him, adding potentially influential elements like color, depth, shadow, background, negative space, symmetry or asymmetry, and so on.

Absurdism

Since one of the main elements of Absurdism is a devaluing or the futility of language, approaches to IM can experiment with an overall

inability to communicate. Absurdist characters often talk to one another a great deal, but they don't communicate; they don't listen, and they never learn. There is a cyclical trend to the way absurdist characters speak to one another, and just when it appears that something might be changed or understood or gained, the characters somehow find their ways back to where they started, forget where they've been and start over again.

What happens when these characteristics are applied to IM? Does the IM move in the same cycle, or is it hoping each time that the cycle will be broken or avoided?

Similar to Expressionism, one possibility is that the IM is trapped, screaming to be understood and struggling to be heard, but the voice and mouth and vocabulary of the character are not capable of releasing it. An inability to communicate does not mean an inability to comprehend communication or a lack thereof. In this, a character's IM might be pleading for understanding, aching for human interaction, longing for connection, and screaming to be heard, but the dialogue is limited to "Red, Blue, Red, Blue, Red, Blue, Green, Blue, Sad." But it has to mean something. How can these two things work together? All too often, Absurdism as a style is reduced to absurd language only. But it is not our chosen language that makes us absurd. It is the futility of our human interactions. These futile interactions can be explored using IM. The futility of our language is a parallel to the futility of our relationships.

To explore this, scene partners might begin a scene by voicing their IM to one another, almost as a reciprocal conversation, with no actual dialogue from the script. In this, they can then compare what they want to communicate to one another to what the playwright has provided for them. They can also use this exercise to discover how language limits each one of them. Might those limitations might be tenuous enough to be influenced by a stronger connection to IM? They might also discover the patterns of substitution that are often found in Absurdist plays. For example, through this voiced IM exercise, an actor might find that when her IM pulls her to say something about being lonely, her character says "door." What might this connection mean? I can't tell you that I don't want you to leave; that I'm scared you will; that I want to stop you; that I don't feel safe; that you represent my home. Instead, she simply mentions the door. These thoughts cannot be voiced in a futile relationship using futile language, but they can be found through IM and tied to the language pattern already present in the script.

Because Absurdist characters usually fail to listen to one another, it is also possible to have all actors in a scene voice their IM simultaneously, focusing on what they want from the other and how their IM might change when then realize they will not get it. They cannot save one another, and they cannot connect because they can't communicate and they don't listen. They know this, but is it revealed in their IM?

Often within Absurdist worlds, the lives of the characters are at once both highly comedic and highly tragic. A "We're doomed so we might as well have fun" or a "We're doomed, but we don't really know it yet" kind of attitude. The futility is comic. Based on this, another IM exercise an actor might try is to isolate each of these elements to see which has the greatest influence on his chosen language. Keep the IM completely comic or completely tragic. If one is internal and one is voiced, how might this opposition enhance understanding? Since both of these are usually present simultaneously, it could be valuable to discover which puts her at ease, which spurs her emotions, which is the most real or upsetting, or to which she feels most connected. This exercise can be done twice, once with a strictly comic IM and once with a strictly tragic one.

There are other elements to consider with an Absurdist approach to IM. The characters are lost or on the brink of loss, set down in a world that is ravaged. IM can be used to discover how aware a character might be of his existence; of his state of reality. Does he maintain hope? Does hemake excuses? Hide from the truth or lie? Deny it? Laugh in its face?

There are also individual and subjective moral codes. Actors can use IM to voice only their moral judgments. Can they use IM to justify "immoral" behavior in an absurdist world?

The greatest danger in Absurdism lies in concentrating only on the futility of the situation. The opposite must be true. IM could be used to find nuggets of hope, moments of humor, sparks of humanity, fleeting connections—anything that is worth fighting for, even in the most futile of worlds.

IM and Other Styles

Any theatrical variation includes an approach similar to IM—let the script dictate the thinking. In devised theatre, you may be thinking of the process. For applied theatre, you may be thinking of the message. Even in improvisation where IM may be thought of as anathema, you

may be thinking about not thinking. Keeping a clear and open mind is actually quite a lot of work.

IM can be found in almost any theatrical style and culture. In *Dilemma of a Ghost* by Ghanaian playwright Ama Ata Aidoo, a character's IM is spoken by a separate character playing her disembodied inner voice. The character thinking the thoughts sits smiling in reverie as the voiced character speaks her innermost thoughts. This is one example of many.

IM is not a purely Western concept. Japanese Noh Theatre has a unique approach to IM. Siiri Scott, head of Acting and Directing at Notre Dame University notes, "The Noh actor's inner monologue echoes the slow meditative nature of the Noh play. It is the time, space, and intensity with which the movement unfolds that will express the emotional content; subtext does not exist in the form. The actor communicates the character's journey through chant, dance, and presence rather than linear thought. As with many Eastern forms, the objective is not to infuse each moment with realistic integrity but rather to represent the character's thoughts in the precise execution of the kata (movement) and the utai (chant)."

In short, when applying IM to style, there is one cardinal rule: the IM must match the style. The demands of the script should enhance, influence, and infuse the actor's thought process. Our goal as actor, director, or educator is to match the specifics of the script to the style of acting. Just like a designer who creates the literal world of the play based on the style and demands of the script, so too must the actor harmoniously inhabit the world. If the design has a forced perspective, so must that acting. If the design is minimalist, the actor must approach her role similarly. The actor must live in concert with the style, not struggle against it.

Rachel, Actor

"The more I act professionally, the more important IM has become to me. Along with subtext, it is usually one of the first tools I use when scoring a script. In fact, even before breaking down beats or establishing objectives, I like to devote one reading of the script purely to IM. I end up jotting down particular thoughts that jump out at me in the margins, which helps me find the voice of my character, establish how she relates to the characters around her, and guides the specifics of her desires and tactics.

Sometimes if, during the course of a run, I find that I am in a rut with a scene partner or 'checking out' during a particularly long speech of theirs, I will revisit my IM to reestablish intimacy with the text and breathe new life into the interaction. Sometimes just trying to listen to my scene partners with fresh ears will alter my IM and bring new nuances to my character. For example, right now I am playing Audrey in a production of *As You Like It*. While I knew I was cast as Audrey well in advance and had plenty of time to explore that character, I was added at the last minute as a member of the forest ensemble to the scene where Jaques delivers his famous 'All the world's a stage' speech and had very little time to decide the subtleties and particulars of my nameless character. Listening to that speech and clocking my honest reactions to his words helped me decide not only how my character felt about Jaques speaking at that moment, but how she felt about her place in life, and the rest of the character quickly followed.

But possibly the time I find the use of an IM to be most helpful is during the auditioning process. For cold reads, or last minute auditions, it is an invaluable tool and the quickest way to make sure that I hit the major bases. When I don't have time to break down a side or monologue into beats and objectives, being acutely aware of my IM helps me stay specific in my intent, organic in my reactions and honest in my inflection. To me, knowing your IM is being able to speak from the heart of your character, which is acting at its most basic and relatable."

18

IM in Auditions

In her book *Auditioning*, Joanna Merlin explores the idea of self-sabotage in any audition situation. An actor spend an inordinate amount of time panicked about the audition, letting her personal IM veer to thoughts of the auditor's view of her rather than remaining focused on her work. More than any other situation in which an actor finds herself, the audition invites the IM to become the actor's enemy. Merlin describes a worst-case scenario in the audition room where an actor is overcome by negativity aimed at herself or at the auditors.

As in the earlier chapter related to the IM veering into enemy territory, a negative personal IM only distracts you from your main purpose—getting a job. It interferes with the good work you should be doing, through distraction and subterfuge. You obsess about your clothing, your hair, your voice, the director, the casting director, the lighting, and anything unrelated to the ultimate question, "Are you the right actor for this role?" This is why everyone has gathered at this time and place. This is why you took time off of work, researched, prepared, and traveled to this room. This is where you must share your work as actor, and any personal IM that distracts from this purpose simply muddies the reason for the audition.

It is completely understandable that you allow a personal IM to enter into the situation. The stakes are high at any audition. You have numerous overlapping and conflicting reasons for attending the audition. You are confident that you are right for this role. You want your talent to be recognized by others. You need the job in order to push your career to a new level. You want this project as a stepping-stone in your career. You are desperate to make money to pay the rent. You need to prove to your parents that this is the right career path. You need a boost to your self-confidence. You need to prove you are

better than the others outside in the waiting room. This audition matters more than any other. This sort of desperate and hyperbolic thinking can only distract you from your very simple task of sharing your work in order to show the auditors that you are the right actor for this collective version of this role. All other personal IM that pressurize the audition situation only negates the simplistic nature of any audition. "Are you the right actor for this role?"

The answer is invariably, "Yes, I am the right actor for the role!" The auditors have opinions that may conflict with yours regarding unchangeable qualities like height in comparison to your love interest already cast in the play. They may think the intangibles like chemistry with your costars are not quite right. They may also decide unthinkable things like "I don't think you are the right actor for this role." That is their prerogative. In all of this, you must contribute only what you can—the best example of your work for this project. The alchemy of the producers, directors, casting directors, accompanist, reader, or anyone else in the audition room with the numerous actors seen for one role is impossible to predict. Anytime spent on unproductive IM merely dissipates the work you should be doing.

"Are you the right actor for this role?" You overthink that simplistic question based on perceived petty politics, imagined gossip, challenged self-esteem, personal desperation, and misplaced confidence. Actually, you have to answer that question by showcasing your work. No amount of excess personal IM can change the answer.

Can you train your IM to think healthily in relation to auditioning? Absolutely, but like in the rest of this book, staying invested in solely productive onstage IM is nearly impossible. In the next section I shall endeavor to explore positive IM from getting the audition through entering the first rehearsal. In this extended example, I aim to offer suggestions to retrain overactive and unfocused IM to better focus on your profession as actor.

Professional IM

Auditions are the place with the least control for an actor to feel prepared in order to invest in character IM work. The personal IM is too prevalent and agitated. I suggest development of a new type of IM—the professional IM. The professional IM has been created as an augmentation from the distracting thoughts of the personal IM. Let's use it now.

You see an audition notice online or receive a call from your agent regarding an upcoming project. Immediately thoughts run through your head regarding the externals. "That director hates me because of my disastrous last audition." "What to wear?" "How am I going to get time off of work?" "Am I too old for this part?" Stop. Breathe. Think. "Great. I get a chance to share my work." And then simply begin the process in an organized, productive, and positive manner. While this may seem easy, use your next audition to simply keep all IM regarding the event organized, positive, and productive. There may be a major change in your approach.

Research

The first thing your professional IM (in conjunction with intuition and common sense) tells you to do is to research the project. At each discovery of information, do not allow your IM to distract you with its possible negativity. Don't let it tell you that the writers always work with that one actor who always gets the role over you. Don't let it tell you that the project is too high budget for you. Don't let it tell you that if this casting director doesn't like your work, your career is ruined. Simply gather the information and let the facts discovered motivate you to your next task—preparation.

Preparation

Just as the research phase may be diverted by personal IM, so too may your preparation. You tell yourself you'll get to it when you can. You tell yourself you don't want to over-prepare, to keep it fresh. You tell yourself that you don't understand the scene. You tell yourself you aren't right for this role. Stop talking to yourself and simply prepare. Between now and the audition, very little in terms of epiphanies will occur related to your training or the world of acting; so why delay? Get to work and don't wait for the never coming "right moment." Why distract with delays or unproductive chats with yourself? Simply prepare in any way that works best for you. Simply organize your thoughts related your analysis and interpretative skills, focus on the scene, and put the audition on its feet.

Once you have done so, your IM may be your friend and offer frank analysis related to what works and what doesn't in your audition choices. Here, the IM as arbiter and critic can use its sometimes negative power for good. It can practically judge what worked and

why. It can help solve the moment that doesn't feel right through analysis and experimentation. Whenever your IM veers into the negative thoughts of your talent, the impossible task of preparing the audition, or the inevitability that you will never get the job, try to re-guide it back to your work. How can the scene get better? What can you do to improve your audition by making it richer, more interesting, and more truthful? What is a new way of approaching the scene? Wasting the enormous energy and power of the IM on negative thoughts based on low self-esteem is the hallmark of many actors.

Actors are also usually very sensitive. Their job is to create characters with deep and various feelings. Therefore, an actor is unusually attuned to the inner workings of a character's mind and, in turn, her own. Acting is also a profession. Most professions would not tolerate or reward their workers for negative thinking and low self-esteem. You must therefore have the skill and knowledge to know when to keep your work moving forward positively and when your work is being distracted by unnecessary negative thoughts. After all, it is your profession.

Organization

Once you have prepared thoroughly, move on to the organizational aspects of the audition. "Does my attendance at the audition impact others?" If so, you will have to have others cover your shift at work, watch your child, or care for your ill friend. No issues related to guilt or stress need enter. These are just facts. In order for you to do your job, you need to be responsible toward others. "What should I wear?" You may choose an outfit that conveys the essence of the character without veering into costume while also capturing your unique personality and remaining professional. Approach this possible landmine moment of what you look like with a practical and businesslike IM, rather than allowing negative feelings to distract from your work. "How will I get to the audition?" You may drive yourself or take the subway, but no matter the means, IM in this solo moment should remain wholly focused on what you need in order to prepare. This may be singing freely in the car in order to warm up. This may be reading a book on the subway to distract you from the inevitable nervous personal IM. This may be talking to a friend to divert your attention in order to remain calm. No matter the motivation, travelling to the audition is an important and personal journey for the actor. In each moment prior to entering the audition, your IM may be retrained to organize your thoughts and focus on your job. After all, this is your profession.

Waiting Room

Upon entering the waiting room, a wave of panic may occur. It is only natural. The room is filled with others in an equally anxious state. They too want the job. As a professional, do the things necessary for you to best prepare for your interview. That may mean that you cordon yourself off and simply review your choices prior to the audition. It may also mean that you distract yourself by talking to your friends and fellow actors. In either case, retrain your IM to focus on your work and not allow yourself to psyche yourself out through your insular preparation alone or your possibly overactive comparison to others in your group. Do not let the situation outside the audition room infect your newly professional IM. You have a job to do, and following the audition you can share your insecurities with others, but in this extended experiment, allow yourself to prepare as best you can. As your turn nears, simply try to relax and look forward to sharing your work with others. And then, your name is called.

Inside the Room

The entrance into the room is a pure balancing act of the various types of IM. Returning to our base psychology approach, our id IM keeps repeating "I want this job!" The id makes sure that the stakes within the audition remain high. Your ego makes sure that you can showcase the work that you have prepared. Finally, the superego makes sure that you interact appropriately with the auditors by presenting the best version of yourself. All permutations of these Freud-based types of thoughts overlap and weave between entering the room and beginning the first few words of the scene, monologue, or song, when the IM becomes the character's.

You enter and your professional IM immediately notes the setup of the room and takes into consideration the possible issues contained within. The acoustics, the camera, the piano, the table, the wires on the floor, the mirror, the lighting, and much more flood the IM as you take in the space where you will do your work within seconds. You note the unextended hand of the director, you note the unhappy assistant texting, you see the half-eaten lunch that implies a long day of auditions, you see the "X" taped on the floor and you head there. Again, all of these elements are merely givens in the audition situation and should not distract you from your task at hand. While

your IM may veer to negative thoughts, try to steer them back to more professionally based positive thoughts about how to best share your work.

The reader has no enthusiasm. The director doesn't make eye contact. The pianist is terrible. The cue cards are sloppy. The lighting is appalling. Your IM can turn from self-judgment to judgment of the audition environment. This is equally distracting. Every other actor came into the same room with the same people and had a similar experience. The whole point of auditions is to offer a level playing field to all. Such judgments simply cloud your work. And while the lunch order may arrive when you are in a particularly heightened moment in the scene, the pianist may have missed the key change at the high point of the song or the casting director yawned when you were recording your audition, all of these are purely human circumstances and not a chance for your IM to create a conspiracy theory that allows your work to unravel.

In your interview, the director simply wants to find out a bit about you for two reasons. The first and most important—are you insane? The second—will you be easy to work with? Your professional IM should allow you to interact honestly without a huge amount of second-guessing that offers a tortured and halting interview. Simply think of this as a first date where you too have the power to interview your prospective partner to see if you are compatible. If you hate first dates, simply reframe the interview process to a less stressful interaction that will allow you a minimum of unwanted personal IM.

Transition In

By the time you get to the actual point of the audition (acting), you should be thrilled to share your work. This is the one aspect of the audition you have the most control over. This is what you came here to do. After all, it is your profession. As you prepare to launch into the scene, song, or monologue, discover the best way to transition into character. This transition from actor to character is one that fascinates me to watch in audition situations. You don't want to take too long, seeming egotistical and pretentious, nor do you want to rush the transition and seem cavalier and shallow in your approach. What does an actor think in the moments between his final interaction as actor and first interaction of character? The answer for you may be to click over to the character's IM. While you announce the title of

the piece or slate your name for the camera, when you next speak, you will be the character. Traversing the "possession" into this new person with little preparation time must be rehearsed, and I suggest scripted or more accurately scored transitions become part of the process for you.

The moment between introduction and first line of the audition piece may sound something like this in your head. "You can do this! You understand her! She wants to save her job. I want to save my job! I need you to listen to me!" The subtle use of pronouns shows the shift from actor to character. You may simply need to picture an image in order to transition to the correct stakes and thought process. The introductory bars of the song may transport you to the emotional territory necessary. Use whatever works best for you.

The Actual Audition

Within the audition itself, you can quite easily lose your concentration based on the falseness of the situation, the proximity of auditors, or a dropped line from the reader. Using your professional IM, guide yourself back to the IM of the character whenever possible. Martin Lloyd-Elliot, in his essay "Witches, Demons, and Devils: The Enemies of Auditions and How Performing Artists Make Friends with These Saboteurs" writes of auditions as a chance to monitor your work while not allowing your inner voice to sabotage yourself within this stressful situation.

Auditions are so lonely. You are on display. All eyes are solely on you and your choices. The camera is tightly focused on your decisions. This is the time to cling to the character's IM. The impediments that auditions place on you are appalling and must be accepted and recognized as part of the business. Your professional IM must embrace and understand the artificiality of the form or you can never transition into character. You stand on an "X" and look to an imaginary person while singing a song or performing a monologue. You imagine and pretend to respond to the fake person. You may be asked to look into the camera and treat is as your imagined scene partner. You may be paired to read with someone who never read the script. It is all part of auditioning, and your professional IM must not allow you to be distracted or depressed. Your professional IM simply keeps you on task. Your job now is to remain in character and focused on your objective.

Transition Out

When the acting portion of the audition is complete, the transition from character back to actor is usually short-changed, as actors don't want to waste time or are humble about their work. The best auditions I have witnessed include that moment when all tacitly understand that the craft of acting requires commitment, and this transitional time back to actor is necessary.

The moment after acting is sometimes muddied by the rush of judgmental IM that undercuts your work by apologizing or joking. Avoid those moments as they showcase your personal IM and not your professional IM. Even upon exiting the room and back to the waiting room, remember to keep your professional IM working. In this experiment of your professional IM, explore how long you can keep the personal IM at bay and remain examining the entire process as the business that it is.

Callbacks, tests, or table reads are all a chance for you to ply your new professional IM. Allow this new IM to lead your calls with your agent, your interactions with the director, and your dealings with your fellow auditioning actors. This may guide you to a healthier and happier auditioning process. The audition process is the majority of an actor's life...don't you want to retrain it to work for you rather than destroy you?

Allow your professional IM to pick up the pieces when the job you wanted desperately didn't work out. Let the professional IM write thank you notes to all involved, find new audition material, and eventually examine the details of the audition. Let the professional IM decide if you need classes to assist you in expanding your work, allow you some time to mourn, explore other avenues, or chalk it up as a mistake.

When you do book the job, allow your professional IM to push away clouds of doubts that tell you that you can't do the role, it was a mistake that you were hired, or that you will be discovered as a fraud in rehearsals. Allow your professional IM to be humble when necessary and proud when appropriate. Allow your professional IM to guide you to your first rehearsal or the next audition ready to take on any challenge. My hope is that you will be able to establish a professional IM that keeps you safe, productive, and positive throughout the difficulties and unknowable adventures to be found when auditioning.

After all, it is your profession.

IM in Other Psychological Theories

As you read earlier, no one theory related to the origin of an individual's IM is accepted by all psychologists. Psychologist Dr. Christopher Hopwood compares psychological disagreement about IM to religion. He says "Inner Monologue, like religion, is indefinable as it breeds different beliefs and assumptions even to those who agree to one faith." Rather than continue the debate, I will introduce you briefly to a few psychological assumptions that may intrigue or deepen your understanding of IM. They also can translate handily to your process.

As mentioned earlier, Katherine Hitchcock and Brian Bates, in their essay "Actor and Mask as Metaphors for Psychological Experience" write about the idea of acting and IM as schizophrenic in nature (having the personal side and the character side) as well as the idea of possession when acting (an actor is possessed by the character). The more traditional definition of possession implies the spirits or manifestations of external forces. Hitchcock and Bates have transformed this definition for the actor. They refer to a double consciousness or a sort of controlled possession. An actor must balance and maintain personal control while also lose it within the character. Observing and living within the moment.

Common psychological terms that resemble an actor's IM include "multiplicity" and "fragmentation." In very general terms, the idea of multiplicity implies the idea of many persons, minds, or souls living within a single person. Fragmentation implies a split or divide between types of thinking within one person. These concepts easily translate to acting related to both the characters you create and the varying IMs we must connect with. Hitchcock and Bates write about IM in terms of multiplicity, fragmentation, and "voices in the head." This concept of other voices affects many psychological theories.

In moments of deep depression, your only "friend" may be your IM. Medication is used in order to retrain, alter, or silence the IM of a depressed person or to focus the sometimes-scattered IM of a person with attention issues. Others self-medicate through alcohol or depressive drugs in order to dull the pain that is heightened by their unending IM. Shock therapy and lobotomies also target the unmanageable IM. No matter the panacea, the aim is to take the edge off, make the IM easier to manage or reduce the frequency and intensity of these "unhealthy" thoughts.

The psychological field most closely mirrors an actor's work in both IM and obstacles. Some characters are paralyzed by their psychological complications and this in turn affects their IM. Making the more dramatic choice related to character is what actors, directors, and educators espouse, and it is here that psychological understanding is necessary.

As armchair psychologists, we, as actors, directors, and educators, toss terms about with a limited understanding of their theoretical origins. While the id, ego, and superego are excellent entrances into the character's thoughts, we usually "diagnose" the characters in other ways. We talk about a character's neuroses and defense mechanisms without the solid foundation as to the true meanings of these terms. Again, I refer you to Robert Blumenfeld's *Tools and Techniques for Character Interpretation: A Handbook of Psychology for Actors, Writers, and Directors* as a primer for richer psychological exploration, but for our purposes we can enter into this exploration in more general terms.

In creating the backstory for any character, you may, as many therapists do, examine the childhood of your character. Whether provided through given circumstances within the script or divined through inferences and inspiration, you may wish to scrutinize seminal events within the character's childhood that have formulated your character's way of thinking. By answering questions related to your relationship to your parents, traumas in childhood, or the ways in which you were punished as a child, you may begin to examine similarities in your character's interactions within the scripted scenes. Are you repeating patterns of learned behavior from your childhood? Are you staying in an unhealthy relationship because of your upbringing? Is your IM full of images from a specific trauma that was influential in creating your current way of thinking? The decisions you make regarding childhood can surface within your IM at appropriate moments. Creating a character with a rich childhood backstory can affect and deepen your IM.

The idea of self-image is another accepted entrance into the psychology of that patient/character. How does your character perceive herself? How does she perceive others? How does she think others perceive her? These questions reveal a character's self-image. Your self-image is created over time from childhood until the moment you arrive onstage. The basis is formed early in life and, depending on the image you have of yourself, most situations confirm that image. You may interpret a situation that may be positive to some as negative, based on the image of self. Self-image commonly manifests itself negatively as low self-esteem, unhealthy body image, or victimization. Your IM must correlate to the character's specific images of self. Your IM as the character must realistically include these complicated and unwavering thoughts.

Using our shallow understanding of psychology gleaned from a class or two in college, personal experience, and a lot of television police procedurals, we analyze and inhabit characters beyond our understanding. We call our characters narcissists, sociopaths, and neurotics without understanding the full impact of that diagnosis. We assign manias, disorders, syndromes, and phobias without the requisite background. When analyzing and entering the character, deeper research must take place. In order to truly inhabit the character, and therefore his IM, we must research what makes a character "tick." Through research that includes reading, recorded interviews, and personal consultations, we diagnose what we believe to be the thought process of the character.

In a production I directed of *One Flew Over the Cuckoo's Nest,* actors worked with a psychologist to help them decipher how their current behavior began, related to their backstories. Once the actors started to create that background and began thinking like the character through long-form improvisations and journaling, a professional psychologist interviewed the actors in character to help them fully inhabit their roles. The psychologist also offered guidance when actors started to veer from the prescribed and agreed upon conditions. Rarely are we as actors, director, or educator ever that lucky.

In the process of writing this book, my consultant from the Department of Psychology, Dr. Christopher Hopwood, and I have shared stories related to how our fields so closely intertwine. The analysis of the actor mirrors so closely the work of the psychologist by examining the motivations and history of our "patients." Chris even came to a recent class of mine discussing Tennessee Williams's *Summer and Smoke.* I had asked the students to diagnose Alma, John,

Mrs. Winemiller, and other characters in the play. With their limited knowledge of psychology, they decided what drove these characters based on the given circumstances contained within the script. Chris, who had read the script in preparation, lead the discussion regarding Alma's histrionics and John's narcissism while examining their respective IMs.

Perhaps, you may be able to find a similar expert in any field to help expand your ability to look at your process. Too often, as actors, we are asked to become experts based on the demands or subject of our current project. Perhaps you may even find someone like Chris who is as fascinated by the actor's analysis as I am by his work. In any case, bouncing ideas off someone outside of the theatrical world can yield dividends and expand your current approach to acting. Most certainly my discussions with him have inspired my understanding of IM.

Psychologists and actors are closely linked. Both must analyze and advocate for their patient/character. Some larger psychological concepts that have affected me are included here, as they may inspire you to similar or tangential ways to approach a role.

Mentalization

Mentalizing is a concept that explores both a personal as well as another's thought process. It is closely linked to IM and acting. Mentalization allows us to analyze and decipher what another is thinking, as well as his motivation. Like any good actor, we use mentalization daily. Dr. Christopher Hopwood describes the concept of mentalization, "Mentalization involves the effortful awareness of why self and others are doing the things they are doing. The ability to empathically shift from the perspective of self to the perspective of others is critical for mentalization."

A concept mostly ignored in this book is the thought of a character's IM actually being dishonest with herself / the character. Our IM can play tricks or justify nearly any situation. While it contains our truth about any situation, it is simply that. Our version of the truth. As Hopwood says,

> One of Freud's most important insights is the degree to which our behavior reflects purposive efforts to trick ourselves into a more pleasant reality. This tendency is usually adaptive but it can at times interfere with functioning, and one of the primary ways it does this is by disrupting mentalization. Most of what is really happening in

relationships is typically outside of our awareness most of the time, and mentalization involves actively trying to become more aware. An implication of the idea of mentalization is that you can come to understand yourself better by having relationships and communication with others. Their reaction to you tells you something about yourself, as does your reaction to them.

Mentalization offers deeper classification of IM based on types and tense. While our IM may not discern this in the moment, examining your personal language can reveal much. Hopwood continues:

What is critical, and where mentalization really connects with the concept of inner monologue, is the "data" of mentalization of your thoughts about yourself and others. These data can be categorized in various ways. For instance mentalization can occur in either proximal or non-proximal relationships, and it serves different functions in each. Mentalization is probably most often thought about as it occurs in the present, "He is insulting me because he is insecure, so I could probably avoid confrontation by tolerating his insults and pointing out his strengths." However, mentalization about the past offers a means for working out the conflicts and anxieties of previous interpersonal situations. "We were in a different place, and she did not realize that what she was saying was hurtful." Mentalization about the future helps prevent distressing interactions, "I had better think carefully about how I want to discuss that with him, so that he will understand what I am saying."

Mentalization depends greatly on a person's ability to intuit another's IM; just as actors must assign IM to a character. As we become more aware of the concept of personal mentalization, the concept expands and extends to include the concept of thinking for and about another. This has an immediate and relevant impact to that of the actor. By understanding mentalization related to another, we may become better interpreters of a character's behavior.

The concept of mentalization is the psychological theory I have found that most closely aligns with the idea of an actor's IM. The use of empathetic thought toward another is exactly the process we use when advocating for our character. The ability to detect and understand another's thought process is clearly an actor's skill. The actual replication or invention of the imagined thoughts is what make actors unique. Hopwood continues, "The critical capacitates for mentalizing to occur are empathy for others' situations and motives and honesty with respect to your own behaviors and desires." Mentalization,

with its main conduit, IM, is clearly a powerful tool. Making sure you can harness this empathetic concept can increase your capacity for interpretation. Understanding another's IM makes you more facile in creating a character's.

Mentalization Exercise

In an effort to understand and empathize with another's IM, use a scene that has been rehearsed, memorized, and polished in the rehearsal process. Without much fanfare, ask the actors to switch roles. No time to think. No coaching other than don't do imitations of the partner's choices and no mockery if playing out of type. Simply inhabit the other's role and present the work honestly.

Following the presentation, ask for feedback related to the thought process of each actor. The object is not how "good" the actors were, but rather how honest they were and how inhabiting another offered empathy for their partner's role.

IPC

Another interesting psychological perspective to consider is the Interpersonal Circumplex (IPC) first developed by Timothy Leary and later refined by many others. The concept describes a person's motivations, especially related to others, by defining their responses on an axis of domination versus submission and warmth versus coldness. (Figure 19.1) Depending on how a person reacts in certain situations, we may graph their personality and resulting IM.

Most of us adjust depending on the situation, allowing ourselves to be dominant in a conversation and submissive when the other is speaking to us. A friendly conversation falls on the warm side of the chart, but when an opinion we disagree with is mentioned, we may fall into the cold area. Complimentary relationships are found when one is perhaps more dominant and cold while the partner is more submissive and warm. Conflict is found when people are too similar based on this scale.

Using *A Streetcar Named Desire* again, we can see the inevitable clash between Stanley and Blanche because they are both dominant. Although Stanley is further on the cold spectrum and Blanche operates from a place of warmth, their quest to be dominant in the apartment and Stella's life portends disaster. We can also see that Stella and Stanley have created their (albeit unhealthy) life together due to Stella's submissiveness and warmth. Mitch can also be a perfect complement

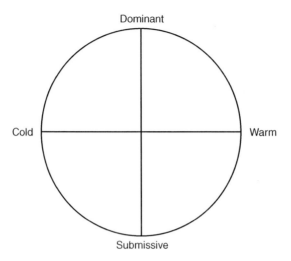

Figure 19.1 The Interpersonal Circumplex (IPC).

to Blanche, as his stoic nature falls onto the cold spectrum of the chart. It is not until Mitch becomes dominant that we realize that his affair with Blanche is doomed.

Transferring this sort of interpersonal examination to an actor's analysis can enhance the IM based on this streamlined and organized theory. While my oversimplification of the theory can be deepened through further study, an actor can use its essence to analyze scripts and explore varied choices in rehearsal. So while one actor's version of Blanche is that for the majority of her life she is dominant and warm, when faced with a challenge like Stanley's revealing his knowledge of her past history in Laurel, she can turn submissive and cold by shutting down. She might also roar back by being dominant and cold by calling the information lies.

The issue here lies in the actor's own IPC orientation. Are you personally a submissive and warm person? Can you alter your way of thinking to think like a dominant and cold person? By understanding that not every character thinks like you and rehearsing your IM to match the character, you can achieve this transformation. It takes practice.

IPC Exercise #1

During a rehearsal, focus your IM on only dominance and submission. If someone dominates you in volume, proximity, or with condescending

choices, force your IM to go to a stream of powerfully based thought that challenges your partner. "He can't treat me like that!" "Oh that's the game we are playing." "Back off Mister!" and let this IM inform your performance of the text. Conversely, if you partner reacts submissively to your choices, force your IM into fear-based IM that hands your partner the power. "I don't want to hurt him." "He's right." "Whatever you say." Following these two very different iterations of the scene, examine what worked and why. Can some choices from the dominant version work within the submissive? By altering your personal IPC in order to match the character's, you can expand your sometime-limited habitual personal choices.

IPC Exercise #2

Recreate the image of the sectioned circle largely on the floor. This image will serve as the playing space for the scene. The actors must move to where they imagine they are in their IPC during the course of the scene. The exercise forces the actor to make decisions that physically reveal internal choices. The map on the floor should be experimented with. Can two actors be in the same area during the scene? Who is forced into submission and why? This could be a great exercise for directors to enhance blocking choices.

CCRT

A third theory that translates handily to character analysis is Core Conflictual Relationship Theme (CCRT). This theory explores interpersonal dynamics through wish, expected response, and actual reactions. It relates to the recurring patterns in patients' central relationships and, some could argue, defines a person's super-objective: the core issue, spine, or overarching need that defines one's interpersonal and personal needs and interactions. Lester Luboorsky in his book *Understanding Transference; The Core Conflictual Relationship Theme Method* uses CCRT to create narratives or stories (mini-plays) from a person's life. These are called relationship episodes. Patients may simply tell their story or in some cases reenact them.

This translates similarly to the actor's reading of the script for clues related to the character's behavior. Then, through analysis of the data, actors are able to assign a core issue or super-objective that drives this person. Once identifying the spine of the character, the actor's IM is easily created. The first part of the theory involves the role of people within the narratives including self, others, and the therapist, as well as the completeness of the narratives. So, we (as therapist) read the

script and discover how Blanche offers incomplete information about her dismissal from school to her sister, and we realize that she is not being entirely forthcoming by offering partial narratives. Luboorsky provides a one-to-five scale for rating the completeness of the narratives to assist in the analysis called the "Essence of the Relationship Episode." Using this scale of what was said versus what is inferred offers an entrance to a patient's (and therefore a character's) core conflict.

The frequency and type of episodes begin to add up to the larger picture of the person's wishes, needs, or intentions. (Almost synonymous with an actor's objective.) The analyst/actor must decipher how much they are inferring based on the language chosen by the patient/character. So while a patient may say he wants to be "independent," what he may really mean is, "I wish to assert myself against domination." Rarely does a character openly say his super-objective, but through analysis, the therapist/actor must discern what the character's real issues are in order to create the through-line on which to hang the character's IM.

Luboorsky urges the therapist to examine interactions for positive and negative responses (wins and losses for actors), expected responses (expectations for actors), and the frequency and manner of these interactions (tactics for actors). Most importantly for IM, he measures the expressed versus the unexpressed within a patient. CCRT examines what the character did not verbalize in the moment and what he truly thought or felt at that moment. By analyzing a character in this manner, we may be able to decipher what he has left unverbalized throughout. Using the CCRT can enhance the careful and thoughtful assigning of an active and playable super-objective for a character. The unspoken remains the IM.

Core Conflict Exercise

Examine the clues contained within the script. Identify the core conflict contained within the character—their super-objective. Improvise a scene with another character from the play that is not included in the written script and is related to your super-objective. The scene should have high stakes and conflict. The scene should contain at least three moments of silence lasting longer than 30 seconds each.

Once completed, explore the moments of silence deeply. Where was your IM focused? Did your IM include variations of your super-objective? If so, was there a better version to be gleaned? Is this in fact your character's core issue?

MMPI

The Minnesota Multiphasic Personality Inventory (MMPI) is one of the most widely used personality tests in the United States. Used by the Central Intelligence Agency and others, it evaluates a person's reaction to various questions that reveal issues that may impact job performance. First implemented in 1939, the test has undergone revisions but still may be a handy tool for character analysis to reveal what drives a character's inner thoughts.

The test uses clinical scales that measure a person's concern with bodily symptoms, depressive symptoms, awareness of problems, and vulnerabilities. It also considers respect for society's rules, stereotypical masculine or feminine interests, levels of trust, anxiety, social alienation, excitability, and people orientation. The test is then used to determine the person's compatibility with a proposed employment position or may reveal deeper issues to be addressed.

The test or similar examination of these subjects offers a unique way to inspect a character's thought process. By offering a standardized and accepted approach, you may find this a codified way to analyze each character.

David S. Nichols in his paper "Tell Me a Story: MMPI Responses and Personal Biography in the Case of a Serial Killer" examines notorious serial killer Jeffrey Dahmer's MMPI responses in order to better offer analysis and entrance into his mind. The graphic details are included within the article but Nichols acts more an actor would, advocating for the motivation of the man. He writes:

> In trying to understand the adult Dahmer, one expects a tale of childhood trauma and an extensive one at that, but there are no indications that his parents were physically or sexually abusive. Although his father reported that Jeffrey had been sexually abused by a neighbor boy at age 8, Dahmer denies any such event.

Without salaciousness, he examines seemingly trivial moments of this man's life and connects them to understandable psychological motivations, painting a larger portrait of his inner workings. He writes about:

> another clumsy attempt to be a part of a community. On this occasion, Jeffrey crashed group photographs of the Revere High School chapter of the National Honor Society. In the honor society photo

ultimately published in his senior yearbook, Dahmer's image is blacked out. However, this prank extended beyond the poignancy of his non-belonging to the irony of his choice of which group to crash. Although he apparently had little time for Jeffrey, his father wanted him to excel and had always shown a keen interest in his son's academic achievement. In crashing the honor society photographs, Dahmer could...attempt a counterfeit of something his father could be proud of.

Too often when playing a villain, we go quickly to the easy choices, the need to play evil. By examining the psychological inner workings of a man's mind, we can ultimately understand and portray the IM of this character with the complications contained within all of us. Nichols writes:

> Although the machinery of prosecution and the media understandably focused on the morbid following Dahmer's arrest, it is not unthinkable that loving impulses survived in him. If his preoccupations with dead animals were morbid, his relations with living ones were not. The record suggests warmth and joy with his kitten, Buffy, his dog, Frisky, and a baby nighthawk, Dusty, that Jeffrey tried to save in Ames. Moreover, his report of having felt sickened when as a passenger in his marijuana supplier's car, the driver deliberately sped up and hit a beagle puppy that had wandered onto the road, suggests a horror of cruelty.

Nichols has invested in the thought process and suppositions that any actor must undertake when examining a role. And while examining the mind of this serial killer is perhaps beyond the realm of normal character analysis, we can note that the introduction of psychology into the mix has allowed us to certainly not condone but gain a deeper understanding of the thought process. Nichols concludes:

> In any case, items such as these reveal that, for Dahmer, sex fell outside the realm of personal amorousness. Rather than a means of escape from alienation and conflict, it was itself alienated and conflicted, and the way out of this conflict, its solution, the path Dahmer found to passionate attachment, was death. In the transformation of his guests to corpses, his potency was restored. No longer the child whose viscera was at the mercy of others, he could handle the viscera of his victims, feel the excitement of their escaping heat, find the penis he once feared lost in congress with their entrails.

This example is extreme. I include it to showcase both the advocacy for the character and the relatable motivations for heinous acts.

The creation of an IM for a person such as Dahmer considered so out of the normal work required of most actors is indeed difficult, but the fascination of what lies within the mind of the character must be explored.

One also must only look at the numerous television police procedurals to see the "twisted villains" that actors are asked to play. Rather than the sometimes shallow portrayals so often seen due to the lack of time for rehearsal or the expected formulaic writing; how can we as actors offer more compelling and deeper portrayals? How can an actor truly embrace the complicated IMs of these killers in order to do his best work?

We speak so often of emotional baggage and yet carry so little of it onstage whenever we create our versions of a character. We simplify the character's behavior; we gloss over the confusing parts, and avoid the darkest of behavior. IM can become the luggage cart that carries that emotional baggage onstage; unpacking it when needed to enhance and deepen the scene.

Think of the hours of study and millions of dollars spent on ways to dampen the overactive IM of the anxiety-ridden, self-destructive or sociopathic clients. Think of the ways in which your personal IM reveals all of your hang-ups and blockages. Think of your IM as therapist with whom you share your most private and uncensored thoughts. Though there are various thoughts about the origin of IM, it is undeniably linked to our psychological fabric.

As actor, you must find your best entrance into the psychological workings of your character. As director, you must find the vocabulary of the psychological world of the play. As educator, you must assist the actor in finding unique ways to inhabit the psychology of a character that is still related to the needs of the script. No matter what the goal, an exploration of psychology can enhance the IM and its role on stage or screen.

IM in Other Performance Forms

While this book concentrates on IM for actors, it is beneficial to examine other performance forms to deepen an understanding of the concept of personal and character IM. The phenomenon of a performance IM is not unique to acting. Performers of varying types all connect in some way to those voices in their head.

In an entirely unscientific collection of data, I asked colleagues, friends, friends of friends, and more to examine what they think about when performing. All were given little information about the thrust of the book. They were simply asked to share what they think about when performing. I collected numerous responses and included what I thought might be the most interesting to examine in relation to our purpose. All are professionals in their field.

Melanie, Opera Singer

For an opera singer there are different inner monologues during different parts of the process. As a professional you've probably mostly mastered your technique in a role before the first rehearsal through a series of coachings and lessons. Because we arrive memorized to the first rehearsal, during a first staging I'm multitasking like crazy. Figuring out the style of the conductor and director, finding out which of my colleagues are strong actors, learning where my feet go in the blocking, and also trying to sing my very best so as to be impressive to conductor, director, and impresario. Further on in the process I begin turning myself over to the character more and more. I often use the idea of a pie chart with my process. At any given time you have eight pieces of pie but they are rarely equal. However, in performance, character needs to be 75 percent of the pie, with the other pieces being dropped props, hard parts to sing (either because the music is difficult or the

technical stuff is difficult), a tight corset, shoes that hurt, raked stages, hearing the orchestra, sneaking a peek at the conductor every now and then, just to name a few. On those rare nights when you are in perfect voice, your love life is good, the hotel is nice and has good cable, you love your colleagues, and feel you are making real magic—ahhh those nights! Magic!

Vasi, Pop Singer

One of my producers once told me that performing is like having sex. The more you worry about how you're doing, the less you'll enjoy it. The more you lose yourself in the moment the better. It's really hard not to get self-conscious when you're putting something out there in front of an audience that you hope they will like and respond to, but in a way you have to be selfish with the experience. If you're not enjoying it, they won't be either. When I first started performing I was very technical, and there were constantly a million thoughts running through my mind, Will I hit this note? I need to breathe here, That sounded not great. Why are my back up singers not loud enough? Is the audience liking this song? The more I performed, the more I learned, or tried, to let go of all those thoughts and focus on my emotional connection with the music and having fun. Almost forgetting like there were people in the room or whatever and focusing on how happy singing makes me, the meaning or story behind the lyrics, vibing with my bassist and my band, enjoying the moment, and the experience and letting it wash over me vs. trying to control it. Sometimes I would surprise myself and think, whoa that sounded amazing, or conversely, that was terrible, and I would jump out of that personal space for a second and be more of a third party observer, but I would always try to get right back into my own head, and not think about judging my performance while I was doing it. It's a difficult balance, but for me, my best performances were the ones where I let all those nagging self-conscious criticisms go, and focused instead on the meaning of what I was singing, how it felt physically and emotionally to be pouring all of that energy out, and using that energy as a kind of force field around me to help me focus and stay connected in the moment.

Jeremiah, Flutist

Inner thoughts as a flutist include, *Start clear...soft articulation...widen the embouchure...ooh, that's flat...damn it...missed that...big breath here, conserve, conserve...relax jaw...crystal sound...upper overtones...easy...easy...I should be using the other head joint for this...grrr...oh!...That worked well...straighten the tone...slow*

vibrato to finish…crystal sound…tune it…tune it…Grrr…almost perfect…move the music stand and let's see if I can get this put away before…where does this go. The fun of this was, these were my thoughts, in a recent performance of the Bach Arioso. It was kind of fun to relive that, and it's also eye opening how little good thoughts or credit I give myself while playing. Oddly enough, I'm far less critical than I use to be, so there is some upward movement in that department. It's still work…in every moment…and the self-critical voice is necessary.

Jerry, Musician and Singer

My thoughts while performing have run a gamut from what a person is wearing to where I'm planning to stop for food on the way home from a show. Mostly I'm considering what song I should play next because I'm always reading the audience to see where they are going by themselves or because of the way they are reacting to what I'm playing at the moment. I almost always have a song chosen before I finish the one I'm playing and it's uncanny how often someone will approach me with a request for the very same song. I've also discovered that I'm capable of doing simple math while I'm singing.

Payton, Contemporary Classical Musician

Most of the music I perform is contemporary classical music. Some of it involves a lot of improvisation and some of it involves no improvisation. The style affects my mental state a bit. If I'm interpreting music that includes no improvisation then I find there is a mixture of "front brain thinking" and "whole self experience." These are my own terms, but what I mean by them is that with the "front brain thinking" I'm using some energy to keep track of where I'm going with the piece, especially so that I don't have any memory slips if I'm playing a piece from memory. If I'm reading the music then obviously some energy is going into keeping my eyes on the page and my body positioned properly behind the instrument so that I can play the part correctly. This kind of "front brain thinking" is somewhat mechanical but necessary for that kind of music.

The "whole self experience" is impossible to describe in words, though I'll try. It involves the mind, the spirit, the gut, and definitely the body. The mental experience is quite focused and involves a lot of mental imagery, including colors, shapes, and moving figures. But the experience is much deeper and more complete than that, as every aspect of my self is involved, including physical, emotional, spiritual, etc. If I'm really engaged with the music this experience is rather timeless and I really have

no sense of what's going on beyond the music I'm making. I typically forget about the audience and even the instrument I'm playing!

If I'm improvising music the "whole self experience" comes to the fore. There is some element of "front brain thinking," especially if I'm improvising within an established style (e.g. North Indian Hindustani raga), but mostly I'm completely immersed in the moment, trying to listen as deeply as I can to what I'm doing and what others are doing if I'm performing in a group.

Pauline, Travel Radio Show Host

I often have to do monologues in my job as a radio talk show host. But since I'm making them up as I say them (often using notes, since I have to keep topics at my fingertips for dead spots in the show), I don't have any "internal monologue" going on about my feelings towards performing. Instead, my brain is buzzing with the thoughts: how can I make this point I'm trying to make clearer? What should I be adding? I'm editing and writing as I'm speaking, so clarity is my main focus. And entertainment. I try to come up with jokes as I speak because I feel there's nothing that drives a point home better than laughter. So though I deal with a technical subject usually—the how to's of travel— I try to enliven it with jokes, funny anecdotes, or information about the "meat" of travel (history, culture, cuisine, etc.). And because I'm in a quiet studio, either alone or with my cohost (my father), I sometimes forget about the audience altogether. It's a more intimate experience. It feels like I'm talking with just a few people at most, though thousands are hearing the show. But I don't think about that. I always feel like I'm having a one-on-one conversation with someone when I'm doing a monologue on the radio. Perhaps because I'm speaking into a huge mic, and it feels like a presence.

Mike, Communications Director

Communication is all about storytelling. In media training, the story-telling became nonfiction. I counseled speakers to think and speak the truth; that the audience could tell when you were being genuine or not, and when you were speaking from the heart. I asked them to visual-ize the people on the other end of the camera and/or microphone, not the electronic devices that carried their image and voice through the airwaves; to picture the people listening to them and watching them in their homes, cars, in bars, etc., wherever. To use the interviewer, the camera, the microphone as the audience's proxy. When coaching exec-utives giving speeches, it was different with every speaker. It depended

on the executive, and how comfortable they were with public speaking in general, and if they had any specific fears about giving a speech. In every case, though, the material they had to deliver was not only familiar to them, but part of their life's work. And it was important for the audience to have the information they had to impart. Once they accepted that, it again came down to having them think about simply telling a story—communicating a plot, a comedy, a drama, a docudrama—but always a story.

Laney, Contemporary Dancer

Whether I allow myself to become lost in the music really depends on the choreography and intention of the choreographer. If the piece is more "technical" then my thoughts become targeted toward executing the movements. (i.e. I have to be at "x" location on count "y" in order to accomplish "z") However, if the rehearsal process has been lengthy, then the piece is more "in my body" and the "thinking" becomes less necessary. So possibly my inner monologue is more technically driven— and often times less enjoyable. The music can shape and enhance the performance, but getting lost in the music becomes more challenging.

If the piece is more character/intention driven, then I have found myself with an inner monologue that deals more with the emotions of the character that are shaped by the movement and music. I worked with a choreographer who was an actor and his work was much less technical and more character driven. I found that type of work far more rewarding and incredibly challenging to perform without "over-emoting" (something that drives me CRAZY when I see it happen on stage). The ideal dancer can combine the extremely technical with the incredibly interesting characters and make it all ring true and seem effortless simultaneously.

Anonymous, Former Top-Ranked Competitive Distance Runner

Training Runs: These are miserable and distraction is welcomed. To get through the boredom and tedium of long and frequent training runs, I first get myself focused for what is ahead of me, get into a rhythm and then force my mind to drift. I try to think about things that I need to do, such as errands or conversations I may need to have with people and then play them out in my mind. Every so often I force myself to think about my run, e.g. am I running at the proper pace, is my form correct and is my breathing free and easy, before drifting off again and forgetting about what I am doing. The faster I get a training run over with the better it is for me, and playing out boring actions or

conversations works great at killing time. Friends of mine play games like trying to list all of the brands of beer, cigarettes, and similar categories to distract themselves, or make up life stories about the people they pass while running. No one enjoys training runs and so anything that can be distracting is shared with other runners.

Races: These are painful (especially the shorter the race) and so distraction is necessary, but can also be dangerous, i.e. if you lose too much focus you can drop precious time and run yourself out of the race. I try to focus on monotonous actions that will kill time, but are also related to what I am doing, so again, I stay focused, but also let my wind go a bit and avoid thinking about how much my legs hurt with lactic acid building up and why my lungs are burning. These thoughts tend to be fourfold:

(1) Focus on my breathing and try to keep it consistent regardless of the terrain. By getting lost in my breathing and counting the seconds between and during breaths, I can make sure I am breathing properly and keeping myself relaxed, all while taking time off the clock.

(2) Focus on the distance between me and the runner ahead of me, and then slowly closing the gap and picking off that runner before moving on to the next. Because in longer distance races it can take a mile or more to overcome another runner, focusing my attention here allows me to improve my position, while again, taking time off the clock.

(3) I pick silly fights before a race—girlfriends are the perfect target for this even when they know why you are doing it—and then play out the argument/fight/resolution in my mind while I run. It's great because I can take the time to think about what I would really want to say, while using that anger and accompanying adrenaline to keep me going. It may be irrational, inappropriate, offensive and a host of other and self-destructive oriented behaviors, but it works unbelievably well.

(4) During marathons when I am running with team members who are handling the pacing, I try to take advantage of having less work to do and really let my mind go. Two favorite thought patterns include: (a) what am I going to do with the rest of my day once the race is over; and (b) how much unhealthy food am I going to consumer later that day. I will spend as much time as possible detailing every aspect of these two topics before I get too bored.

Michael, Attorney

As an attorney, my job is to advocate for my client. Advocacy can take on many different forms and is often influenced by your audience, which can include opposing counsel, your client, colleagues, a court, or a jury. For example, when I am arguing for or against a legal position to a judge, I'm thinking about what can I say that will influence the judge's decision

in a way that is favorable to my client. A critical aspect of the process is listening to the judge and opposing counsel so I can formulate a persuasive argument. Preparation is also critical so you can avoid surprises. The process is like putting a jigsaw puzzle together but in the back of your mind knowing at any moment that the pieces you put together can get mixed up again. As part of the internal monologue, you are constantly sorting and resorting the pieces with the hope that in the end all of the pieces will fit together and form a coherent and persuasive argument.

Ethan, Stand-Up Comedian

My inner monologue is raging all the time, and with stand-up, it's a perpetual issue because I'm both writing and performing at the same time. Lots of stand-ups are more natural performers, others are more natural writers. While I can't speak for how it works for other stand-ups, as there's no fixed process, I will tell you that the inner monologue is raging at all times, and is what's normally considered a character flaw is generally associated with good discipline and professionalism. I actually find that my inner monologue is less active on stage than any other point (or if it is, it's working so fast and the stakes are too high for me to pay attention to it). Before and after I'm performing, however I tend to obsess. Before I perform, my inner monologue focused on what I was going to say, how to make what has been working stronger (I record every set), and talk it through myself (my roommate's learned to deal with me talking to myself). After a show I usually regret the things I didn't say, try to fix up things that worked once, and compare and contrast to previous sets (distinguishing between particular wordings, if any jokes work better when placed in a particular order, etc.). In fact, when I acted for the first time in years a few months ago, I found it relieving that I didn't have to worry about what I was gonna say, just how to say words that were handed to me.

James, Rock Musician

Inner Monologue is one of those things that I try to stay very aware of while performing. I find it's loudest in between songs. When the amps stop blaring, reality gets sucked back into my head like a vacuum. I start thinking about how the audience sees us, hears us, how tired their feet might be while standing, if they have enough attention to make it through the set. But when the next song starts, it's like a switch goes—I'm totally on emotionally driven auto pilot. I don't think of the notes, the chords, the audience, today, tomorrow, the pay, etc. It's all about living out the story of the song. I am the song, as are the other guys on stage. No room for voices in the head.

Adriana, Tango Dancer

As a follower in tango, I have developed a deep awareness of how important it is to wait and listen to my partner. Undoubtedly, connection is a vital element in the dance so I consciously focus on it and try to maintain it throughout the dance. It is one of the most important aspects of tango dancing.

Before performing I look for getting into a peaceful, quiet mind state, where silence becomes priceless and staying relaxed, calmed and in control is the key to find connection. I immerse myself in thoughts and I review in my mind the technique subtleties we worked on in the rehearsal that morning, the things we corrected and my embellishments. I visualize myself at the dance floor dancing with absolute confidence, flowing and enjoying.

Once I am on stage, it is purely feeling and moving together in perfect connection, it is interpreting the music and flowing through the movement. I feel I am not thinking when I am dancing because if I do it I start getting tense and looking rigid and most likely I will miss the lean. So feeling each other, connecting, and listening to the music will lead us for sure to an enjoyable and successful performance.

Erika, Lady Gaga Impersonator

As a Lady Gaga tribute artist, I have learned to manipulate my mind into thinking differently than my usual acting methods. Without inner monologue my thoughts and feelings toward her message and Gaga's songs I wouldn't be able to honestly portray her. During my shows, I usually stick to a pretty basic script, but several audience members will call out to me or things will happen differently than planed each day and I have to be aware / respond accordingly as Gaga. Thoughts such as quick changes, on the spot re-blocking due to injuries from dancers, and costume malfunctions are always on the mind but playing a pop star such as Lady Gaga it doesn't truly effect my performance but instead keeps me on my toes and focused. Doing two shows a day, every day of the week, things become so routine that some shows I find myself thinking about my future plans for the evening or going over what things I needed from the grocery store. The audience is what kept me alive during most days—if the audience was responsive to the show, I immediately became so free in my performance that at times I would do riffs or dance moves that I didn't even know I was capable of. My usual acting techniques of relying on other actors instead becomes relying on the audience's response and sometimes they don't give out exactly what you need. I try to keep the audience engaged as much as possible, but sometimes they enjoy things most when I get lost in enjoying myself

onstage. I think inner monologue is critical, without it, words, actions, and motives become word vomit and purposeless movement. The inner monologue is what keeps "the flow" of naturalness, ease, and honesty. Luckily for me, portraying Lady Gaga allows me to focus on a very specific character that doesn't necessarily change. She is mostly simple thoughts throughout the show: "Be brave and make them have a good time, but don't forget to double snap that mirror dress!"

＊　＊　＊

While these testimonials are from disparate performers, their ability to analyze IM when "onstage" offers unique perspective. Examining the thought process of other performers may offer insight and identification into your personal and character IM. Acknowledging and empathizing with another's struggle in regards to performance IM may empower you to overcome similar issues. Knowing when and how others use IM productively when performing may inspire you to examine your approach to IM in acting.

You will note that several of these testimonials include IMs of self-doubt and inward-focused criticism. Similarly to the "IM as Enemy" chapter (chapter 5), we see that performers of any ilk are bonded by an insecurity about their talent and constant questioning of an audience's reaction. The actual act of sharing your work, live, immediately raises the internal stakes and increases the volume of the negative aspects of the IM. While some performers may say they thrive on this heightened and increased activity of the enemy IM, most benefit from an IM that can nurture and support through encouragement.

This book has been written to help you focus your IM on creating a clearer understanding of the difference between personal and character IM. By focusing on the character's thoughts, you may free yourself from the self-doubt that plagues so many artists from doing their finest work. Feeling "free" within the character's thoughts or creating a personal IM of confidence allows better performances. The contemplations contained within this book offer new elements to concentrate on when acting. Distracting or redirecting your IM with the concepts contained within may positively enhance your current approach. No matter what the performance form, your IM must become your best friend and biggest supporter.

Ian, Actor

"The first time that I worked with inner monologue as an actor, I didn't even know that that was what I was doing. I was in high school working on a show, and decided that an interesting way for me to connect to the character would be to write what I thought he was thinking after every line. I didn't have a name for it at the time, and I just did it because it helped me memorize and connect.

Fast forward two years to my very first acting class in college, and my professor says the words 'Inner Monologue' and suddenly I had a name for this thing that I had been doing. Not that I really KNEW what I was doing yet.

Fast forward again three years, when I am asked to work on this book as an assistant. I immediately jump at the opportunity, given the (rather naive) thought that I had that I knew everything that there was to know about inner monologue. I mean, I'd been in plenty of plays, and had always paid attention in class when inner monologue was brought up and I still did that exercise from high school whenever I would score a script of mine. I thought that this was a perfect opportunity!

Fast forward one last time, six months later as I am typing this. I realize now that there was so much to be learned and so much to find out about myself and my IM, even compared to six months ago. I think back to my experiences with IM and I see a lot of successes and shortfalls. There is a lot that I probably got right the first time, but there's definitely just as much that I realize now was an absolute mess. The combination of my training, experience, and having worked on this book, has forever changed my personal approach to IM and acting, for the better.

That is not to say that I haven't had positive experiences that have helped me in the past. For example, I was in a production of *The Laramie Project* a number of years ago that has really stuck with me.

I played a number of characters, but the most difficult to connect to was the murderer of Matthew Shepard, Aaron McKinney. I tried all sorts of conventional ideas of research and learning the backstory and sorts of things to try and connect to this character. Despite all of the work that I put into the show, I still struggled with the character. I even did that 'silly' little exercise of writing in the character's thoughts onto my script. But still I couldn't connect on the level of what was expected of me. So I e-mailed a professor of mine and told him about the role and all the different work I had done and how I was still having immense difficulty getting to the place that I needed to be at for the show. And his response was one that changed my approach to acting forever. He told me that everything I was doing was great, but that I seemed to be ignoring it when I got on stage. He said that it was great that I knew what the character was thinking, but now I had to make it what I was thinking as well. It seems like such a simple jump of logic now, but at the time, the idea of making these thoughts my own was monumental for me. And I hold on to that idea even now.

However, despite all the progress that I have made in my acting roles and in classes, I still struggled with outside thoughts creeping in. For example, a well-developed character thought of 'I need to get out of this room' would quickly be invaded by a personal thought pertaining to 'How am I doing?' or 'Are they getting it?' I would get so easily distracted that I would lose all sense of true emotional connection to my IM and it would become a simple mask as opposed to a living breathing character. I always felt that I wasn't doing good enough of a job or that I needed to focus more and that I could avoid such ideas. But every role that I had, no matter how much I worked and no matter how much I focused, I'd still have issues. Then I started working on this book, and things started to change. One of the books that I read for research brought up this very issue of these outside thoughts. And it gave ways and tips on ignoring these thoughts that were very simple. The biggest one was just this idea of letting the ideas and thoughts that weren't wanted just slip off my brain. Letting the brain recognize the invading thought and just avoiding it seems like a simple enough idea, but seeing it described in such a manner of 'Zen' was a truly helpful thing. I started practicing with this Zen thought just when I was by myself, focusing on a specific thing and working around the incoming thoughts. I've gotten pretty good at it and can be more focused than ever. And I truly cannot wait to get the chance to apply it to my acting in the next year.

IM has been a part of my life forever. But it took until working on this book to truly realize that and see that I can apply it in a truly meaningful way to my craft. I hope the same type of Eureka moments can happen to any of the actors, directors, or teachers that read this book, and all of the exercises that it has within."

Conclusion

May We Agree?

May we agree that IM is a necessary and powerful element to be included in acting at appropriate moments. The IM muscle needs constant flexing and attention in order to make the actor adaptable to any situation and waits below the surface ready to assist any interaction that needs processing. The IM does not supplant or interfere with pure interaction but assists in the internal logic of the scene.

Its deep, intimate, and sincere roots create actors that are vulnerable, honest, raw, flexible, compassionate, responsive, and bold as they honestly replicate the human condition in all its forms. IM is the internal struggle that impacts external work.

May We Accept?

May we accept that an actor should try to think the thoughts of the character whenever possible. Personal IM is revised to thinking a character's thoughts. Despite the constant influx of unwanted or unnecessary personal IM, the job of the actor is to remain invested in this alternate reality of playing a character.

If more IM study is desired, two books that attempt to transform the personal IM and may prove helpful, are Rick Hanson's *Just One Thing: Developing a Buddha Brain One Simple Practice at a Time* and Michael A. Singer's *The Untethered Soul: The Journey Beyond Yourself*. Both aim to place a personal IM in a Zen-like state that accepts, understands, and empathizes with the complicated and sometimes antagonistic thoughts within the personal IM. They suggest that when an unwanted image pops in, we must simply let it float away. Some call it a Zen IM, a Teflon mind or awakening the Buddha

within. This calm within the heightened state of acting is a concept to be personally explored. This concept of relaxed readiness is an accepted idea in acting that can include the IM.

Within this investment of thinking a character's thoughts, you should attempt to maintain a Teflon mind related to personal IM. This refers to a state where you accept without self-flagellation that unwanted thoughts appear, allowing them to be whisked away rather than to remain trapped in your brain. There is great and lasting value in the recognition and acceptance that unwanted personal IM may interfere with the main job of thinking like another. Rather than shoving a personal IM away (which may cause an avalanche of unnecessary personal IM), guide yourself back to the character's innermost thoughts. In this enlightened state, a personal thought may enter into your consciousness. It may be disregarded, acknowledged, or processed with little effort wasted on its acceptability. It doesn't stick and fester. It is active, understood, and, most likely, deflected. Your new way of thinking understands your unique job and can exist on two very different planes—personal and character. And without much tension, can categorize and deal with any stimuli on stage or screen.

Trusting that you can do your job, acknowledging that you have done your homework, and accepting momentary lapses within the process may allow you to relieve yourself from personal thoughts that may distract. This gentle guidance back to the character IM can be achieved with little effort once you have accepted the multiple layers of IM necessary.

May We Align?

May we align our purposes? With three very different audiences, the book's goals remain simple for each.

As educators, we have a responsibility to prepare our students for any professional situation they may encounter when pursuing work.

As directors, we must have a keen and steady hand that offers guidance when necessary and shared examination with all collaborators when called for.

As actors, we must keep alive and in active thought as we listen and respond, employing IM when appropriate and necessary.

May We Conclude?

May we conclude that IM is a concept that many of us have heard about but have rarely invested in fully. Allowing yourself to explore IM deeply is a valuable supplement to approaching any role. IM is a unique and important augmentation to the standard approach to acting.

Works Referenced

Aidoo, Ama Ata. *Dilemma of a Ghost*. Ibadan: Abiprint & Pak, 1981. Print.

Allen, Woody, Dir. *Annie Hall*. MGM / United Artists Entertainment, 1978. Film.

Berlin, Irving, Herbert Fields, and Dorothy Fields. *Annie Get Your Gun*. New York: Rodgers and Hammerstein Organziation, 1967. Print.

Bernstein, Leonard, Betty Comden, and Adolph Green. *On the Town: A Musical Comedy in Two Acts*. New York: Tams-WitmarkMusic Library, Inc, 1944.

Bernstein, Leonard, Arthur Laurents, and Stephen Sondheim. *West Side Story*. New York: Random House, 1958. Print.

Blumenfeld, Robert. *Tools and Techniques for Character Interpretation: A Handbook of Psychology for Actors, Writers, and Directors*. Pompton Plains, NJ: Limelight Editions, 2006. Print.

Bunim, Mary-Ellis and Jonathan Murray. *The Real World*. Bunim/Murray Productions, MTV, 1992. Television.

Carroll, Jon. "Transformed by Art." *San Francisco Chronicle*. SF Gate, Aug. 6, 2000. http://www.sfgate.com/entertainment/article/Transformed-by-Art-Writers-actors-and-critics-2745401.php.

Chekhov, Anton. *The Three Sisters*. Translated from the Russian by Constance Garnett, New York: Macmillan, 1916. http://www.eldritchpress.org/ac/sisters.htm.

Clark, Bob, Dir. *A Christmas Story*. MGM Films, 1983. Film.

Cohen, Robert. *Acting One*. Palo Alto, CA: Mayfield Publishing Company, 1984. 44–5. Print.

Colson, Mark. "Media Acting." Assistant professor of Media Acting, Michigan State University, Personal interview. Nov. 2012.

Cukor, Geroge, Dir. *A Star Is Born*. Warner Brothers, 1954. Film.

Eyen, Tom and Henry Krieger. *Dreamgirls*. New York: Tams-WitmarkMusic Library, Inc, 1981. Print.

Ferber, Edna, Jerome Kern, and Oscar Hammerstein. *Show Boat*, New York: Rodgers and Hammerstein Organziation 1927. Print.

Fincher, David, Dir. *Fight Club*. 20th Century Fox, 1999. Film.

Freud, Sigmund. *The Ego and the Id*. New York: W. W. Norton, 1960. Print.

Gerstenberg, Alice. *Overtones*. Project Gutenberg-tm. http://www.gutenberg.org/files/3068/3068-h/3068-h.htm#link2H_4_0006.

Gervais, Ricky and Stephen Merchant. *The Office*. BBC Television, BBC, 2001. Television.

Gilliam, Terry, Dir. *Fear and Loathing in Las Vegas*. Universal Pictures, 1998. Film.

Hagen, Uta. *A Challenge for the Actor*. New York: Scribner's, 1991. 66–8. Print.

Hammond, Jacqueline and Robert Edelmann. "Double Identity: The Effect of the Acting Process on the Self-Perception of the Professional Actors." In *Psychology and Performing Arts*. Amsterdam: Swets & Zeitlinger B. V., 1986. Print.

Hanson, Rick. *Just One Thing: Developing a Buddha Brain One Simple Practice at a Time*. Oakland, CA: New Harbinger Publications, 2011. Print.

Harron, Mary, Dir *American Psycho*. Lionsgate Films, 2000. Film.

Heckerling, Amy. *Clueless*. Paramount Pictures Entertainment, 1995. Film.

Heerman, Victor, Dir. *Animal Crackers*. Paramount Pictures, 1928. Film.

Hitchcock, Katherine and Brian Bates. "Actor and Mask as Metaphors for Psychological Experience." In *Psychology and Performing Arts*. Amsterdam: Swets & Zeitlinger B. V, 1986. Print.

Hopwood, Christopher. Assistant professor of Psychology, Michigan State University, Personal interviews. August–November 2012.

Ibsen, Henrik. *A Doll's House: A Play in Three Acts*. Translated by William Archer, Boston: Walter H. Baker & Co, 1890. http://archive.org/stream /adollshouseapla00gossgoog#page/n4/mode/2up.

Ince, Thomas. *The Dream*. Independent Moving Picture. 1911. Film.

Isherwood, Christopher. "A Glitzy Execution in a Religious Revival." Review of *Jesus Christ Superstar*. *New York Times* Mar. 22, 2012. Print.

Jung, C. G., and Aniela Jaffé. *Memories, Dreams, Reflections*. New York: Vintage, 1989. Print.

Kander, John, Fred Ebb, and Joe Masteroff. *Cabaret*. New York: Random House, 1967. Print.

Kaufman, Charlie, Dir. *Adaptation*. Columbia Pictures, 2002. Film.

Kaufman, Moisés, and Leigh Fondakowski. *The Laramie Project*. New York: Dramatists Play Service, 2001. Print.

Kelly, Gene and Stanley Donen. Dirs. *Singin' in the Rain*. MGM Films, 1952.

Leary, Timothy. *Interpersonal Diagnosis of Personality; a Functional Theory and Methodology for Personality Evaluation*. New York: Ronald, 1957. Print.

Liepa, Torey. *Figures of Silent Speech: Silent Film Dialogue and the American Vernacular, 1909–1916*. Ann Arbor, MI: ProQuest LLC, 2008. Print.

Lloyd, Christopher and Steven Levitan. *Modern Family*. Disney-ABC Domestic Television, 2009. Print.

Lloyd-Elliot, Martin. "Witches, Demons and Devils: The Enemies of Auditions and How Performing Artists Make Friends with These Saboteurs." In *Psychology and Performing Arts*. Amsterdam: Swets & Zeitlinger B. V., 1986. Print.

Luboorsky, Lester and Paul Crits-Christoph. *Understanding Transference: The Core Conflictual Relationship Theme Method*. Washington, DC: American Psychological Association, 1998. Print.

Maslow, Abraham H. *Religions, Values, and Peak Experiences*. Harmondsworth, UK: Penguin, 1976. Print.

McKay, Adam, Dir. *Anchorman: The Legend of Ron Burgundy*. DreamWorks Pictures, 2004. Film.

McQueen-Fuentes, Glenys. 1986. "Theatrical Clown—A Theatrical Exploration of the Inner Self." In *Psychology and Performing Arts*. Amsterdam: Swets & Zeitlinger B. V, 1986. Print.

Merlin, Joanna. *Auditioning: An Actor-Friendly Guide*. New York: Vintage, 2001. 3–18. Print.

Meisner, Sanford, and Dennis Longwell. *Sanford Meisner on Acting*. New York: Vintage, 1987. Print.

Miller, Arthur. *The Price*. Harmondsworth: Penguin, 1970. Print.

Molière, Jean-Baptiste Poquelin. *Tartuffe*. Project Gutenberg-tm. http://www.gutenberg.org/cache/epub/2027/pg2027.html.

Nichols, David S. "Tell Me a Story: MMPI Responses and Personal Biography in the Case of a Serial Killer.," In *Journal of Personality Assessment*, 86:3, 2006, 242–62.

Odets, Clifford. *Waiting for Lefty*. New York: Dramatists Play Service, 1962. Print.

O'Neill, Eugene. *A Play: Strange Interlude*. New York: Boni & Liveright, 1928. Print.

Recinello, Shelley. "Toward an Understanding of the Performing Artist." In *Psychology and Performing Arts*. Amsterdam. Swets & Zeitlinger B. V. Print.

Roznowski, Rob. *Happy Holy Days*. Michigan State University, 2011.

Scott, Siiri. Head of Acting and Directing, Department of Film, Television and Theatre, University of Notre Dame. Theatre Nohgaku, company member. The Skilled Speaker, owner. Personal interview. December 2012.

Shakespeare, William. *As You Like It*. Project Gutenberg-tm. http://www.gutenberg.org/cache/epub/1121/pg1121.html.

——. *The Tragedie of Hamlet*. Project Gutenberg-tm. http://www.gutenberg org/cache/epub/2265/pg2265.html.

——. *The Tragedie of Macbeth*. Project Gutenberg-tm. http://www.gutenberg .org/cache/epub/2264/pg2264.html.

——. *The Tragedy of Romeo and Juliet*. Project Gutenberg-tm. http://www.gutenberg.org/cache/epub/1112/pg1112.html.

——. *Twelfth Night*. Project Gutenberg-tm. http://www.gutenberg.org/cache/epub/1526/pg1526.html.

Shire, David, Sybille Pearson, Richard Maltby, and Susan Yankowitz. *Baby: A Musical*. New York: Music Theatre Interantional, 1984. Print.

Simon, Neil. *Barefoot in the Park: A New Comedy*. New York: Random House, 1964. Print.

——. *Brighton Beach Memoirs*. New York: Random House, 1984. Print.

Singer, Michael A. *The Untethered Soul: The Journey Beyond Yourself*. Oakland, CA: New Harbinger Publications, 2007. Print.

Sondheim, Stephen and James Lapine. *Sunday in the Park with George: A Musical*. New York: Dodd, Mead and Company, 1986. Print.

———, Hugh Wheeler and C. G. Bond. *Sweeney Todd, the Demon Barber of Fleet Street: A Musical Thriller*. New York: Dodd, Mead and Company, 1979. Print.

Sophocles. *Oedipus the King*. Project Gutenberg-tm. http://www.gutenberg.org/files/31/31-h/31-h.htm.

Stanislavsky, Konstantin. *An Actor Prepares*. New York: Routledge, 1989. Print.

Strasberg, Lee, and Evangeline Morphos. *A Dream of Passion: The Development of the Method*. Boston: Little, Brown, 1987. Print.

Strouse, Charles, Michael Stewart, and Lee Adams. *Bye Bye Birdie*. New York: DBS Publications, 1968. Print.

Strouse, Charles, Thomas Meehan, and Martin Charnin. *Annie: A Musical Comedy*. New York: Music Theatre International. 1973. Print.

Styne, Jule, Arthur Laurents, and Stephen Sondheim. *Gypsy; a Musical Suggested by the Memoirs of Gypsy Rose Lee*. New York: Random House, 1960. Print.

Warren, Harry, Michael Stewart, Mark Bramble, Al Dubin, and Bradford Ropes. *Forty-second Street: The Song and Dance Fable of Broadway*. New York: Tams-WitmarkMusic Library, Inc, 1980. Print.

Wasserman, Dale and Ken Kesey. *One Flew over the Cuckoo's Nest: A Play in Two Acts*. New York: S. French, 1974. Print.

Wilde, Oscar. *The Importance of Being Earnest*. Project Gutenberg-tm. http://www.gutenberg.org/files/844/844-h/844-h.htm.

Williams, Tennessee. *A Streetcar Named Desire*. New York: Signet, 1947. Print.

———. *The Glass Menagerie, a Play*. New York: New Directions, 1949. Print.

———. *Summer and Smoke*. New York: Dramatists Play Service, 1950. Print.

IM Testimonial Contributors

Mikayla Bouchard, professional actor, Los Angeles, CA
Carolyn Conover, MFA candidate
Nic Dressel, undergraduate student
Rachel Frawley, professional actor Atlanta, GA
Sarah Goeke, MFA candidate
Andrew Head, MFA candidate
Stephanie Koening, professional actor, Los Angeles, CA
Ian Page, undergraduate student
Kirill Sheynerman, MFA candidate
Zev Steinberg, MFA candidate
Jacqueline Wheeler, MFA candidate

IM in Alternate Forms Contributors

Laney Abernethy, contemporary dancer: Former contemporary dancer who now operates the Pilates Body Shaping of 8th Street Studio in Charlotte, NC. Her clients include Olympic swimmers, professional dancers, members of Cirque Du Soleil, and the touring cast of *The Lion King.*

Anonymous, former top-ranked competitive distance runner.

Jeremiah Davis, flutist: Jeremiah has spent nearly two decades working in the professional music scene, including work as a flute soloist as well as a professional tenor and countertenor in opera, musical theatre, and choruses throughout the United States.

James Downes, rock musician: James is a guitarist and singer. He has performed on many projects including "Call It Arson" and "The End of America."

Pauline Frommer, radio host: Pauline is cohost of The Travel Show, a radio show produced by Clear Channel and heard in every state except Alaska (about 130 stations overall).

Melanie Helton, opera singer: director of the MSU Opera Theatre at the Michigan State University College of Music. She has sung leading roles in such opera companies as New York City Opera, Seattle Opera, Santa Fe Opera, Houston Grand Opera, the Teatro de Colón (Bogotá, Columbia), as well as many others.

Mike Jenkins, communications director: Head of Communications for the College of Arts and Letters at Michigan State University. Mike has an extensive communications and marketing experience including 10 years with Fortune 500 firms and 15 years' consulting work.

Payton MacDonald, contemporary classical musician: Composer/improviser/percussionist. He has created a unique body of work that draws upon his extensive experience with East Indian tabla drumming, American military rudimental drumming, jazz, European classical music, and the American experimental tradition.

Erika Moul, Lady Gaga impersonator: Las Vegas–based actor and singer. Erika has toured the country as Baby Gaga and now performs nightly at a tribute show in Las Vegas.

Adriana Salgado Neira, tango dancer: Danced for more than ten years with her partner, Orlando Reyes, in their native Colombia and has appeared on international stages from Dubai to Aruba. They have won numerous awards and were semifinalists in the 3rd Tango World Championship in Buenos Aires.

Michael M. Shoudy, attorney: Focuses on labor and employment law, education law, tenure law, collective bargaining, and litigation. He is a frequent speaker and author on issues affecting the workplace.

Jerry Sprague, musician and singer: Veteran performer for over 20 years. His diverse repertoire has earned him praise from college students to baby boomers across the upper Midwest whether performing solo or with the Sprague Band.

Ethan Stanislawski, stand-up comedian: A stand-up comedian, storyteller and sketch writer based in NYC. He studied History of Science at University of Chicago and Journalism at Indiana University.

Vasi, pop singer: North of Madison is an American/British duo comprised of DJ/producer Andrew Rispoli and artist/songwriter Vasi. The NYC-based team produced and recorded their debut EP in the eclectic North Of Madison neighborhood in Manhattan giving inspiration to the group's name.

Index

Abernethy, Laney, 195
Absurdism, 164–6
accompaniment, 65, 138, 139, 140, 141, 172
acting, 1–2
 good, defined, 5, 69
 head-centered versus out of your head, 31, 70, 80, 81–3, 85, 87–8, 90–2
 methodologies, 3, 6–7, 16–17, 25, 32, 69–71, 92, 179, 185–6
 psychological, 92
 as a schizophrenic state, 26, 35, 147–9, 179
 teachers, 5, 16, 34, 53, 63, 69, 92, 203
 theory, 11, 33, 69, 74, 77, 92, 155
 truth in, 5, 53, 55, 72, 84, 89, 92, 125–6, 182
 see also actors under individual names; actors; IM
actors, 5–7, 9, 47, 57, 83, 92, 206
 alone on stage, IM of, 61–5
 household of, 12, 157
 IM and regular, 33–4
 IM testimonial, actor Andrew, 98, 99, 102, 155–6
 IM testimonial, actor Carolyn, 37–8, 98, 100–2, 104
 IM testimonial, actor Jacqueline, 53–4, 104–8
 IM testimonial, actor Kirill, 67–8, 94–6
 IM testimonial, actor Sarah, 102–4, 135–6

IM testimonial, actor Zev, 96–8, 111–13
IM testimonials, alternate performers, 192–9
IM testimonials by other, 1–2, 19–20, 79–80, 169, 201–3
 see also under individual names; IM
Adler, Stella, 92
affective memory, 92
Aidoo, Ama Ata, 167
 Dilemma of a Ghost, 167
Allen, Woody, 122
 Annie Hall, 122
Anchorman (film), 152
Animal Crackers (film), 117
Annie (theatre), 142
Annie Get Your Gun (theatre), 142
apostrophe, 127–8, 131–2, 133
archetypes, 41–4, 151
aside, 115, 127, 130–2
audiences, 83–4, 92, 121, 125, 129, 130–2, 139, 145, 157
 actors use the, 19, 25
 director management of, 14
 feedback from, 36, 88, 118–19, 147–53, 196–9
 IM and, 33, 49, 62–3, 65, 88, 115, 117–19, 122, 127–8
 reaction to performance, 2, 14, 19, 40–3, 47, 60, 65, 147–8, 193–5
 transcendence and, 40, 53
auditions
 IM and, 25, 45, 169, 171–8
 self-sabotage in, 43, 171–2, 177
 waiting room at, 172, 175, 178

Baby (theatre), 142
backstory, 37, 62, 63, 65, 85, 180, 202
Ball, Lucille, 150
Bates, Brian, 26, 179
 "Actor and Mask as Metaphors for
 Psychological Experience," 26,
 179
bench exercises, 12, 14, 16
blocking, for performance, 63, 72
 camera, 125
 planned, 90
 stage, 40, 43, 56, 61–2, 90, 186,
 191, 198
 unplanned, 198
blocks, *see* obstacles
Blumenfeld, Robert, 11, 180
 *Tools and Techniques for Character
 Interpretation*, 11, 180
Bouchard, Mikayla, 19–20
Bye, Bye Birdie (theatre), 143

Cabaret (theatre), 144
Carroll, Jon, 40
 "Transformed by Art," 40
CCRT, 186–7
Chaplin, Charlie, 150
characters, 87, 195
 ancillary, 163
 development of, 6, 24–6, 29–30,
 39, 54, 177
 IM of, 34–6, 81, 89
 immersion into, 26, 33, 35–6, 39,
 64, 71, 198
 scripts drive, 180, 182, 186–7, 190,
 202
 thinking of, 1–2, 12, 14–16, 25,
 29–30, 140, 167
Chekhov, Anton, 56–7, 58, 59, 155
 Three Sisters, The, 53, 57–9, 67
Chekhov, Michael, 92
choices
 acting, 16–17, 30–5, 40, 50–2, 69,
 76, 86–91, 111, 180
 actor's and, 1–2, 6
 analysis and, 7, 30, 33, 186
 audition, 43, 173, 175, 177
 blocking, 186

directorial, 14
 emotional, 23, 85, 86
 IM and onstage, 13, 25, 27, 33–4,
 108, 119–21, 161–3, 184–6
 musical, 111–12, 138, 140–1, 151
 script scoring, 93, 101, 105
 tactical, 72, 74
 transition, 55, 56
Clark, Bob, 122
 Christmas Story, A, 122
classical theatre, 115, 127–33, 139,
 145, 159
Cocteau, Jean, 151
Cohen, Robert, 84
 Acting One, 84
Colson, Mark, 123
comedy, 79, 130
 clowns, 150–1
 farce and, 153, 159
 IM in, 147–53, 159, 161, 197
 Pedrolino archetype in, 151
 scripts, 149, 152
 songs as, 142
confession, as a form of IM, 64, 125–6
conflict, 33, 35, 84, 119, 139, 184
 CCRT and, 186–7
 IM and, 49–50, 65, 72, 74, 83,
 130, 141, 153
Conover, Carolyn, 37–8, 98, 102, 104
conscious thought, 5, 9, 17
continuity, 124–5
Core Conflictual Relationship Theme
 (CCRT), 186–7
Crits-Cristoph, Paul, 186
 Understanding Transference, 186
cultured self, 115–16

Dahmer, Jeffrey, 188–90
dance, 143–5, 167, 195, 198
Davis, Jeremiah, 192–3
dialogue, 20, 24, 83, 87, 138
 Absurdism and, 165
 character choices in, 29–32
 Chekhovian, 56–9
 film, 19, 121–2
 IM and, 19, 27–8, 30–5, 49–50,
 96, 98, 100, 104, 108, 118

IM spoken in, 115–17
inner, 33–4
directors, 92, 149, 162, 180, 190–1,
 206
 IM and, 7, 9, 12, 16, 41, 43–4, 51,
 82, 85, 119
 notes, 2, 14–15, 25, 41, 51
 transitions and, 57, 60
Doll's House, A (Ibsen), 53–4
 IM, 32, 64, 68, 155
 IM, of Krogstad and Linde (act 3),
 32, 35, 64, 89, 94, 96–7
 Krogstad in, 32, 91, 94–8, 99, 102,
 104–8
 Linde in, 91, 98, 99, 100–3, 106–8
 scoring, 32, 93–8, 99, 100–8, 155
double consciousness, 147, 148, 179
drama, 128, 131, 159, 161
 IM in, 115, 117, 119–20, 127, 164
 narration in, 118
 solo in, 140
Dreamgirls (theatre), 141
dream journals, 22
dreams, 6, 21, 22, 23, 121, 129
Dressel, Nicolas, 1–2
duets, 142

educated self, 115
educators
 IM and, 7, 9, 12, 14–15, 17, 30,
 33–4, 51, 57, 60
 job of, 71, 83, 84, 85, 88, 92, 206
ego, 11, 16, 17, 41, 42, 85, 175
 defined, 13
 exercises based on, 13–14, 23
 see also psychology; Streetcar
 Named Desire
emotion, 1, 53, 80, 97, 122, 138, 176,
 197, 237
emotional recall, 10, 32, 92
ensemble, 91, 142–4, 169
environment, 7, 30, 33, 37, 49, 63,
 103
exercises, 68, 88, 118
expectation, 63, 73–4, 77, 150,
 157–8, 187
Expressionism, 162–3, 165

farce, 153, 159
film, 138, 152, 157
 camera blocking in, 125
 continuity and, 124–5
 dance in, 143–4
 IM in, 118–23, 124
 reality television and, 125–6
 silent, 121–2
Fincher, David, 122
 Fight Club, 122
Forty-second Street (theatre), 144
fourth wall, 100, 117, 179
fragmentation, 266
Frawley, Rachel, 169
free association, 9, 10–12, 22, 23, 51
Freud, Sigmund, 11–13, 15–16, 115,
 175, 182
 see also psychology; Streetcar
 Named Desire
Frommer, Pauline, 194

genre, 149, 159, 161, 162
Gerstenberg, Alice, 115
 Overtones, 115–17, 120, 122
Gilliam, Terry, 122
 Fear and Loathing in Las Vegas,
 122
Goeke, Sarah, 102–4, 135–6
Gypsy (theatre), 142

Hagen, Uta, 63, 92
 Challenge for the Actor, A, 63
Hanson, Rick, 205
 Just One Thing, 205
Harron, Mary, 123
 American Psycho, 123
Head, Andrew, 98, 99, 102,
 155–6
Heckerling, Amy, 122–3
 Clueless, 123
Helton, Melanie, 191–2
Hitchcock, Katherine, 26, 179
 "Actor and Mask as Metaphors for
 Psychological Experience," 26,
 179
Hopwood, Christopher, 9, 179, 181,
 182–3

Ibsen, Henrik, 155
 see also *A Doll's House*
id, 12–17, 41–2, 71, 85, 115, 175
 defined, 11
IM, *see* Inner Monologue
improvisation, 1, 72, 126, 158, 166,
 181, 187, 193–4
Ince, Thomas, 121
 Dream, The, 179
Inner Monologue (IM)
 actor Andrew on, 98, 99, 102, 155–6
 actor Carolyn on, 37–8, 98, 100–2,
 104
 actor Jacqueline on, 53–4, 104–8
 actor Kirill on, 67–8, 94–6
 actor Sarah on, 102–4, 135–6
 actor understanding of, 11, 22,
 33–4, 44, 51, 118, 126, 132,
 144, 179
 actors on, 1–2, 19–20, 79–80, 169,
 201–3
 actor use of, 1–3, 9, 11–14, 21–6,
 28–9, 131, 174, 206
 actor Zev on, 96–8, 111–13
 alternate performers on, 192–9
 archetypes (hurdles list), 41–4
 aside as, 115, 127, 130–2
 audience and, 41, 43, 88
 auditioning and, 169, 171–8
 champion in, 41, 44
 character, 26, 31, 35, 42, 44, 199
 and character needs, 12
 in character thought and action,
 27–9, 54, 61, 81, 115, 155–6,
 201, 205
 choices, acting, and, 6–7, 16–17,
 30–5, 40, 51, 69, 76, 89–91
 choices and, 13, 25, 27, 33–4, 108,
 119–21, 161–3, 184–6
 in classical theatre, 127–8, 130
 in comedy, 147–51, 159–61
 confession as, 64, 125–6
 critic and, 41, 42, 44, 173
 criticism and, 38, 42, 148, 193, 199
 debating, 82
 definitions of, 2–3, 5–6, 9, 19–20,
 25–6, 117, 179

dialogue as, 19, 27–8, 35, 50, 96,
 98, 100, 104
dialogue in, spoken, 115–17
director in, 7, 9, 16, 41, 43–4, 82,
 85, 119
directorial use of, 12, 25, 51, 83,
 119–20, 162
dominance and submission in, 184–6
drama and, 115, 131
dreams and, 21
educators and, 7, 9, 12, 14–15, 17,
 30, 33–4, 51, 57, 60
as enemy, 6, 39, 41–5, 65, 67, 90,
 148, 171–4, 176, 199, 205–6
everyday life and, 10–11, 21–6, 29
in film, 118–23, 124
free association in, 9, 10–12, 22,
 23, 51
head-centered versus out of your
 head, 31, 80, 81–3, 85, 87–8,
 90–2
id and, 11–17, 41–2, 71, 85, 115,
 175
image, characterization, 29, 32,
 58–9, 64, 86, 94, 103, 177
image, scoring, 94–6, 102–3
image and, 24, 68, 90–1, 95, 121,
 156, 180–1, 193, 205
image as, 111
image exercises and, 15, 22, 38, 75,
 86–7, 111–12, 164, 186
image verbalizing and, 23
importance of, 2, 32, 77
introspection is, 42
logic informs, 14, 17, 30, 55, 60,
 94, 152, 162, 205
memory and, 22–3, 45, 59, 60, 92,
 178
mentalization and, 182–4
misdirected, 45
morality and, 15, 188–90
motivation is, 9, 12, 17, 32, 89
music and, 10, 29, 39, 68, 87, 102,
 111–12, 135–8, 156, 159
musicians and, 137–9, 192–5,
 197–9
in musical theatre, 137–45, 191–3

objective/tactic/obstacle and, 70
oblivious in, 41, 42
origins of, 9, 17, 179, 180, 190
pathways, 82
Other and, 85
peak experiences and, 39–41, 82
performance and, 191–9
personal, 5–6, 21–9, 36–41, 82–5,
 92, 102, 108, 199
personal becomes character, 15–17,
 25–6, 31, 44–5, 67–8, 126, 205–6
planner in, 41, 42
professional, 172–5, 176, 177–8
props and, 88, 115–16
psychological aspects of, 6, 8, 9–17,
 119, 179, 189–90
real life and, 6, 35–6, 81–2, 86
rehasher in, 41, 43, 44
scoring and, 31–2, 40, 51, 86,
 93–8, 99, 109, 112–13, 169
scoring with, 93–8, 99, 108–9, 112,
 136, 169, 201
scripting, 32, 112, 136, 167, 185
scripts and, 31–2, 37, 40, 51, 67,
 86, 118–20, 155–6
silence filled with, 47, 49, 50
silencing, 10, 21, 35, 42, 67
single-word exercise and, 86, 156
soliloquy as, 61, 115, 127–32, 133,
 139, 197
sources of, 9–10
sports focus and, 195–6
style, 157–9, 161–2, 165, 166–7
subtext and, 47–52
transitions are, 36, 39, 56–7, 87,
 112, 176–8
transitions and, 17, 19, 25, 31, 42,
 55–60, 164, 197
universal scene and, 54, 88–90, 91
verbalization and, 11, 13, 15, 23–4,
 33–4, 59, 111
victim in, 41, 44
vulnerability and, 5, 38, 84–5,
 89–91, 150–1, 205
whispering, 33–4, 38, 74, 86, 111,
 132
Zen-like, 202, 205

see also A Doll's House; objective;
 obstacle; psychology; Streetcar
 Named Desire; tactic
inner object, 92
inner voice, 22, 69, 122, 130, 167,
 177
Interpersonal Circumplex (IPC), 184,
 185, 185–6
introspection, 38, 42, 132
invulnerability, 84
IPC, 184, 185, 185–6
Isms, 161–2
see also Absurdism; Expressionism;
 Symbolism

Jenkins, Mike, 194
Jesus Christ Superstar, Isherwood
 review of, 137
Jung, Carl, 115

Kaufman, Charlie, 122, 147
 Adaptation, 122
Keaton, Buster, 150
Keaton, Diane, 122
Kelly, Gene, 143
Singin' in the Rain, 143
Koening, Stephanie, 79–80

labels, 9, 127, 163
Laramie Project, The, 201–2
Leary, Timothy, 184
Liepa, Torey, 121
 "Figures of Silent Speech," 121
lists, 21, 23, 72, 163, 193
Lloyd-Elliot, Martin, 177
 "Witches, Demons and Devils," 177
Luboorsky, Lester, 186–7
 Understanding Transference, 186
lyricist, 138, 145
lyrics, 60, 87, 138, 140–4, 192

MacDonald, Payton, 193
make-believe, 25–6, 35, 123
Mamet, David, 30
Maslow, Abraham, 39
Religions, Values, and Peak
 Experiences, 39

McQueen-Fuentes, Glenys, 150, 151
 "Theatrical Clown—A Theatrical
 Explanation of the Inner Self,"
 150–1
Meisner, Sanford, 92
memory, 9, 16, 143, 193
 emotional recall and, 10, 32, 92
 IM and, 22–3, 45, 59, 60, 178
mentalization, 182–4
Merlin, Joanna, 171
 Auditioning, 171
metaphor, 26, 84, 158, 163–4
Michigan Sate University, 9, 123
Miller, Arthur, 64
 Price, The, 64
Minnesota Multiphasic Personality
 Inventory (MMPI), 188–9
MMPI, 188–9
Modern Family (television), 125
Molière, Jean-Baptiste Poquelin, 130
 Tartuffe, 130–1
mood, 58, 62, 71, 87–8, 94, 138–9, 141
 Symbolists and, 163–4
motivation
 character, 1–2, 12, 17, 89
 IM is, 9, 12, 17, 32, 89
 role of, 9
Moul, Erika, 198–9
multiplicity, 179
multitasking, 82, 191
music, 88, 102, 111–12, 139
 characterizations and, 87, 195
 duets, 142
 IM and, 10, 29, 39, 68, 135–8, 156, 159, 192–5
 IM and musicians, 137–9, 192–3, 197–9
 reveals objectives, obstacles, and transitions, 87, 195
 torch song, 141–2
 underscoring, 87, 138, 142
musical theatre
 duets, 142
 IM in, 137–45, 191–3

narration, 121, 123, 131
 first-person, 117–20, 122

narrative, 37, 38, 186–7
New York Times, The, 137
Nichols, David S., 188–9
 "Tell Me a Story," 188–9
Noh theatre, 167
notes, 45, 70, 72, 75, 194
 directorial, 2, 14–15, 25, 41, 51

objectives, acting, 6, 27, 69–75, 77, 82, 177
 audience and, 129, 131
 Eastern forms of, 167
 music reveals, 87
 scoring includes, 31–2, 40, 51, 93, 169
 and super-objectives, 71, 72, 75, 76, 186–7
obstacles (blocks), 1–2, 6, 68, 69, 82, 83, 155, 190
 defined, 74, 75
 music reveals, 87
 scoring includes, 31, 93
 wins and losses of a scene as, 76–7, 187
Odets, Clifford, 1
 Waiting for Lefty, 1, 75
Office, The (television), 125
One Flew Over the Cuckoo's Nest (theatre), 181
O'Neill, Eugene, 117
 Strange Interlude, 117, 120, 121
On the Town (theatre), 142
opera, performing in, 191–2, 193
organization, 13, 15, 174–5
out loud, speaking, 23, 62, 63–4, 73, 98, 111, 139

Page, Ian, 201–3
peak experiences, 39–41, 82
Pedrolino archetype, 151
percentages, 41
personal clown, 150–1
physicality, 83
Pirandello, 147
preparation, audition, 173–4
primitive self, 115–17
priorities, 14, 23

professional IM, 172–5, 176, 177–8
projecting, 22–5
props, 36, 63, 64, 65, 96, 132, 143,
 191
 IM and, 88, 115–16
protagonist, 162–3
psychological gesture, 92
psychological problems, see blocks
psychology, 94
 CCRT and, 186–7
 ego, 11, 13, 16, 17, 41, 42, 85, 175
 Freud and, 11–13, 15–16, 115, 175,
 182
 id, 11–17, 41–2, 71, 85, 115, 175
 IM and, 5–6, 8, 9–17, 119, 179,
 189–90
 on IM as schizophrenic, 26, 147–9,
 179
 MMPI and, 188–9
 on motivation, 9
 subconscious thought, 5, 10, 22,
 98, 100
 superego, 11, 13, 15–17, 41, 43,
 85, 175
 theories, 115, 182–7

realism, 86, 158, 161
reality and IM, 6, 35–6, 81–2, 86
reality television, 125–6
Real World, The (television), 125
relationship episode, 186–7
research, 30–2, 37, 132, 171, 173,
 181, 202
riffs, 139, 198
Roznowski, Rob, 3, 6–7, 27, 32, 37–8,
 53–4, 181
 Happy Holy Days, 27–9

Salgado Neira, Adriana, 198
San Francisco Chronicle, 40
scenes, wins and losses of, 76–7, 187
schizophrenic state, 26, 35, 147–9,
 179
scoring
 IM, 31–2, 40, 51, 86, 93–8, 99,
 108–9, 112–13, 169, 201
 with images and sounds, 96

IM scenes in A Doll's House, 104–8
IM scenes in A Doll's House, act 3
 (Krogstad and Linde), 32, 35, 64,
 89, 94, 96, 98, 100–3
 objectives and, 31–2, 40, 51, 93, 169
 personal, 108, 138
 psychological, 94
 styles of, 94–8, 99, 100–8
 traditional, 93–4, 109, 140
 see also scripts
Scott, Siiri, 167
scripts, 26, 30, 53–5, 71, 76, 124
 characters driven by, 180, 182,
 186–7, 190, 202
 comedy, 149, 152
 IM and, 32, 112, 136, 167, 185
 musical, 140–5
 needs of, 7, 14, 27, 34–5, 47, 59,
 84–5, 126, 167
 non sequiturs in, 60
 scoring, 31–2, 37, 40, 51, 67, 86,
 118–20, 155–6
 scoring with IM, 32, 93–8, 99,
 108–9, 112, 136, 155, 169, 201
 style and, 167
 subtext, 49–50
 transitions in, 177
 see also research
self-image, 181
Shakespeare, William, 30, 128, 129,
 130
 As You Like It, 169
 Hamlet, 129–32
 Macbeth, 130
 Romeo and Juliet, 128–9, 132
 Twelfth Night, 130
Sheynerman, Kirill, 67–8, 94, 96, 97
Shoudy, Michael M., 196
Show Boat (theatre), 141
silence, 108, 121
Simon, Neil, 117–18, 151
 Barefoot in the Park, 151–2
 Brighton Beach Memoirs, 117–18,
 129
Singer, Michael A., 205
 Untethered Soul, 205
Singin' in the Rain (film), 143

soliloquy, 61, 115, 127–32, 133, 139, 197
solo, 63–4, 140–1
 alone on stage and IM as, 61–5, 197
 musical, 137–42, 193
Sophocles, 128
 Oedipus the King, 128, 131–2
Sprague, Jerry, 193
stage direction, 50
 blocking, 40, 43, 56, 61–2, 90, 186, 191, 198
Stanislavski, Constantin (Konstantin), 69, 92
Stanislawski, Ethan, 197
Star is Born, A (film), 141
Steinberg, Zev, 96, 97–8, 111–13, 148
Strasberg, Lee, 92
stream of consciousness, 5, 9, 38, 68, 102, 104, 117, 186
Streetcar Named Desire, A (Williams)
 audience and, 118–19
 Blanche DuBois, IM of, 29, 35, 62–4, 71, 74, 76, 86, 184–5, 187
 Blanche's IM in ego, id, and superego, 12, 14, 16–17
 dominance and submission in, 184–6
 Eunice in, 62
 Mitch in, 184–5
 Stanley in, 76, 118, 184–5
 Stella in, 12, 36, 62–3, 74, 86, 88, 118, 184, 187
 Stella's ego in, 16
style, IM and, 157–9, 161–2, 165, 166–7
 see also director
subconscious thought, 5, 10, 22, 98, 100
subtext, 19, 70, 72, 75, 79, 96, 111, 159–61
 defined, 47
 IM and, 47–52
 scoring and, 51, 169

subvocalization, 9, 11
Sunday in the Park with George (theatre), 142
superego, 11, 13, 15–17, 41, 43, 85, 175
super-objective, 71, 72, 75, 76, 186–7
Sweeney Todd (theatre), 142
Symbolism, 163–4

tactic
 acting, 6, 69, 71–4, 75, 77, 82
 defined, 71–2
 scoring and, 40, 51, 72, 93
teachers, acting, 5, 16, 34, 53, 63, 69, 92, 203
Teflon mind, 205–6
theatrical devices, 115, 117, 119, 125, 127, 133
 see also apostrophe; aside; IM; narration; soliloquy
torch song, 141–2
transitions, 7, 20, 112
 audition, 176–8
 Chekhovian, 57–9
 IM and, 17, 19, 25, 31, 42, 55–60, 164, 176–8, 197
 IM in, 36, 39, 56–7, 83, 87, 112, 177–8
 music reveals, 87
 props and, 96
 truthful, 53, 58, 76, 112

unconscious, thought, 5, 11, 17, 19, 21, 22, 115
underscoring, musical, 87, 138, 142
units
 of song, 112
 of thought, 27, 32, 89, 93
 transitions and, 55, 112, 156
universal scene, 54, 88–90, 91

Vasi, 192
verbalization, 11, 13, 15, 23–4, 33–4, 59, 111
villains, 121, 188–9, 190

vocalization, 26, 60, 135, 139
 musical solo, 137–42, 193
 subvocalization and, 9, 11
 torch song, 141–2
vulnerability, 5, 6, 65, 188
 IM and, 38, 84–5, 89–91, 150–1,
 205

waiting room, audition, 172, 175, 178
West Side Story (theatre), 142

Wheeler, Jacqueline, 53–4, 104, 108
Wilde, Oscar, 50, 159
 Importance of Being Earnest, The,
 49–50, 159–61
Williams, Tennessee, 12, 17, 29, 63,
 118, 155, 181–2
 Glass Menagerie, The, 118, 122, 131
 Summer and Smoke, 181–2
 see also Streetcar Named Desire
wins and losses, 76–7, 187